W9-BOO-286

Professional
Nature
Photography

Professional Nature Photography

Nigel Hicks

OXFORD AUCKLAND BOSTON JOHANNESBURG MELBOURNE NEW DELHI

Focal Press
An imprint of Butterworth-Heinemann
Linacre House, Jordan Hill, Oxford OX2 8DP
225 Wildwood Avenue, Woburn, MA 01801-2041
A division of Reed Educational and Professional Publishing Ltd

A member of the Reed Elsevier plc group

First published 1999

British Library Cataloguing in Publication Data
A catalogue record for this book is available from the British Library

Library of Congress Cataloguing in Publication Data
A catalogue record for this book is available from the Library of
Congress

ISBN 0 240 51521 8

Typeset by Avocet Typeset, Brill, Aylesbury, Bucks
Printed and Bound in Italy by Printer Trento srl.

CONTENTS

PREFACE

It is often assumed that a skill in taking photographs is all that is needed to become a professional photographer. Yet, the assumption overlooks all the hard work that the professional must put into promoting their work, the amount of management and general organization that is needed to run a variety of projects, ensuring that each one progresses to completion on time, that new ones come in to replace those finished, that bills are paid and income brought in. In short, being a good photographer is just the first stepping stone along the road towards running a photographic business.

The market is filled with books on virtually every photographic technique imaginable and, yet, it is surprisingly empty when it comes to covering the gap that exists between the worlds of the amateur and professional photographer. That publishing void might be at least partially due to the false assumption alluded to above, but anyone who has ever made the journey from amateur to professional will be only too well aware just how big the gap is. They will also be keenly aware of how little help has traditionally been available, how many simple steps could ease the way and how many pitfalls could be avoided if only something or someone was there to illuminate the road.

While many of the steps involved in setting oneself up as a professional photographer will be pretty much the same regardless of what speciality fields you decide to enter, some are specific to each specialization and so require rather more tailored guidelines. Thus, this book looks at the route to entering and becoming successful in the field of professional nature photography. The steps described here are very much the result of personal experience and, in some cases, of much trial and error to find out what does and does not work. I have no doubt that some of my colleagues will disagree with parts of the advice I have given but, as I said, this book is very much a product of my personal experience. There is more than one way to proceed down the road to success as a professional nature photographer, and what works for one photographer may not work for another.

Nevertheless, what I have written here gives a useful guide and framework to work within as you develop your career. Following my advice does not guarantee success; that is down to each individual

photographer, the quality of his or her photography and the amount of hard work and commitment he or she puts into following the process I have outlined.

Nigel Hicks

Acknowledgements

The author would like to thank those numerous people who gave advice and help while putting this book together, most especially Tricia Glass, Kenneth Hicks, David Golby and David Woodfall. Mark Berry, executive officer of the British Institute of Professional Photography was of great help with the list of international contacts.

GETTING STARTED

In these days of mass media and information overload, with images of everything from fizzy drinks to tantalizing sex and horrific war leaping out at us from every conceivable angle, it is hardly surprising that photography looms large in so many areas of life. Interestingly, the people behind the cameras collecting all those images are rarely visible to the public and, yet, in such an intensely media-conscious world they have gained a certain mystique, dare I say even glamour. To become a photographer is an important part of an increasing number of people's idle, and not so idle, daydreams. After all, are not photographers often their own bosses? Do they not get to travel to exotic locations? And is not all that expensive gear hanging round photographers' necks testimony to the huge amounts of money they earn?

The world of the nature photographer is one area of photography that attracts special interest. Some wonderful television and magazine wildlife documentaries and stories have fired many a person's imagination into seeing him or herself as a modern day camera-toting Indiana Jones or Crocodile Dundee, boldly venturing out into the wilds to capture on film what no one has captured before. 'If only I knew where to start!' might be one of the first soon-to-follow enthusiasm-dampening refrains, one of many ensuring that few people realize their dream.

Without any doubt, the first few steps towards turning dream into reality can be the hardest. Almost everyone will need some help, whether it be from friends and colleagues already involved in the field, a course of full- or part-time study, or books such as this one. Even for a photographer who already has all the necessary photographic techniques at their fingertips, the process of learning to make a living from those techniques can be a long and tortuous one. The world's most brilliant photographer will not succeed commercially if they do not know how to sell themselves, whereas even an average photographer can do well if they have just the right business acumen.

Those with dreams of a glamorous life as a nature photographer may even find themselves a little disillusioned as they come to know more about the business. The reality for the great majority of those who have made it into the ranks of professional nature photographers is that for most of the time they are very ordinary people working in rather ordinary ways, running what is, admittedly, a rather unusual business. Part of the work does involve the opportunity to don a bush hat and

PROFESSIONAL NATURE PHOTOGRAPHY

sweat-stained jacket, and go trail-blazing into the forest, but there is also plenty of office work in the form of preparing submissions for clients, filing new photographs, planning and organizing the next assignment, writing proposals, chasing up people by telephone – rather like any office job.

Many an amateur photographer, whatever their chosen field, has remarked that they would never want to be a professional owing to the fear of getting sick of holding a camera. Impossible. It is all that tedious, but essential, office work that drives me up the wall, and I can hardly put into words the wave of relief and excitement I feel when I escape from the computer and desk, camera in hand, to go and do what I believe I do best.

But whatever your starting point, whether a keen amateur photographer, a student studying photography at college, or even already a professional photographer working in some other field, inevitably you do not just suddenly become a nature photographer. It can be a slow, rather evolutionary process, one that must involve the resolution of a number of questions which will be introduced briefly here. The first may seem rather obvious, but it is surprising how varied views can be, and it is essential to have from the beginning a clear idea of your photographic aim.

What is nature photography?

Strictly speaking, nature covers the world of plant and animal wildlife but, in these days where the need to make connections with all sorts of interacting forces is widely recognized, nature has to take a much wider view than simply one of living organisms. Thus, habitats are of great importance too, along with all the negative and positive impacts upon them. The result for the nature photographer is that work should also include landscape photography, along with the effects of humankind, both good and bad, through pollution, farming, population growth and conservation programmes. It is surprising how much people photography a nature photographer can end up doing!

Thus, there is plenty of overlap with other areas of photography that have traditionally been thought of as rather separate. Landscape and travel are probably the two most important such areas. In the case of the former, it can often be hard to know exactly where the dividing line is between, say, a plant and a landscape photograph. A view of a single tree may be seen as a plant photograph, but as the camera pulls back to reveal more trees, and hence that first tree's habitat, it becomes a landscape. Similarly for a distant image of a wild animal: is such a picture a wildlife shot showing the animal in its natural habitat or a landscape view given added interest by the presence of the animal? The difference actually is rather immaterial, just so long as the photographer realizes that a viewer may pigeonhole any given picture in not quite the same way as they would. Similarly, the viewer should appreciate that, in taking such wide view shots, the photographer has not strayed from the nature photographer's remit.

In the case of travel, a picture of women selling bats in a Philippine market, for example, might not look out of place in a typical guide

book. But it is also quite definitely a nature photograph, revealing one of the many ways in which rural populations exploit, and all too often decimate, their local wildlife. Further examples abound, whether it be photography of a rice or wheat harvest, sheep grazing the land, or evidence of the reverence shown to animals in some religions.

Even business or economic photography impinges upon the world of the nature photographer, whether it be with an image of a new road ploughing through beautiful countryside, an opencast mine tearing into tropical rainforest, or again that rice or wheat harvest.

In this way, a nature photographer may end up unintentionally wearing several different hats all at once, and it is quite usual also to be seen by others as a specialist in landscape or travel photography without in your own mind having ever strayed from nature. You should not be so stuck on nature as to see this as any kind of a problem, for alternative labels can also open up a wider range of opportunities, thereby expanding your potential client base.

For the photographer whose personal interests lie solely with photography of fauna and flora, the wide range of subjects that suddenly seem to fall within the remit of the nature photographer may be a little off-putting. Needless to say, setting up as a nature photographer does not automatically imply any compulsion to cover all aspects of the subject, but it should be borne in mind that in these days of intense competition – and there really are a large number of people out there working at being nature photographers – flexibility and versatility are key tools towards success.

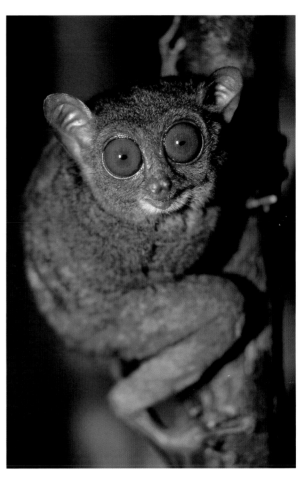

Figure 1 At about 3 inches (7.5 cm) long excluding tail, the Philippine tarsier is one of the world's smallest primates.

Why specialize in nature photography?

Motives for taking up a camera to capture the natural world on film are probably almost as varied as the number of people involved, ranging from the dreamer aiming to cultivate the camera-toting Rambo-cum-Indiana Jones image, to the dedicated scientist trying to record particular species or habitats, to the ardent environmentalist crusading to change the world's profligate ways. Probably, the majority of people have a little of all three in them, plus a number of very personal reasons.

While most people choosing to become professional nature photographers probably do so out of some concern for the natural world and its protection, undoubtedly many enter the field purely out of an interest in animals and/or plants. Yet, when it comes to wildlife and the environment, I think it almost impossible for any photographer to remain an impartial observer for long. Support for the conservation movement is almost inevitable, although followed with highly

variable degrees of fervour, in which any desire to affect the course of history will at times be overwhelmed by the need to make a living.

Certainly, any photographer entering the field cannot fail to be acutely aware of the importance of photography in conservation. Few environmental issues have reached widespread public attention without the aid of photographers, whether it be evidence of the mass slaughter of whales or elephants, devastation wrought by uncontrolled logging, or the impact of pollution on both the human and natural environments.

These features are the negative aspects of the conservation cause; but there is also much to be done on the more positive side, the subjects that do not generate stark mind-shaking headlines. These include the enormous task of recording the many beautiful places and species that still exist around the world, reminding everyone that there is still much beauty out there worth protecting, illustrating the work that increasing numbers of people are involved in to bring that protection about, and continually working to keep the glory of wildlife and the natural environment in the mind of the general public.

There are many ways of achieving these goals, and of ensuring that the work is enjoyable and rewarding not only emotionally but financially too. You may be a nature photographer for the sheer thrill of capturing a wild animal, a plant or a landscape on film, the feeling of

Figure 2 A pine forest and mountain peak climb above low cloud at sunset; Yushan National Park, Taiwan. For a calming, restful image it can be hard to beat sunset or dusk, and this one taken high on the slopes of Taiwan's highest mountain I find especially effective.

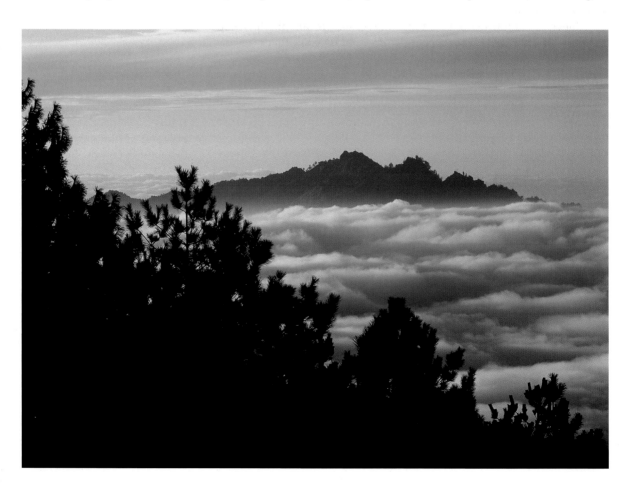

making a valuable contribution to an essential cause, or simply for some of the freedoms it offers as your own boss often working in the great outdoors. However, one of the hardest truths as a professional is that at the end of the day when the rent collector comes, the bank takes its mortgage payment or the tax man shows up, you have to have made a profit with which to pay them. It is a goal that must be borne constantly in mind, and which, alas, always has to be weighed up in deciding how to approach each project, or even whether to take on a specific job at all.

Is there a living to be made?

To profit from wildlife and conservation is sometimes seen in some countries as a little obscene, almost something to be ashamed of. But we all have to make a living, and the photographer is no exception. The nature photographer has one of the best opportunities available to make a living while doing something truly worthwhile, which I suppose is one of its main attractions in the first place. Balancing the need to make a living with a desire to make an effective contribution to conservation or an understanding of the natural world can at times be difficult, especially in the early days, but it is by no means impossible, and many a photographer can eventually look back and identify photographs that not only brought in a reasonable financial return but which also had an impact on the public.

Inevitably, knowing how to take photographs is only the first step along the road to being a successful professional. Beyond that is all the knowledge – much of which can be accumulated only through practical experience – of how to work in the field, and how to organize office time to effectively promote your photography and handle money matters that are some of the keys to success.

As with any new venture, the initial phase of investment both in time and money to get started can seem like an awfully big gamble. When I first launched into professional photography there were many times when I seriously wondered whether I would ever get my money back, and it must be said that the returns can be a long time in coming. However, a persistent approach to marketing combined with an ability to consistently produce work of high quality and with a distinctive personal style will eventually find its reward in terms of a flow of commissions, sales and, hence, income.

It should be stressed that nature photography is an area that attracts a large number of would-be professional photographers so, to be sure of progressing past the would-be stage through the just-managing phase and on to the delights of the secure and successful peaks, you must be quite determined. For those who have clear goals, work tirelessly towards them and develop both good marketing skills and a clear understanding of the different potential markets, there is quite definitely a good living to be made from nature photography. Furthermore, it should be a living in which it is not necessary to make too many uncomfortable compromises with environmental issues, although admittedly in the early days when every new job counts this may be a luxury that from time to time will need to be sidelined.

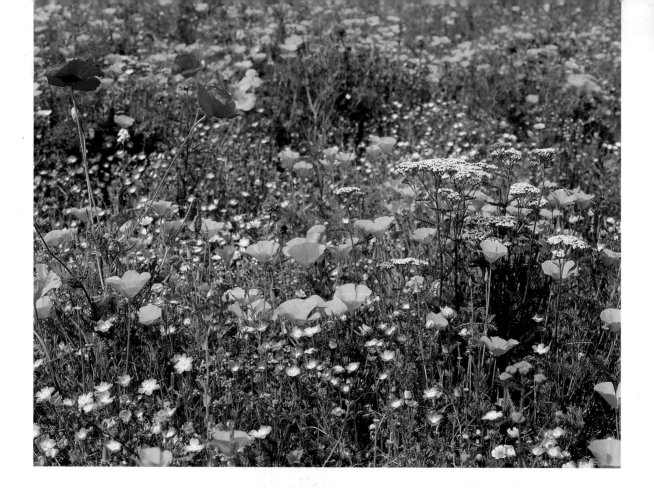

Figure 3 A field of wild flowers, Yokohama, Japan. Not a remote pasture that agriculture somehow forgot, but a vacant building site right in the centre of Japan's second city. When Japan went into recession in the early 1990s building projects across the country were abandoned, leaving ugly empty construction sites scattered around its cities. In Yokohama, one enterprising organization took such a site, right next to the city's main railway station, and seeded it with wild flowers, setting up posters to explain what they all are. The result is a wonderful blaze of colour and a feast of flowers.

The basic requirements

It is all in the mind

From the foregoing it can be easily concluded that the most basic and crucial requirements for success are commitment and enthusiasm. Enthusiasm for both nature and photography, and commitment to achieving the twin goals of high-quality photography and commercial success. It is only natural, when standing on the threshold of this new career, to be anxious as to whether you have the photographic and self-promotional skills needed to succeed. This is to be expected, but what should be avoided is launching into the arena half-heartedly, filled with doubts as to whether this is what you want to do. Make sure in your own mind first before taking what may be barely reversible, and expensive, steps. Work in the field for a period of time as an amateur, devoting only your spare time to photography and marketing, while having some other, perhaps unrelated job, to give you financial security until you are quite sure you are willing and ready to take the plunge.

Being a biologist as well as a photographer

Beyond the most basic requirements of commitment and enthusiasm there is, of course, the question of knowledge: being sure that you have the necessary photographic techniques as well as knowledge of wildlife and the environment lodged in your head and ready for action. Both

take years to accumulate, though the basics can be learned in college or from books. Both also require large amounts of field work to hone them into a real skill, especially in combining them to make truly successful natural history photography.

This does not mean to say that you should know all there is to know of theory in both photographic techniques and nature studies before taking up a camera or, indeed, before there is any hope of producing good photography. I have heard it said a number of times that a successful nature photographer must be a naturalist first and a photographer second. This is a sentiment I do not agree with. The two need to go hand in hand, it is true, but as a rule of thumb I would say that a good photographer with only a modicum of knowledge of natural history will be able to take better photographs, although within a relatively narrow band of the subject, than a brilliant naturalist with only a modicum of photographic knowledge.

Of course, a certain amount of biological knowledge is needed as a basic minimum before any kind of reasonable nature photography can be undertaken but, at the outset, perhaps a more fundamental requirement than a vast amount of pre-existing knowledge is a willingness and ability to almost literally soak up information at a great speed while on the job. The need for this, although most obvious during the early days of a career, will almost certainly remain an important feature throughout the years of life as a professional nature photographer, leading to a vast fund of knowledge that can be readily drawn on. There will still be many situations in which even an experienced professional will need to do some rapid research before starting a new job, as there is absolutely no way that a professional photographer, asked to photograph in a wide range of habitats in perhaps a number of different countries, can have all the necessary knowledge to hand. Thus, developing an ability to research information, to absorb newly discovered knowledge and then make use of it in the field is probably more important – and will remain an essential tool throughout a career – than having an advanced knowledge even before that career starts.

The equipment

It is surprising how little equipment you need to get started. The starting point and main workhorse, at least for wildlife photography, is the 35 mm camera, equipped with a range of lenses from a powerful telephoto down to macro and, of course, with a number of lenses of in-between sizes for the more standard focal length kind of photography, all backed up with a flash gun and a versatile tripod.

For photography of landscapes and subjects that are not about to run away, you will have to seriously consider investing in medium format. Despite improvements in film and lenses for 35 mm cameras, as well as the advent of digital imaging, medium format is still heavily in demand from photo libraries and many clients. Although not an essential tool at the beginning of a career when budgets are usually very tight, this kit should be high on the list of priorities as soon as your financial situation allows it.

Extras will depend to a large extent on what areas within nature photography you end up concentrating on most, whether they include

bellows for more powerful macro photography, a studio setup for controlled lighting and environment, a hide for efforts to get close to wild animals, and underwater camera gear for subaqua photography.

The final piece of equipment that is a definite must is a computer. A standard inclusion for several years now, especially among those photographers who also write, but also as an aid to marketing and filing photographs, the computer has recently become even more important as a result of the mushrooming field of digital imaging. A standard computer capable of handling all the traditional office paperwork is these days a relatively inexpensive investment. It is not necessary to fork out for the digital imaging equipment right at the start of your career in photography, but with the cost of such equipment positively crashing, this revolution in photography is set to become a standard feature of every photographer's arsenal. More on this follows in a later chapter.

Respect the environment, know the law

It may appear superfluous to urge nature photographers to respect the environment and all the wildlife that lives in it, but it is surprising how easily the necessary caring attitude can be forgotten in the struggle to get the perfect photograph. More than once I have heard park rangers complaining about the damage done by photographers, for example, trampling just-developing rare orchids in order to get to the one in flower.

When planning and carrying out work, even a fiendishly difficult job where only highly innovative solutions might win the day, it is essential to remember that the end does not always justify the means, and that (if you will excuse the phrase) if the only way to stop the music is to shoot the piano player you had better leave the bar.

As the orchid example above illustrates, be very careful when moving in to get close-up photographs of plants or small animals: make absolutely sure that you are not about to inflict serious or irreparable damage to surrounding vegetation. Do not cut down the forest in order to photograph the last wild ginseng plant. When photographing animals, even one as lowly as an insect, never do anything that will inflict pain, that will cause young to be abandoned or which will in any way have some other lasting effect on behaviour. Remember, too, that fear in a bird or mammal, although not strictly pain, and a feeling that will subside once you have faded from the animal's memory, may well show up in the resulting photographs – something which may not only make the photographs unusable but which will also be spotted by other naturalists and photographers. This does not mean to say that it is wrong to take animals or plants into a studio in order to photograph them in controlled surroundings and light – provided that wild animals are released unharmed afterwards – although, of course, with mammals and birds such work will most likely entail using tame animals.

Plants and most animals cannot let you know when you are going too far, inflicting damage or pain when all you want is a decent photograph, so every photographer must develop a code of ethics and their own yardstick as to what is and what is not acceptable in trying to get the best pictures. The need to leave a subject alone when it is actually physically dangerous for the photographer to get the picture – like

hanging off a cliff – is easy enough to recognize and act on. However, knowing when to back off and leave an animal alone – and actually doing so – simply when crossing an invisible and unfelt ethical boundary forbidding interference, even when an important job is at stake, takes a lot of discipline. Nevertheless, it is one that every nature photographer needs to develop and adhere to.

For those photographers unable or unwilling to develop that self-discipline there is still the law. Many countries have laws governing what you can and cannot do with plants and animals (wild or tame), and such laws apply as much to well-intentioned nature photographers as they do to the most bloodthirsty of hunters. Admittedly the level of enforcement and the punishments vary enormously from country to country, but laws banning or controlling through the issuing of permits such acts as photographing nests or collecting plants are now widespread. Be sure you come to know and understand the laws of the country in which you operate and, if commissioned to work overseas, try to familiarize yourself with that country's laws before you set out.

Similarly, laws governing land access vary widely from country to country, from a right to roam almost anywhere, to the drawbridge mentality of others in which private land is totally off limits to all but a select few. Of special importance to the nature photographer are the laws that many countries have introduced to control access to nature reserves and some parts of national parks. As someone almost certainly involved in conservation, the nature photographer must be sure to stay

Figure 4 A country road lined with beech trees in autumn; Haldon Hills, Devon, UK. Autumn in sunshine is arguably the best annual show that nature puts on, but putting it on film in such a way as to really catch the mood of the season relies on being able to find the right views with the right trees at their peak of colour in the right light. Achieving that may be a matter of pure luck, or may as in this case entail carefully watching a known location for several weeks until all the elements come together.

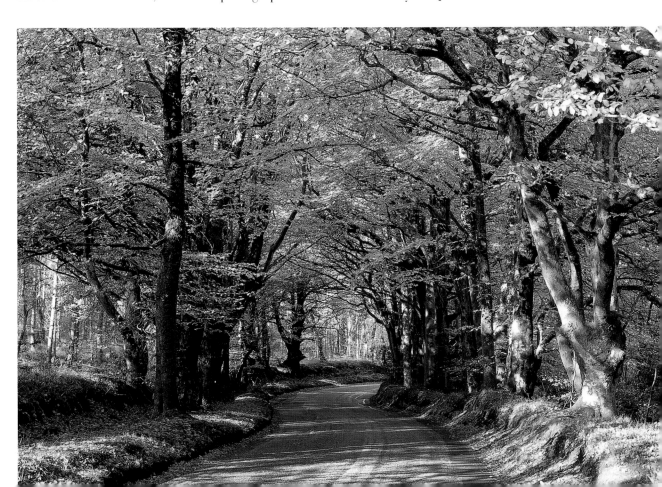

on the right side of the law governing access to protected areas, so get in the habit of checking requirements before visiting a nature reserve or other protected area for the first time, and be sure to have all the right permits and, if necessary, guides. Do not give anyone the chance to label you irresponsible and uncaring.

Summary

This chapter has outlined some of the aspects of nature photography that any would-be professional will need to consider right from the outset, whether these aspects are the level of enthusiasm and commitment needed, the amount of start-up knowledge and equipment that must be to hand or the attitudes towards the treatment of plants and animals as well as towards land access controls that should be developed. Some of the problems that you will encounter in the early days may seem daunting but, for the photographer who really does have talent in this field, persistence and patience will eventually pay off. After all, nothing that is worth having comes easily. If it did, everyone would already have it. Many of these problems, as well as other steps along the road towards becoming a successful professional nature photographer, will be described in more detail in the chapters that follow.

2 THE NATURE PHOTOGRAPHY 'INDUSTRY'

So now you have decided to take the plunge into professional work. You have reached the conclusion that nature photography is for you, and you are tempted to launch into a frenzy of photographing every conceivably appropriate subject that comes to hand. After all, you must have a body of work to show to prospective clients before there is a chance of convincing anyone that you can do the work.

But wait a minute. Before rushing out with camera in hand it is worthwhile spending more time thinking about two important questions:

1 Exactly what types of images do you take?
2 Who do you think might buy them?

For a professional photographer the photography itself is only half the story. The second half is knowing to whom to sell your work and how. This chapter looks at understanding your own images and thinking about who your clients might be.

Types of images

There are many different types of image, both in terms of subject matter and visual impact, and their usefulness will differ according to the type of client that you market them to. As a rough rule of thumb, and with considerable overlap among some, in terms of subject matter these image types might be listed as follows:

- mammal and bird portraits
- flowering plant 'portraits'
- macro photography of small animals and plants, or parts thereof
- animals and/or plants in their natural environments
- habitats and landscapes
- subaqua
- pollution and other human-made negative impacts
- conservation and other human-made positive impacts
- studio setups for almost any of the above
- collages that are composites of several photographs brought into one by traditional or digital techniques.

PROFESSIONAL NATURE PHOTOGRAPHY

11

You may feel that you photograph one or a few of these image-types better than others. Perhaps you can take accomplished mammal and bird portraits, for example, but feel rather out of your depth when faced with a plant or something that requires macro photography. While it may well be fine initially to concentrate on the few areas that you are already competent and confident in, and which could almost certainly enable you to generate a good portfolio, excessive specialization may limit the kind of clients you can call on. For example, a great skill in animal portraits could be very useful with calendar and card publishers, and may generate a market for photography of pets, but when it comes to magazine and book publishers, as well as photo libraries – particularly the specialist environmental ones – you would be limiting yourself. Magazine and book editors more often than not require a range of image-types, often covering most of the above categories, to illustrate a story, a chapter or an entire book on a given subject or region. An editor who knows a photographer that is competent to photograph all the image-types he or she needs for a given job (for example, portraits, landscapes and conservation work) is obviously going to commission that photographer rather than one who can only do some of the image-types.

Another way to classify images is according to their visual impact, something that can be categorized as follows:

■ provides a simple record (of an event, a species, etc.)
■ is useful in species identification

Figure 5 A Philippine eagle, the world's second largest raptor and one of the most endangered, is unique to the rainforests of the Philippines. This shot was taken at a captive breeding centre in the south of the country, using a 500 mm lens, handheld with a flash, and shot through a wire fence. This shows the effectiveness of the handheld/flash technique, as well as the good results that can be obtained photographing through a fence.

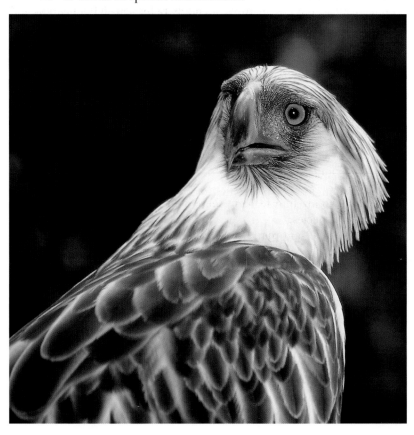

- sets the scene as an opener, for example to a magazine story or book chapter
- sends a message, for example highlighting an environmental issue
- is simply amusing
- has a stunning effect, such as a starburst sun or a kingfisher diving off its perch into a river
- provides a mood, such as the calmness of a dawn or the fearsome energy of a storm.

These different images will have a variety of uses according to the client and the project. That kingfisher diving off its perch may make a great postcard or an opener to a magazine story, but it will probably be useless for a book on the identification of birds. For that you would need an image taken a few seconds before, with the kingfisher sitting calmly on its perch, preferably side-on to the camera and frontally lit.

The latter illustrates another point. A dramatic picture of a backlit kingfisher diving off a perch may win every competition in sight, but that does not guarantee its commercial usefulness. Neither does an apparently boring side-on shot of the same bird sitting motionless deserve to sit in the file forever, unused and gathering dust. These two very different shots may well be equally useful, but with different commercial applications.

Fads and fashions

You have all seen them: pictures of cuddly baby seals lying helpless and with black appealing eyes staring at the camera, playful polar bears sliding around on the ice, lethal cheetahs stalking their prey through the tall grass. They have all been highly fashionable, and in their various ways have helped launch or maintain important environmental causes. They have also enabled a number of photographers to make a reasonable living. So if you like taking these types of pictures keep a sharp lookout for trends in the market and try to predict which cuddly mammal or perhaps some other kind of strange animal is going to provide the next line of highly saleable, adorable images. Although some of the animals that have so far reached the limelight have stayed in fashion for a remarkably long period, this may not always be so, and so you need to attempt to be in there with the early wave of images of any new fad species.

It has to be said that although images of some animals come and go in fashions, there are a few that seem to be perpetual favourites, including some of those mentioned above. Photographs of polar bears and cheetahs seem to have been around forever, and look likely to continue to be so, and they undoubtedly share that undying fame with the likes of penguins, giant pandas, tigers and elephants. Good portraits can be obtained at many zoos, but with some superb environmental shots – at least of African wildlife – widely available these days, photographers who really want to do battle in this field would do well to invest in a safari to that great continent.

In the 1990s views of the submarine world, especially tropical coral reefs, are very popular. Subaqua photography is notoriously diffi-

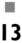

cult to get right but, when achieved, the results can be quite astonishing. This is truly a niche form of nature photography and, with very few competent photographers operating in this field, those that are able to work under water should do well, as long as the fascination for coral reefs lasts.

Other subjects less in the public gaze tend not to experience widely fluctuating cycles in demand but, with a general and gradual increase in environmental awareness, interest in the less glamorous species is slowly growing, along with demand for pictures covering conservation stories. Moody landscapes will always have a place in the market, if less visible than the most famous of mammals, though fashions as to the actual views do go through changes. Popular and long-lived types of landscapes include stunning alpine vistas, bleak and snowy polar white-out views, brooding and fecund tropical rainforests, and the soothing colours of a calm dusk taken just about anywhere.

Digitally manipulated images have also become popular in the 1990s. Digital alteration of photographs can vary from as little as simply erasing a survey ring from the leg of a bird, to the combination of fragments of several images to generate a collage. The whole range of manipulation techniques is already very common for all kinds of photography in advertising, but so far manipulated images, especially the more extreme forms of manipulation, have been largely shunned by the nature photography world. The philosophy is that the creation of an image digitally could deliberately or accidentally generate something that simply does not exist in nature: for example, an image of a gazelle running in a quite ungazelle-like manner, or a raptor catching prey in a way that is quite wrong for the species shown. Nevertheless, for the generation of publicity for environmental causes, such as the production of a collage showing in one picture all the different kinds of pollution and other damage that can afflict a given habitat, digital manipulation will almost certainly have a future in nature photography.

Matching your photography to the market

A large range of potential buyers exists, but they will not all have the same needs. It is no exaggeration to say that what to one client is a brilliant shot, to another will not even rate a second glance. As already pointed out, there is a multitude of types of photograph you can take, both in terms of subject matter and visual impact, and these differences are often linked with the categories of people that might use the photographs. So, from the outset understand that it is impossible to do everything, especially in the early days of a photography career, and think seriously about concentrating on what you are already good at. Do some homework before starting to shoot; find out what categories of client look for what types of photograph. Once you have established this, ask yourself some questions about your own work – and give honest answers – and then consider the clients that you would most likely be able to supply in view of the answers to those questions. Here are some of the questions you might ask:

1 What kinds of photographs within the general field of nature

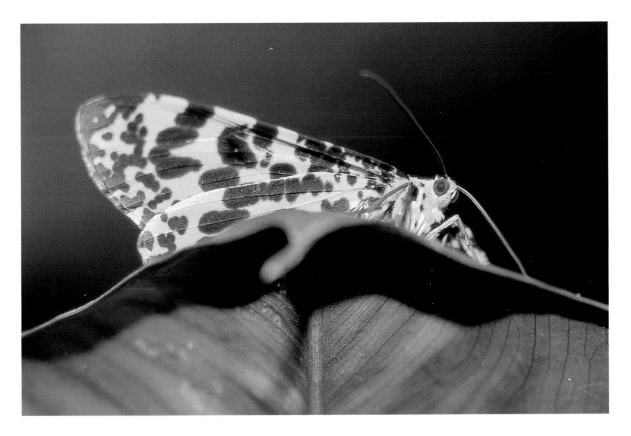

photography do you most like to take and are best at doing?

2 What other areas would you like to expand into?

3 What types of subject are you actually equipped to photograph, both in terms of the hardware and knowledge?

4 Who is most likely to want to use the types of photograph you can take?

5 Bearing in mind your most likely clients, does your work need fine-tuning in terms of subject matter and/or quality, or are you already shooting exactly the right types of photograph and to the standard that clients require?

6 Are there enough buyers of your type of photography for a living to be made? If not, what other subjects that are in greater demand could you expand into?

Not surprisingly, subjects that you most enjoy photographing are likely to be the ones that you are most skilful at and are properly equipped to handle. You should, therefore, seriously consider specializing in those few areas to begin with. Nevertheless, it is not a good thing to be confined exclusively to a few subjects for too long in your career, and from the outset you should have your sights set on other subject matter that interests you, is saleable, and that you could move into with only a modest investment in extra equipment and study.

Next you need to identify the likely buyers for your particular brand of nature photography, not necessarily the names of individual

THE NATURE PHOTOGRAPHY INDUSTRY

Figure 7 Five Flowers Lake, Jiuzhaigou Nature Reserve, Sichuan province, China. Renowned for its dense forests and stunning blue lakes, this remote region attracts visitors from all over China, mainly for its autumn colours. I found the rich greens of the newly leafed forest in May, set against the vivid blue lake (caused by dissolved salts) quite astonishing.

companies or organizations, but their broad categories and, hopefully, the relative size and degree of economic activity of those categories. This is not an easy task, although this chapter will aim to give some help here, and there are a number of publications dedicated to providing massive lists of potential buyers (see Appendix 2 for details).

The final question is even more difficult to answer in advance of trying to sell your work, not least because fashions as to what is and is not saleable come and go. If it is blindingly obvious before starting work that your own photographic interests and skills do not have a large enough market to provide a living, then you must expand those skills before making any attempt to be a financially viable professional. Conversely, if what you do is massively in fashion then, of course, proceed as fast as possible. More likely, your analysis will put you somewhere between these two extremes, leaving you filled with doubt as to whether there will be enough work available, but fairly sure that there is at least some. The only solution is to get started, watch carefully what aspects of your photography sell well and what do not, and as time goes by adjust the balance of your work accordingly. Similarly, monitor those

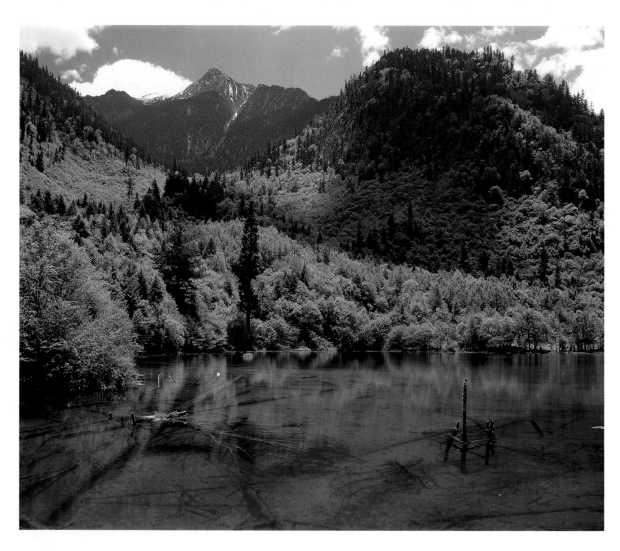

areas of natural history photography that you are not active in, but which you could move into quickly as and when you become aware that they are saleable.

One final point concerns the types of film that you will need to use for most of your photography. As a general rule, in professional photography colour is king and there is only a very limited use for monochrome. This is especially true for nature photography where colours can be a vital ingredient in photographing species. So, for most work use colour. If you feel you have to use monochrome, do so only for your own personal work or on projects where it has been specifically requested.

Within the field of colour one is faced with the choice of transparency or print film. The choice will depend on the intended end use. Whereas print film is generally reserved for photography intended for display purposes, in any work connected with publishing – and this includes photo libraries – transparency film is preferred owing to its better colour saturation. Anything submitted as prints will hardly ever be considered, with the possible exception of work submitted to newspapers. This remains so despite the advent of digital imaging, even though a negative can be scanned into a computer just as easily as a transparency. However, it is likely that, with most publications scanning as part of the normal design process virtually every image to be published, the bias against print film will decline with time. But then again, old habits die hard.

Categories of photography buyers

The main groups of photography buyers can be divided up as listed below:

- magazines and newspapers
- book publishers
- cards and calendars
- photo libraries
- compact discs
- conservation, animal welfare and government organizations
- advertising, public relations and non-media businesses.

Not surprisingly, the dividing lines between them can be very fuzzy, with considerable amounts of overlap, which shift with time according to fashions in the industry. A general description of each category is provided, together with a few of the positive and negative features of each. Further details of how to approach each – and how to avoid some of the pitfalls – are given in the next chapter.

Magazines and newspapers

The editorial world is truly huge, within which environmental and nature photography form an active niche. Literally thousands of daily, weekly and monthly publications are constantly in production worldwide, almost all consuming repeatedly a vast range and number of photographs. Of course, only a minority at any one time will be in need of nature photographs, but this is still an extensive potential market worth

tapping into, especially if you are able to market internationally, thus freeing yourself from complete dependence on local or national productions. Not only overtly nature or environmental magazines need nature photographs, but also geographical, travel, science and technology, photographic and gardening magazines, together with – from time to time – home design and women's magazines.

Editorial's high visibility ensures that this is the one area that newcomers to professional photography will probably attempt to enter first, and with good reason. As ever, there are many problems to overcome. Editors can be notoriously fickle, with requirements chopping and changing seemingly at a whim, but often the result of behind-the-scenes commercial manouevres over which the editor has little control. With the exception of some of the top magazines, the days of lucrative commissions are long gone, and many magazines do not even pay expenses. Rates of pay are usually rather low, probably the result of there being too many people wanting to get published. Worst of all for the newcomer, editors are constantly bombarded with ideas and portfolio material from people they have never heard of, making it very hard to get noticed. These problems notwithstanding, the editorial world is without doubt a worthwhile area of work for a nature photographer to become established in, and persistence during the sometimes frustrating early days will have its reward.

Book publishers

Book publishing is also a huge and very active field, with plenty of potential for sales, although one that is generally harder for new photographers to penetrate than magazines, despite the fact that books are at least as visible an aspect of our lives. This problem is not the result of any intrinsic difficulty in the field itself, but more because the production team is quite invisible. Whereas magazines almost always give a clear listing of their staff and how to contact them, book publishers (and newspapers, too, for that matter) never do. Even with the aid of the various directories available, the complex ownership and staffing patterns of book publishing houses and their multitude of imprints often make it very difficult to find the photographic departments among the tangle. As usual, persistence is the name of the game.

Not surprisingly, the world of books is often lumped together with newspapers and magazines under the editorial banner, but I generally think of book publishers as being quite separate since their requirements can be so vastly different. Book editors may be in search of anything from a single photograph to fill the cover, up to several hundred shots to illustrate, say, an entire country, region or specialist subject. Magazine and newspaper editors, on the other hand, will rarely use more than a handful of shots to illustrate a given story. If you are to be the sole photographer to supply photographs in either situation, the latter requires a concise punchy set of photographs that together encapsulate the story's central theme, while the former will entail a large body of work, shot in a meticulously consistent style, and often with in-depth coverage. The resulting requirements can, thus, be quite different.

Cards and calendars

Another large market, producers of cards and calendars are probably more closely tied to image fashions than almost any other sector. The numbers of greetings and postcards available on store shelves seem to be growing all the time, and yet it is a very hard market to supply successfully, partly because of the rapidly changing fashions. The publishers understandably look for images that very closely fit their product lines, either already existing or planned, often sourcing the largest photo libraries for their images, and so making it difficult for the individual photographer to obtain a decent opening. The kinds of shot that seem to do well either capture a season, a moment or a mood, say in a landscape or garden scene, or – in the case of animal portraits – are humorous or cute, usually with a strongly anthropomorphic sense of that animal's personality.

Some card publishers are constantly in search of new images, others only sporadically, depending on how many product lines they run or are starting. Calendar images are usually sought after at least eighteen months before their intended publication. This is an area where medium format is definitely preferred over 35 mm, especially for calendars, and many publishers stipulate that 35 mm slides will only be considered if absolutely pin sharp. Anyone shooting only on 35 mm will be automatically at a disadvantage in this field.

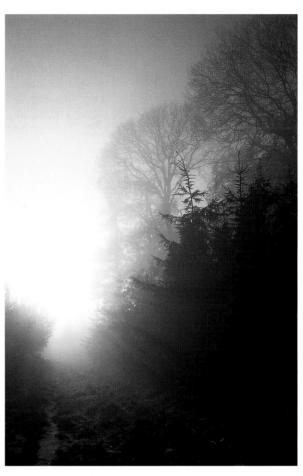

Figure 8 When winter fog reduces a view to grey outlines and puts a filtering veil over the sun, then is the time for some moody landscapes, as can be seen in this image of woodland in the English Midlands.

Photo libraries

This is an area that has seen dramatic growth since the early 1980s – one which is partly responsible for the demise of the photographer's well-paid commission. Editors and designers no longer need to send a photographer on an expensive trip to find many of the pictures they need: instead there is a wealth of libraries to call on, some of which – due to the huge files they maintain – are almost guaranteed have just the perfect shot.

The idea of a photo library is that the photographer goes out and photographs just whatever they think might sell well, and these are then put on the library's files and made available for any clients that come along. The library does not sell the photographs as such but licenses their use, usually for single usage, nationally, throughout a given region or worldwide, with or without exclusivity. The resulting fee is then split fifty/fifty between photographer and library.

At the risk of seeming to oversimplify things – if I have not already done so – there are essentially two kinds of photo libraries: general and specialist. The general libraries are often big organizations, with a large clientele. Theoretically they take every subject under the sun, but with

their customers usually heavily biased towards the advertising world their emphasis is very much towards business, lifestyle and other shots that show the world in a graphic, rosy light – theirs is a clean, sunlit, happy world, free of problems. Most such libraries have a nature section, but the images show the glorious side of the subject, with dramatic one-off shots of superb landscapes, dazzling lighting, and cuddly pandas, polar bears and tigers. This is fine, of course, for photographers taking this kind of photographs, but it represents a very narrow band of the spectrum of nature photography work.

For the apparently more mundane material, in other words photographs of all those other hundreds of less fashionable but nevertheless important species, as well as tree planting and other conservation programmes, plus the gritty work showing environmental devastation, we have to turn to the specialist libraries. Specialist libraries exist for a whole plethora of subjects, the environment and nature among them, with libraries specializing in this field greatly increasing in number and size during the 1990s. As well as one-off shots of views and species, their files will often contain photographs covering subjects in depth, for example, a complete set of photographs showing the demise of a forest due to logging, or the life cycle of some species of bird. Not surprisingly, advertising forms a much smaller proportion of these libraries' clientele, their activities being much more tied into the editorial world.

The photo libraries are without doubt an extremely valuable sales avenue for the nature photographer, one that frees them from marketing, thereby leaving more time for the photographer to do what he or she loves to do most – taking photographs. But it can be a difficult field to work in, demanding a high initial input of time and money. Obtaining a return on such an investment may take several years and, even then, income may be unpredictable and variable. This is a field that should be taken very seriously as a long-term investment for future income, but which should not be undertaken until a solid body of material applicable to photo libraries has been built up.

As with magazines and newspapers, there are directories that list hundreds of photo libraries along with their specializations (if any) and particular photographic requirements. Before signing up with any library, spend plenty of time researching to ensure you join the one that is right for you: getting the right library for your brand of photography can make a big difference between successful and mediocre sales.

Compact discs

The 1990s has seen an explosion of new technology sweep across all forms of photography, and nature photography has not been exempt. Part of this new era has resulted is the compact disc loaded up with hundreds of photographs, on sale and available to anyone with a compact disc – read only memory (CD-ROM) on their computer. This opens up a whole new ball game for photography, one with which many photographers and photo libraries are far from happy. The companies producing these CDs have marketed them as libraries of royalty-free photographs: once purchased the owner of the CD can do whatever they like with the pictures – including publishing them – thus depriving the

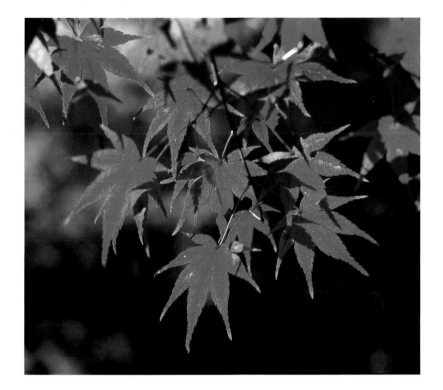

Figure 9 Maple leaves in autumn colour; Hiroshima, Japan. There is no tree with more vivid autumn colours than the Japanese maple, and in this image backlighting has further enhanced their red colour.

photographers whose photographs have been used of the royalty traditionally demanded for each use.

The photo CD manufacturers have defended this new product by claiming that what they have done is open up a new, additional avenue for photographers to sell their work. They argue that the low resolution with which images are loaded onto the CDs precludes their use in high-quality glossy publications, but for the first time makes them available to low-end productions that cannot afford the normal photographers' royalty fees but which can afford to buy a CD. Up to the middle of the 1990s this seemed to be quite true, but by the second half of the decade this argument no longer seems to apply, with dramatic improvements in CD photo resolution making the pictures available to increasingly better-quality publishing.

Whatever the rights and wrongs of the argument, photo CDs are not about to go away, and many photographers in search of an income may come to the 'if you can't beat 'em, join 'em' conclusion. Apart from the major drawback to this product – that once sold you no longer have any control over how any given photograph is used – there are a number of plusses to the photo CD from the photographer's point of view. First, depending on how you are paid, the claim that the photographs on a CD are royalty-free may not be strictly true. One way that manufacturers pay the photographer is to give an upfront flat fee for every photograph accepted, in which case the royalty-free claim holds true. But the second means by which one can be paid is via a royalty on every CD sold, the exact amount determined by the number of photographs belonging to you that have been included on the CD. In this case, the photographs are not royalty-free.

THE NATURE PHOTOGRAPHY INDUSTRY

■

Figure 10 The River Li and karst limestone peaks of the Guilin area, Guangxi province, China. An extremely well known view, it can be hard to find a new way to shoot it, especially when the light is flat and lifeless as it was on this morning. The use of a graduated filter — in this case a tobacco colour — has overcome both difficulties. Although photo libraries often reject shots taken with such coloured filters, many clients love them: this image found its way onto the cover of an Asian airline's brochure.

The advantage of the former method of payment is that you receive payment quite quickly, perhaps within as little as six weeks of submitting your photographs, something that could be a major consideration for a photographer just starting out and in serious need of a quick turnaround in sales and income. Furthermore, you get paid for each photograph accepted by the company regardless of whether or not they even make it on to a CD, let alone whether or not that CD eventually sells well. The latter method of payment will see a much slower return, but if the CD sells well it probably will result in much higher earnings than are possible with the upfront flat-fee method.

A final consideration is that copyright for the photographs still remains with you, so you are free to continue marketing and using these photographs elsewhere. You cannot, however, expect to get paid if you see one of your photographs pop up somewhere and it turns out that it was downloaded from a CD. It is almost certain that any agreement you sign with a CD manufacturer will entail granting exclusive digital rights, at least for a number of years if not irrevocably. You are thus precluded from later selling these images via another digital route, so before handing over such rights for any given photograph be sure that it will not affect any of your future plans.

In the mid-1990s the number of companies producing photo CDs is still relatively small and lists of them are hard to come by. Nevertheless, they frequently advertise in the photographic press, so

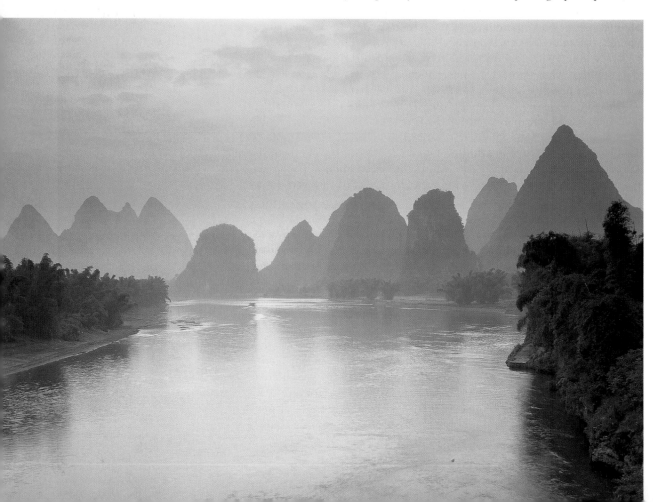

photographers interested in pursuing this avenue should watch the magazine pages. Before committing yourself, make sure of the payment and digital rights conditions, and for each image you submit be sure that you can live with losing control of its use should it be selected.

Conservation, animal welfare and government organizations

There are many non-governmental organizations (NGOs) that campaign on a number of environmental and animal welfare issues, ranging from such international bodies as the World Wide Fund for Nature (WWF) and Greenpeace, through national groups such as Britain's Wildlife Trusts, down to small local bodies that might use your photographs. Government departments that might be interested in nature photography include tourism, environment and water control bodies, as well as national parks and nature reserve management teams. I would also include in this category United Nations (UN) organizations, such as the United Nations Environment Programme (UNEP) and the United Nations Development Programme (UNDP).

The scope for photography with all these organizations ought to be rather large. Campaigning, general publicity and the simple recording of work in progress or finished all require good photography that could provide reasonable earnings for many nature photographers. Indeed, some photographers manage to make a living from this work, but generally there is not half as much of it around as you would expect. For one thing, many such organizations contain at least a few competent amateur photographers, often people who spend so much time out in the field that they know their patch intimately and, as a result, are able to obtain perfectly acceptable nature photographs for their employers to use. Secondly, nearly all – with the exception of the UN bodies – plead perpetual poverty so that even government departments are usually unable, or at least unwilling, to invest in the cost of commissioning a professional photographer.

You may find yourself frequently asked by NGOs to do jobs for free. For a photographer with a busy work schedule, high costs and a family to support, this may be a non-starter, but for someone just beginning a photographic career it might be just the ticket, for a while at least. Such work, while miserably failing to pay the rent, provides a situation with a focused project that should have clear goals, as well as a client to satisfy, though hopefully one who – since they are getting the work done for free – will not be upset by mistakes, delays and reshoots. It will also help to clarify which aspects of the work a new photographer likes and dislikes, and will contribute enormously to a working portfolio to show to later fee-paying clients. In short, free work with environmental NGOs provides very good practice.

Even for the well-established and busy photographer doing such work from time to time in their home area is not a bad idea. For one thing, it is worthwhile simply to use your skill to do something for the local environment. What is more, it keeps you in touch with what is happening in the local nature and environment scene (not photographically, but in terms of study and/or issues). It may also provide contacts that could lead to future remunerative work as well as generate photographs that may be suitable for your own file or for submission to a

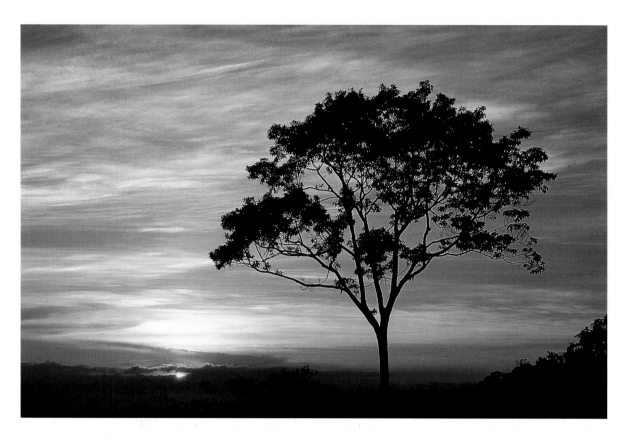

Figure 11 A tree silhouetted by sunrise in the tropical rainforests of Mt Kitanglad Range Natural Park, Philippines. Wherever you are in the world, trees make superb dusk/dawn, sunrise/sunset silhouettes, generating images that are both lovely landscapes and studies on the tree in question.

photo library. Thus it makes you feel righteous and is a good public relations exercise.

Advertising, public relations and non-media businesses

It has to be said that as a proportion of the total number of non-media businesses (i.e. those companies not involved in the world of publishing) their demand for nature photography is relatively low. However, it does not take much to work out that with such a huge sea of businesses, the actual number of companies that may want the services of a nature photographer at some point in time is not small. The problem is finding those companies, and finding them at just the right time – when they need you.

Of course, for those nature photographers that are committed environmentalists, this is the one field of work that may well present some conflict. How would you react, for example, if a quarry company asked you to take flattering photographs of their latest piece of landscaping or habitat creation, put together by them to either hide or somehow compensate for the enormous hole they have hacked in the earth just a short distance away? You might well be put in a quandary about whether you wanted to support that project, though economic necessity may push you into it anyway.

However, for every dubious case there are others where valuable environmental work has been done that you might be only too pleased to help record. How about photography of the healthy forest that that

same quarry company protected close to one of its sites? This really could be a joy to work on, and you may find yourself only too pleased to help give the quarry company some good publicity.

But how on earth can you find businesses at just the moment they need your services? After all, the standard commercial world is not the media, with its constant, insatiable demand for photographs. Their need is very sporadic, perhaps only once every five years. So, instead of you going out searching for these companies, a more appropriate question would be how can they find you?

It is here that advertising agencies and public relations consultants come in. They are very much the bridge between the media and the general commercial world, and for this reason they are used by large numbers of companies in search of publicity and reportage. Therefore, anyone attempting to move into photography in the commercial world would do well to start with approaches to at least some of the advertising and public relations (PR) companies. As with publishers and photo libraries, lists of these exist, often with information detailing the kinds of clients they deal with. This makes it possible for a photographer to concentrate on targeting those agencies that specialize in working with, for example, travel companies, leisure facilities or water utilities: companies that are most likely to have an interest in nature photography.

There are other ways to market your skills that may allow potential clients to come directly to you, such as direct mailing, membership of professional bodies and advertising via a website. All this is covered in detail in Chapter 4.

Figure 12 A larch plantation caught in the full glory of its autumn colours, enhanced by the glow from a setting sun and an 81A filter. Seen in the English Midlands, even a manmade landscape such as this can still be astonishingly vivid.

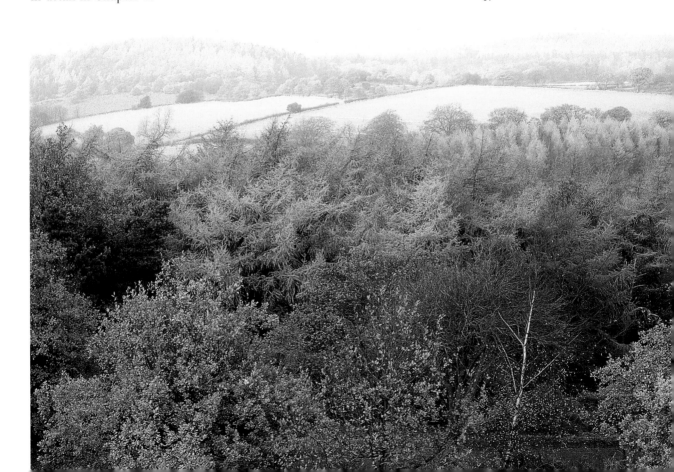

Marketing can be a long, slow process. One reason for this is that advertising agencies and PR consultants are often bombarded with information from photographers in all specialities, and it can be difficult to get them to pay attention to your material above everyone else's, especially when they already have a bank of photographers to draw on, whom they know well and can rely on. Another reason is that, even if the advertising agent/PR consultant loves your work, he or she will still have to wait for just the right client to come along with the right project before they can offer you any work. Do not rely on this field for a good income right at the beginning, but develop it over a long period, slowly building up your contacts.

Searching for your clients

One of the biggest headaches for a photographer starting out on a career in photography is knowing how to find potential clients. Indeed, even for an experienced professional this can sometimes prove difficult, especially when moving into a new field of work. When hunting out magazine work, you can always rifle through the magazine racks at the local bookstore, or help yourself to in-flight magazines if and whenever you fly (or badger jet-setting friends to do it for you). This is rather unsatisfactory, however, because not only are there many magazines that never go on sale in bookshops, but there are literally thousands of other would-be photographers and writers also rifling through bookshop shelves and writing off to the editors of those publications. Any letter you sent would have to be truly exceptional to get noticed.

Then there are *Yellow Pages* and other telephone directories which can be useful search tools, especially if searching out work in specific geographical regions. Access to directories covering areas away from your home patch should be possible by making a trip to your local library. The problem here is, of course, the lack of any kind of information about the companies or organizations you find: out of the long list of publishers, which are the right ones for nature photography? Which of all those advertising agents is likely to use your kind of photography? And so on.

Much more targeted, and thus of greater use, are the specialist directories available for different fields. An absolute must for photographers in the UK is the *Writers' & Artists' Yearbook*, while a close runner-up is *The Freelance Photographer's Market Handbook*, both published at the end of each year. Both books provide extensive lists – though with the former giving more detail – of British and a few other countries' magazine, newspaper and book publishers, UK producers of postcards, greetings cards and calendars, photo libraries and photographers' services. The listed information usually includes the kinds of material required by each publisher, the rates of pay and the names of the appropriate staff to contact.

A truly phenomenal directory to the publishing world is the *Willings Press Guide*, which is published annually. A mammoth production, it is available in two volumes, one detailing publications in the UK, the other overseas. It lists everything from *Encyclopaedia Britannica* down to the local church newsletter, and wading through it can be quite a cultural eye-opener – the things available for people to

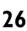

read! I would not recommend anyone to buy this as it is extremely expensive, but everyone should be aware of its existence. Make a trip to the library to scan its pages.

Directories and lists for other fields also exist, including the *UK Press and Public Relations Annual* and the *Advertiser's Annual*, both invaluable sources of information on Britain's public relations and advertising companies, along with data on many of the companies that use them.

Vast numbers of companies have websites on the Internet but they are intended mainly for the marketing of products; they are not much use for tracking down the right departments or individuals within the company whom you need to approach. At the time of writing, the directories described are available only in book form; they are not on the Internet. The Internet is not, therefore, a good place to go hunting for the right contacts, but it is a good place to advertise yourself, something that will be discussed in Chapter 4.

Once you have managed to track down lists of likely – or at least possible – clients you are then faced with the task of contacting them, convincing them that your work is better than anyone else's, that your price is right and that they need you. This mighty task is covered in Chapter 3.

Summary

This chapter has concentrated on encouraging you to think about the types of photographs you take under the general heading of nature photography, and has then shown ways to match that photography with the clients available. Try to categorize the types of photographs you take, both in terms of subject matter and visual impact, work out who might be interested in that type of photography and decide whether there are other subjects that you could or should expand into. Potential clients can be divided into a number of categories, each with rather different needs. The demand for different types of photography varies, not only according to the types of client but also with time, according to fashions, although there are certain kinds of image that retain a long-term popularity. The following chapter looks at the practical aspects of how to put all these considerations into practice and so truly begin the life of a professional nature photographer.

3 LAUNCHING INTO BUSINESS

So far I have assumed that, though not already working as a professional nature photographer, you are actively taking photographs and hence have built up at least a modest file of good pictures. You may have achieved this by working in your local area or by travelling halfway round the world, working either on your own self-formulated projects or perhaps doing free work for conservation organizations. In doing this, as described in the last chapter, you should have developed a good idea of what kinds of photographs within the field of nature photography you are good at and enjoy taking, and have developed some sense of who might want to use them. We now come to the big leap, where you start to market yourself to those potential clients.

Finding a base

The first consideration is where to base yourself and how to work. Sort this out before you start approaching potential clients, because if you keep changing addresses you run the risk that people will give up trying to find you, resulting in lost valuable opportunities. In which part of the country do you want to live? Should you be in a big city, small town or the countryside? You may feel that in a big city you will be closer to a greater range of large clients, be they publishers, conservation organizations or commercial companies. But you may also feel that, as a nature photographer, you should be nearer the countryside where more of your subject matter is. After all, with modern postal, courier, telephone, fax and e-mail communications, do you really need to be physically close to your clients? Perhaps what you need is a place where you are at least reasonably close to your subject matter – the natural environment – but with the cities sufficiently accessible so you can reach them for the occasional meeting with clients.

How do you want to work: from home or a separate office/studio? Presumably, in the early days at least, you will not be employing any staff – that may come later when you are so busy you cannot find time even to file your new photographs. So, what about working from home? That cuts out commuting, and if you have a family you can be very close to them the whole time. However, this route requires a great deal of self-discipline to maintain concentration. Having an office would overcome that problem, but then if you are working alone it could be rather lonely. Besides, an office means more expense in terms of another rent or mortgage to pay. If you are intending to do studio work or to run

a darkroom, an office might turn out to be a necessity, unless you are lucky enough to live in a house that has space to accommodate all this.

Clearly these are decisions that ought to be made before you equip your office and launch into marketing your work. Once done and your office is set up, you can really get down to business. It is now time to start ploughing through your files of photographs to select images that should go into that vital marketing tool, your portfolio.

Putting together a portfolio

A portfolio is a collection of your best work presented in a way that clearly shows the kind of photography you do. It is the heavy artillery in your marketing armoury; it is what you are going to use to influence potential clients, and wipe away from the battleground all your competitors. So it has to be good.

Figure 13 Temperate forest with wild azaleas in flower; Wolong Nature Reserve, Sichuan province, China. Wolong is a place not just for wild pandas, but also for some stunning forest. In this image the rich greens of newly leafed forest in May are set against the vibrant purple of wild azalea flowers, providing a chance both to add a splash of colour to a dense forest picture, and to show off this well known garden plant in its original wild home.

Your portfolio should exist in two forms; the main portfolio that you use in personal presentations, and a smaller one that you can send out to potential clients as an initial introduction to your work. I will describe the main portfolio first. This should consist of a mixture of original photographs and samples of completed jobs, whether that is published material such as magazines or books, or work from projects for commercial or conservation organizations. At the very beginning of a career, material for the latter part of the portfolio is going to be scarce. This is where free work that you may have done for a conservation organization will come in, or indeed material from self-directed projects.

The original photographs should consist of transparencies or prints that represent accurately the kind of photography you do but which are the very best of your work. In deciding the balance between transparencies and prints remember to consider who you are aiming your work at. If this portfolio is to be aimed entirely at publishers you do not need to put in any prints at all: transparencies will be all that interests the editors and they will be keen to examine the quality of these. If you are aiming more at commercial businesses or perhaps conservation organizations, a mixture of transparencies and prints will be more in order. Unlike publishing houses' editors, the people you will meet at other organizations are not likely to be expert analysers of images, and for them prints are a much easier medium to view and understand. If you are hoping to aim at both areas, then you may want to generate enough portfolio material to be able to vary its content according to whom you are going to see.

All the images that go into your portfolio must be the very best. If selecting transparencies, regardless of format you must use a light box and loupe to examine each and every picture that is a candidate for inclusion. Every image must be pin sharp, perfectly exposed, with the colour balance just right and all the elements correctly composed. Any flaw in any of these four components will weaken your portfolio. Remember that photo editors are experts at understanding images – they look at hundreds every day – and the first thing they will check for in your transparencies is sharpness. An image that is soft due to poor-quality lenses or bad focusing (as opposed to deliberate softening due to use of diffusion filters, or blurring of part of a picture to show motion) is of no use to anyone no matter how well composed the image is, and is one of the most basic tests for the quality of a photographer. Inclusion of any such image in a portfolio – no matter how attached you personally may be to that image – will seriously damage your chances of getting work.

It should also be remembered that some images make better portfolio pieces than others. You may have only ten minutes in which to impress your potential client, so you need to give them something that will ensure they remember you for more than five minutes after you have left. You must hit them with images that make them say, or at least think, 'Wow!' Complex images, no matter how perfect or brilliant technically, may take some time for the viewer to appreciate. What you need are images that have an instant impact, which often means very simple shots with a single quite obvious main subject, strong clear lines and perhaps bright colours. This does not mean that you should not include

some gentle, subtle shots, just as long as such images remain simple and easy to interpret, and do not get lost among stronger, more dynamic shots.

The inescapable conclusion from all this is that when selecting your portfolio images you must be utterly ruthless. It is all too easy for a photographer to select pictures not so much on their technical and artistic merits, but on the memories and other psychological associations they call up; the weather you experienced or your general mood at the time, even the fact that you may have had a little romance. The editors and marketing managers that you are going to show these images to know nothing of these associations and probably care even less. They will judge the photographs purely on their own technical merits. So it is essential for you to cut the emotional baggage and look at your pictures in the cold light of objectivity. I have to say that this can be remarkably difficult for a photographer to do. After years of practice, I still sometimes fall into the subjectivity trap.

As for samples of completed work, this can come in so many forms it is hard to make generalizations. For material published in books, simply take the book along. For magazine or newspaper work, you could show off the entire publication, but my personal preference is to remove the pages I need, laminate them and then finally mount them on black card. When it comes to double-page spreads, this can make for some rather large pieces of card but it should still be a simple matter to view them from a portfolio case. Material from jobs undertaken for commercial or conservation organizations and which resulted in pamphlets, brochures or annual reports, for example, can be treated in a similar way. Just ensure that the client gives you copies of the final product – they often forget.

Presentation is, of course, important. Prints should either be mounted in an album or on cards inserted into some kind of folder, even a simple clip file, provided it is an elegant one. Many professional-quality albums, folders and files are available from photographic suppliers, most of whom regularly advertise in the photographic magazines. Transparencies can be mounted in specially designed black card masks, those for 35 mm slides holding up to twenty-four images, with other masks also available for other formats. Transparencies presented in this way look quite stunning, but they suffer from one serious problem. Once enclosed within the mask you cannot retrieve any given image without destroying the entire mask. So it becomes difficult to chop and change the images whenever you feel the need, or when one is needed for a project. If showing transparencies to publishers, it is not a bad idea to forget about the black masks and just show the photographs in their frames, compiled in clear plastic sleeves with twenty or twenty-four images per sleeve. The photo editors are less concerned with presentation than the quality of your pictures and, who knows, when looking through them may spot a picture that is absolutely ideal for a project they are tussling with right then (honestly, this has happened to me). If the picture is held simply in a sleeve they can grab it right then and there, greatly to your benefit. If mounted in a black mask with twenty-three other shots, they cannot.

The drawback with the main portfolio is that it is intended for personal presentations, i.e. for face-to-face meetings with potential clients. Yet obtaining that first meeting appointment can in itself be an achievement, and to make that happen you need something to show off the very first time you contact a would-be client, something that will get them interested in allotting some time to see you in their busy schedule. This is where the mailable portfolio comes in.

Whatever you choose to put in this little package of goodies, it most definitely should not contain original transparencies. You may never see the contents of this envelope again, so do not send anything that you must not lose. The problem, then, is how to show off your photography? If you have had material published, some sample tear sheets – i.e. the relevant pages torn out of a magazine, brochure or report – should be included. Showing photographs can be achieved in a number of ways. With prints there is little problem; just include a range of small prints, mounted on black cards and inserted into a simple folder. With slides, the need to not send off your precious originals can create some difficulties. You could include duplicate slides, but this can become expensive if you are regularly sending off packages. You could make a number of small prints, or another route is to make contact prints; one 10 × 8 inch print can hold up to twenty 35 mm slides, but if taking this route try to ensure that all the images to go on one sheet have at least about the same density so they will print evenly – a contact print with a mixture of pictures that are either too dark or too light will not impress anyone.

However, this technique harks back to the bad old days when digital imaging was just a distant dream. Since the early 1990s it has become an increasingly simple matter to make rapid computer printouts of any image, transparency or negative, that has been scanned into the computer and stored on a CD. If printing out at thumbnail size, more than twenty images can be fitted on to one sheet of paper, complete with brief captions. This method, of course, requires you to have invested in, or at least have ready access to, a computer with all the relevant equipment. Another route that is increasingly used is to send sample images to potential clients on a CD. In this way large numbers of pictures can be sent out easily – again provided you have access to the relevant computer equipment. Similarly, this route is only useful if you know your intended recipient has the necessary hardware to view your CD.

A very useful inclusion is an advertising card. This may be just an A5-sized piece of glossy card, with your name and one or several truly terrific shots which hopefully capture the spirit, nature and quality of your work printed on one side, with some brief details of your work on the other. These are very popular tools with photographers as they are reasonably cheap to produce and easy to send out. Magazine editors seem to like them too, as they provide an easily identifiable way of remembering their photographers and, moreover, make for great wall decorations to cheer up what might otherwise be a rather dreary office.

Finally, a résumé is fairly important, especially once you have accumulated some experience that needs to be shown off. It should highlight your training, any photography-oriented awards you may have gained, photographic organizations to which you belong and, of

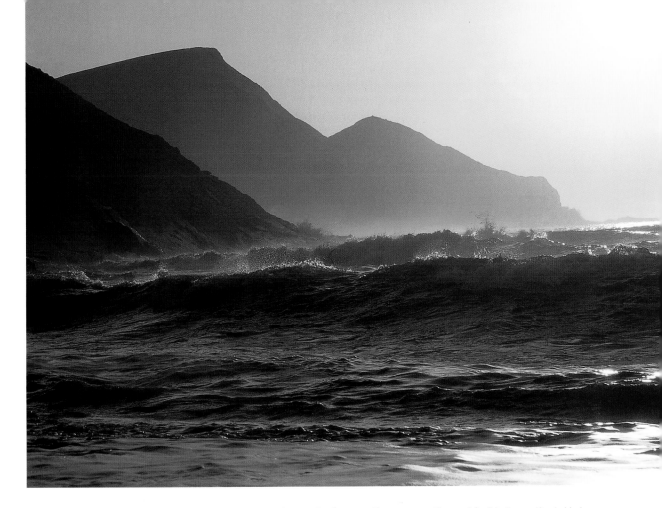

course, any clients for whom you have already worked as well as any projects you have already completed or even just started. It should be concise, neatly laid out and with all the salient information clearly visible and easy to follow. Create your résumé on a computer, either making your own layout (perhaps include a couple of photographs if possible), or using one of the standard templates included with many word-processing software packages.

Approaching potential clients: some general thoughts

Once you are satisfied that your portfolio shows your work off in its best light, and have decided what types of material to put into your mailings, it is time to start making some approaches.

The first step is to decide where to start. This section describes ways in which to approach a variety of types of client, but at the outset you would be ill-advised to try tackling all of them, if only because there are not enough hours in a day. Focus your efforts in one or two areas, those that are most suitable – as outlined in Chapter 2 – for the kind of photography you do, such as in magazines and books, before later trying to expand into other areas.

Whomever you approach make sure you have all the relevant contact details, preferably including the name of the person to contact. This is important as most companies receive so much mail that anything not addressed to an individual will often be assumed to be

Figure 14 Light is everything. I visited Crackington Haven, a very ordinary-looking cove on the rugged north coast of Cornwall, UK, at the end of a long day attempting to collect photographs for a magazine story about the Southwest Coast Path. Even with the low sun, at first I could not see a way to get any meaningful shots of the place. But then I looked out to sea, concentrating hard on the surf and the basic outline of the cliffs. What a magical view I suddenly had!

advertising junk mail (which your letter definitely is not), with the serious risk that it will be thrown in the bin without even being opened. Addressing your letter to 'The Editor' or 'The Marketing Manager', for example, does not significantly overcome this problem: a letter addressed in this way may or may not reach the right person, depending on such unpredictables as the mood of the secretary sorting out the office mail and how much mail has been received that day.

With magazines, identifying the person to whom you should write is usually a simple matter as the staff are listed in the opening pages of every publication. For many other companies, especially in the media, much help is at hand in the form of the directories mentioned in Chapter 2: be sure to have copies of at least the most important of these books. In some media companies, however, the personnel organization seems to be so complex that no simple directory can really get to the bottom of it and, with so many people involved, the photo editors and sometimes even the main editors, do not make it to any directory's lists. This is especially so for the larger newspapers and book publishers.

In non-media companies, conservation organizations and government bodies it may be very difficult to find out to whom you should send your portfolio material since, in general, their photographic requirements are sporadic. In a company, the marketing manager is usually the most likely character, although he or she may come in a number of guises, such as director of communications or promotions manager. In such uncertain situations, a phone call can be very worthwhile. An explanation to the receptionist, or whoever answers the phone, usually (though admittedly not always) yields a remarkably sympathetic response and can quickly set you on course to the right person. With many companies you may be referred to their public relations or advertising consultant, in which case you may have no choice but to direct your efforts down that road.

Now you are ready to start filling your envelopes with sample goodies. You need to enclose enough material to show the recipient how good your photography is, but not so much that they throw up their hands in horror at the sight of it all. I have never quite decided where the dividing lines are between too little, just enough and too much. I suppose you just have to use intuition and think to yourself how much you would be prepared to wade through. From what has been outlined above, here is a checklist of what should go in each envelope:

- photographs in the form of small prints, contact prints, computer printouts or CD
- examples of previously published material or other completed projects, if you have any
- an advertising card or small brochure
- a résumé
- a covering letter.

Do not forget the covering letter. This should state who you are, what you do and how you think you can work with this particular client. Do not make it too long – no more than one side of A4-sized paper. Instead,

make sure that for further information you refer the reader to the enclosed material. If you need to have any of the material returned (such as magazine tear sheets) do not be shy to point this out somewhere in the letter, perhaps as a postscript at the very end.

So far, everything I have said about approaching clients has been deliberately fairly general: the things you should do regardless of who your intended targets might be. There are, however, differences in the ways you would approach media companies from other organizations, and these are outlined below.

Approaching magazines, newspapers and book publishers

Magazines, newspapers and some book publishers are constantly hungry for images and stories. That is the business they are in after all. But, as I have already pointed out, they are also being constantly bombarded with portfolios and ideas from would-be contributors. For you to be noticed, especially when you are new and completely unknown, your material must be outstanding, and you must be tenacious.

The first step in maximizing your chances of obtaining work is to make sure you target the right publications. It may sound an obvious statement, but it is surprisingly easy to send off material 'just in case' to publishers who are never going to use nature photographs. Do your research and make a list of the most useful publishers to target, whether they publish books, magazines or newspapers.

In making your initial approach you must decide what work you want to do. Are you going to simply supply file photographs? Do you want to obtain commissions to go out and shoot projects? Do you want to write as well, providing the publications with complete text-and-photo packages? Do you want to do all three? The answers you give to these questions may affect to whom you write.

In a typical publishing house, the photo editor and picture researchers concern themselves, not surprisingly, entirely with sourcing photographs either from photo libraries and individual photographers' files, or by commissioning a photographer to shoot what is needed. If you intend to stick entirely with photography, concentrate your efforts on these people. With newspapers and magazines, the drawback is that this is rather passive in that once you have made the initial approach you have to wait until the photo editor feels there is a project in which you can help, either by supplying photos from your file or by going out and shooting. You will probably have to keep reminding them of your existence until something is eventually found for you to do.

A more active approach is to go out and create the projects by proposing them to the editor, the person responsible for the text and overall content, either of the entire publication or if large, such as a national newspaper, of the relevant section, such as features. To do this you will either have to become a writer as well as photographer, thus supplying text-and-photo packages, or team up with a writer and together make proposals. You should provide a list of about four projects that you could do for the magazine, each one explained by an introductory paragraph, and this can be slipped in with the other material that goes in your initial mailing. Preferably, some of these projects should have been already started on your own initiative, perhaps even

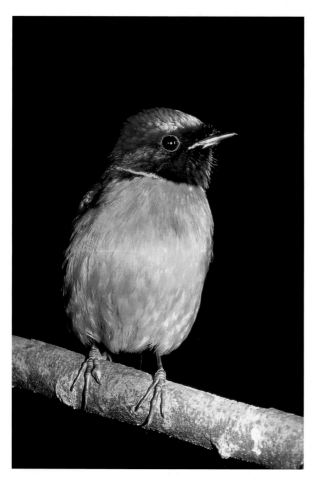

Figure 15 A Fujian niltava, a flycatcher that lives in southeastern China. A frontal view like this creates a portrait of the bird, while the highlight in its eye pupil, caused by the flash, adds a certain amount of 'personality' to the image.

finished, so that they can be made available quickly if and when the editor shows an interest.

As with supplying file photographs to the photo editor, success can be a long time coming, as most editors are overloaded with ideas coming in from contributors. Not only do you have to come up with a story that fires the editor's enthusiasm, is a story that has not been done before and fits in with the magazine's editorial goals of the moment, but when you are new you also have to overcome the editor's natural reluctance to try out someone new and untested.

It has to be said that initially you are likely to get a more positive response from the photo editor. This is because, whereas the editor is often truly bombarded from all sides with all kinds of material and yet has a very finite requirement in terms of what they can put into each issue of the publication, the photo editor has to maintain an extremely wide net of photographers in order to be sure of filling just about every photo request, no matter how weird and obscure, that the editor may ever require. Nevertheless, in the long run the proposals-to-the-editor approach can be beneficial in that, instead of being right at the end of the line hoping for a chance to be able to slip a few photos into an almost completed story, you can get to the forefront of creating some of the publication's stories. In this situation it is your material that will be used before all others, with obvious benefits to the size of the pay cheque and the amount of exposure your name receives.

In the case of book publishers, the great majority of your interest will be confined to the photo editors and picture researchers. Initially, you should aim at supplying occasional file photographs or at doing small shoots to provide a few pictures to ongoing projects. A commission to photograph an entire book is no small accomplishment and book publishers will hand out such contracts only to people they are convinced will fulfil the project: do not expect to be handed this kind of work after just your initial approach.

Whoever you send your sample materials to, try to make a phone call to them about a week or ten days afterwards. This not only reassures you that they did actually receive the material, but it also serves as the first reminder to them that you exist and that there is a real person linked to that envelope of goodies. It may also remind them that you might just have some photos that they are searching for at that very time, thus providing your first, very positive, opening to the publication.

The phone call is also important in the attempt to secure a meeting in which you can show off your portfolio. I have always found that, provided your portfolio is good, in a face-to-face meeting it is much harder for an editor or photo editor, at a magazine at least, to refuse to give you

PROFESSIONAL NATURE PHOTOGRAPHY

■

36

a project to do, so it really can be an important coup to be able to fix an appointment. Do not be disheartened, however, if they resist having such a meeting: some feel they simply do not have the time to spare to look at anyone's portfolios, and so is not a sleight directed at you personally. In this instance, you will have to work harder over the following months, repeatedly phoning (although not too frequently) to see if any work, supplying file photographs, shooting a commission or – if you are aiming at this – supplying a story-and-text package, is coming your way.

What can be disheartening is when the phone call reveals that the person to whom you sent the material has absolutely no idea who you are and has no memory of seeing your letter. This happens rather too often at large daily newspapers, where the staff are frequently in a mad scramble to get the pages of each issue together (even if they are working on a weekly section of the paper) and simply do not have time to look at anything that is not urgent. Do not give up immediately. Patiently explain who you are and what you sent them, gauge the level of interest in their response and try to kindle in them enough enthusiasm to get your material looked at over the next few days. In this way, more than once have I turned an apparently hopeless situation into a fruitful project.

Approaching card and calendar publishers

Card and calendar producers are usually willing to view anyone's work if they are in the process of looking for new material either to expand existing product lines or to start new ones. If you feel you have file images that would suit this market or, if having studied the products on store shelves you are able to go out and copy those styles, then you may well be able to market your images to card and calendar publishers. Sometimes photography is commissioned by these publishers, but more often they rely on people or libraries to supply stock material.

While it is possible to judge what kinds of images any given publisher specializes in by looking at their products in the shops, and so learn which publishers might be worth approaching, it is impossible to know exactly what they might be intending for the future. So before putting together and sending off an extensive and, perhaps, wholly irrelevant package of photographs, a brief letter or better still a phone call to the company to establish their current needs would definitely be a few minutes well spent. Depending on the news from the company you may well be able to tailor your photo selection much more closely to each publisher's needs, and undoubtedly will find a few companies to which it is not worth the trouble of sending selections.

Approaching photo libraries

Photo library work should be seriously considered, since with this work you are not dependent on hunting out clients and, once established, it can provide a steady income. However, there are a number of factors to be considered which may make you want to delay any step in this direction until you are an established professional photographer.

Photo library work entails a great deal of initial photography and upfront expense – with which the libraries give no assistance – after

which the payback can be very slow in coming. It is definitely a bit of a gamble at the outset as often not even your library can be sure that your brand of photography will sell even if the subject matter and style seem to be perfect.

Before joining up and launching into a serious bout of library photography, you should probably devote only spare time to building up a good body of work that is relevant to photo library application, while simultaneously studying the libraries that are appropriate for your work. Make sure that you have a reasonable financial cushion before making the library leap, as such work is likely to be quite a drain on your bank account for at least the first two years, requiring considerable support from other aspects of your work before it will start to make a meaningful contribution to your income.

Another drawback for a newcomer to professional photography with a limited equipment budget is that it is almost essential to be equipped with a medium format camera. Even though the resolution of 35 mm film is more than adequate for perhaps 80 per cent of jobs, many libraries still insist that as much work as possible is done on medium format. This is partly because the larger image gives improved resolution and hence capacity for enlargement. It is also a result of the fact that many library clients are not themselves photographic experts and when viewing a set of pictures will almost always choose the shot they can see clearly without having to crouch over a lightbox with a loupe.

The good news is that for animal wildlife photography few people expect anything other than 35 mm work. The mobility of the subjects and the power of the lenses needed to capture them on film often preclude the use of anything else.

Finding the right library for your work is the most important initial manouevre. Should you go for a general library with a large client base but with all that this entails, i.e. the glossy, life-is-rosy image that must come with the photographs? Or is a smaller specialist library that will cover the less spectacular and nastier side of the environment and with an editorial slant more appropriate? Remember that you can sign up with more than one library, even within the same geographical region, provided you give them different photographs. So it is perfectly reasonable to give your glossier shots to a general library and those with a more editorial style to a specialist one, but then of course there is the danger of spreading your work too thinly. It might be better to concentrate your work in one library, at least to begin with.

With photo libraries, you are not trying to get them all interested in your work but, instead, are out to choose only the library that is best for you. It is a much more selective process, in which you do the first round of vetting. The first phase is to look through the photo library directories and find five or six that appeal to you. Visit their websites as these may give a good indication as to how the photographs are marketed to the world, as well as what they have on file. Ask yourself some questions, such as: do they stock nature photography? Are they targeting the right types of client for your work? Is their location reasonable, and does this matter anyway? Can you fulfil their requirements for such things as film format and submission sizes?

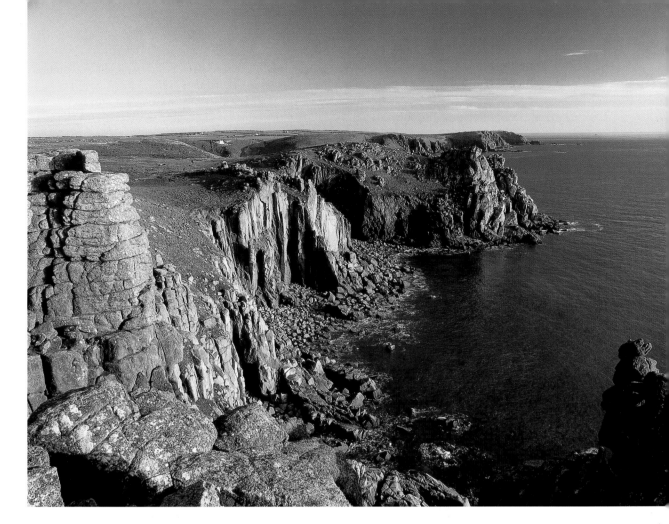

After identifying the potentially useful libraries, phone up or write a brief letter to explain who you are and to ask them to send you some more information. Knowing the name of the contact person is less important with a photo library than with other companies as they are usually happy to consider new talent, making a friendly welcome fairly certain.

Finding out as much as possible about a library before signing up is critical, and yet can be surprisingly difficult. You need to ascertain from each library you approach the answers to a number of questions, some of which you may think you already know. Ask again anyway, just to be sure. The questions are as follows:

1 What kinds of clients do you mainly supply?
2 What film formats do you require?
3 How many photographs are there in your files?
4 How do you ensure that all photographs are marketed equally and that many do not simply disappear into an anonymous sea of film?
5 Do you produce a catalogue and, if so, how often?
6 What rights do you request or expect (exclusivity/non-exclusivity, national, regional or worldwide)?
7 How long is a contract for?

Figure 16 Mighty granite cliffs near Land's End, Cornwall, UK. This most westerly outpost of the British mainland culminates in high, rugged cliffs that drop straight into the Atlantic Ocean. In this image their shattered, weather-battered appearance is brought out to the full by the low, setting sun.

**PROFESSIONAL
NATURE
PHOTOGRAPHY**

39

8 How large should an initial submission be, and how often do you expect to receive subsequent submissions?

9 How long does it take for a submission to be edited, processed and the selected photographs to reach the files and hence become available to clients?

10 Do you have one member of staff whose sole job it is to liaise with photographers?

11 How are fees split between photographer and agent?

12 How often are sales reports and payments issued?

Most libraries have some kind of information pack available for enquiring photographers, but the degree to which they are able to answer the above questions varies enormously. A great deal can be learned about the library from this information pack, and not just by the words printed on the paper. The degree of glossiness and expense put into its production will tell you something about the library's size and comparative wealth, while this combined with how well all the above questions have been anticipated and answered will give you insight into the importance they attach to communicating with their photographers. Questions which are not answered in this material can be pursued by means of a follow-up phone call, fax, e-mail or letter, and the speed, ability and willingness of staff in answering them will give a further indication of a library's responsiveness to its photographers. This is an extremely important point, and one that really needs to be tested before you commit yourself to any library, since one that is hopeless at answering photographers' queries is clearly one that does not respect their efforts or their professionalism. Who knows, perhaps they treat clients in the same way, and what would that mean for your sales?

Assuming one or more of your chosen libraries passes these tests, try to arrange a visit to their office. If it is a large library be sure to visit the head office, not one of the branches, although if you are looking at a large international library this, of course, may not be possible. Not only will such a visit give them a chance to view your portfolio and give an instant appraisal of whether or not your material has any hope of being accepted by them, but you can also review them. Are the staff friendly, helpful and informative? Do they seem happy in their work, and is their environment conducive to this? Is the office tidy and does it appear to be efficiently run? Is it understaffed? Can staff members remember your name five minutes after being introduced? Be sure to get a good long look at their catalogue, if there is one, as this will give the best possible indication of the types of images that make up the bulk of their files, and how big a chunk your type of nature photography occupies within them. Try to take one away for closer study.

Beyond this it is hard to go. It is difficult to judge the true economic state of any library – even one that is in danger of closing can seem wealthy and well managed – and you will never know the truth about how evenly the staff are able to market all the photographs in their files until you have been with them for a time and seen how well your pictures sell.

By the time you have finished all this reviewing you will probably be down to, at best, two libraries to choose from, and then it may be just

a case of tossing a coin to choose, or a choice based on how well you got on with the person you met when you visited the library.

Finally, you opt to go for one library: they seem to stock the kinds of images you shoot; the company appears to be efficient and helpful to photographers; it looks to be in good economic health; you can live with the kinds of distribution rights they are asking for (more on this in Chapter 4); the staff are friendly and happy; and, last but not least, they liked the portfolio you showed off during your meeting. So take the plunge. The next step is for you to send in your first submission, however many photographs the library requires for this initial review, a batch of photos that is representative of the photo library-style photography that you do. From this batch of pictures, the library will make a final decision on whether to represent your work, and if the answer is 'Yes' a first selection will be made from it and a contract will be issued for you to sign. Congratulations, you are now a photo library photographer.

Selling to compact-disc producers

Approaching CD producers is a relatively simple process, one reason being that there are fewer of them. Most are international companies and you are not likely to be able to visit their offices, so start by contacting their local agent, visit each of their websites and browse around computer stores to see what discs they already have on the market. In general, the images they are after are not so dissimilar from the general photo libraries – bright, glossy and spectacular one-off images that capture a moment or encapsulate a concept. One big plus is that they do not care whether your photographs are on 35 mm or medium format film, slide or negative, so material that is not appropriate to a photo library for this reason might just be fine for a CD.

There is no need to first send in any portfolio material. Simply discuss what the general requirements are with the local agent and whether payments are likely to be a flat fee or a royalty on disc sales, and if satisfied send in a submission – as many photographs as you would like to submit. After a few weeks you will hear whether the company is interested in using any of your photographs and, if so, how many. The number of pictures accepted will be far smaller than are taken up by a photo library as these are almost certain to be used; they are not going to sit in a file for months waiting for a client to come along – the CD company is the client. Payment of a flat fee or a royalty on discs sold will be confirmed, and a contract issued for you to sign. This is not a contract for you to work with them, as with a photo library, but covers the digital rights merely for the photographs accepted by the company at that time. If you make later submissions which result in further sales, the company will issue addenda to that contract.

Approaching public relations, advertising agents and non-media organizations

I have lumped this rather vast and disparate group together for the purposes of making your initial approach because for all of them the need for a professional nature photographer is likely to be sporadic – as out-

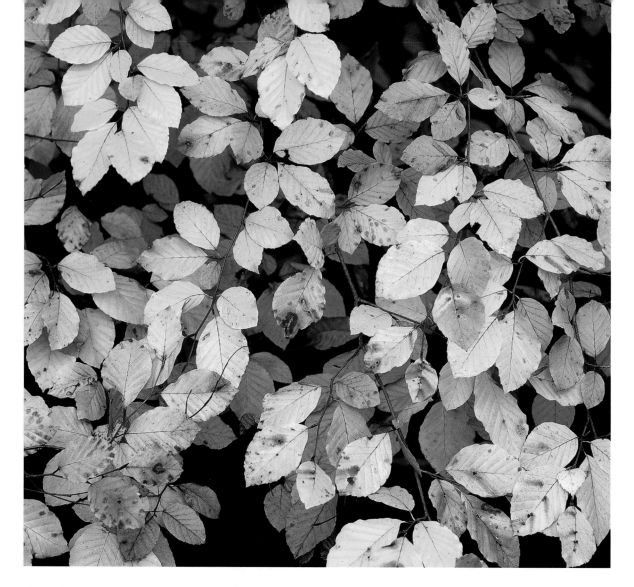

Figure 17 Beech leaves in autumn colour, Devon, UK. The golden colours of beech trees in autumn can be caught in a number of ways, the most common being to shoot up into a tree with sunlight filtering through. An alternative approach, as here, is to home in on a few leaves, leaving just this cluster to bring to life the entire idea of autumn.

PROFESSIONAL NATURE PHOTOGRAPHY

■

42

lined in the last chapter. Moreover, unlike media companies, which in theory at least should be constantly on the lookout for new talent, these organizations may tend to be rather more conservative in their choice of photographers, using only one or a small group whom they already know can be trusted to provide the work required.

Thus, depending on how adventurous these groups happen to be feeling in your area, breaking into this field can take a long time. First, one of them has to come up with a suitable project, and then a path must be beaten to it, past all the other photographers that the organization concerned already knows and trusts.

Achieving that goal is what marketing is largely all about; a long, slow process of building up contacts, getting to know who to contact in a range of companies and organizations, making sure that they hear about your photography – and keep hearing about it at regular intervals – and can find you quickly and easily should they decide to give you that all-important break. You cannot possibly do this for every company and organization within your own locality, let alone nationally, but needless to say you should target those most likely to need your kind of

photography. Any of the conservation organizations, those government bodies charged with protecting the natural environment and companies and their PR and advertising agents with an involvement in the environment – a wide selection of these should be targeted for whatever marketing you may put together. Identify the companies and organizations involved in projects that are of particular relevance to your work, try to keep well informed of their progress and be sure that your name is prominent at the time when photography is being considered.

Any mailings you send out to commercial and government bodies should be of a high presentational standard; something to truly grab the attention and put across the message that you produce work to a high standard. In terms of reachability, make sure that you are listed in a range of professional and general public telephone directories, seriously consider placing advertisements in trade magazines and consider setting up a website on which to advertise your work.

Marketing is truly a vast field, one which can take up a huge amount of your energy, sometimes with unpredictable results. There will be a more in-depth look at marketing in the next Chapter 4.

Summary

In launching yourself into professional nature photography you will first have decided where to base yourself and whether to rent an office or work from home. With your base established, you should start putting together a portfolio, both a main one to show at meetings, and a collection of smaller items that can be sent through the mail as initial openers.

Finally, you are ready to start approaching potential clients. Start in the areas most appropriate for the photography you do. In publish-

Figure 18 A Creoboter mantis, almost perfectly camouflaged on a matching green plant. Somtimes finding subjects such as this comes down to knowing where to look and being able to spot subjects through their camouflage.

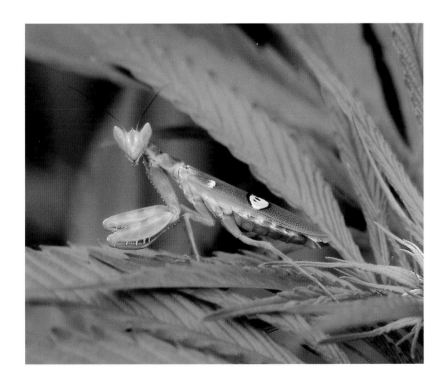

Figure 19 Fallen leaves and ground plants covered in frost. An image that screams 'cold', the fallen oak leaves create a pleasing pattern on the ground, as well as providing a second colour in an otherwise monochromatic image. They also let the viewer know that with this image we are well into winter, the autumn fall well advanced.

ing, the photo editors are usually ready to review work from new people, and once on their files you may be able to supply file photographs or do the occasional small commissions. Approach the main editors if you also wish to write, creating new projects and supplying complete stories-and-photo sets. Large commissions, to photograph entire books for example, will only be offered to you after the editors have come to know and trust you.

Images that capture a mood or a season, or show cute or humorous animal portraits may well be useful in the card and calendar market. Study product lines on store shelves and then phone the publishers to see what their current needs are. This will help you tailor your submissions to their requirements.

Photo libraries can be a valuable source of income, but require a high initial input that is expensive and time-consuming. Take your time getting involved, and be careful in selecting the right library for your work. Supplying photographs to CD companies is less complicated, but you will lose control of those photographs accepted, which may not be acceptable.

Unlike publishers and photo libraries, who are constantly in search of new photographs, non-media businesses as well as conservation and government environment bodies have a relatively sporadic need for

photography. The approach to these bodies is one of general marketing, ensuring that the right people within them are aware of your photography, and are from time to time reminded of it. Make your name, and if possible your face too, well known among those organizations most likely to need the services of a nature photographer, stay informed of any relevant projects that they may be involved in and try to ensure that your name goes forward when photography is being considered.

A start has been made at last, but you have to keep plugging away at your target people, whether they are in publishing, general non-media business or conservation, to be sure of getting some work from them. The next chapter will look at some aspects of what to do once you do have some work, and how to build on your initial successes.

4 BECOMING ESTABLISHED

In the last chapter we looked at the process of starting to hunt for work. In this chapter we consider what happens when you are actually offered some. We will also look at some aspects of the ongoing process of getting your name known, the general marketing process.

Being accepted

When making approaches to potential clients you would be lucky to be offered work immediately after making the initial contact, especially as a new photographer. More likely you will have to wait some time not only until a suitable project comes up, but also until those responsible for commissioning photographers are sufficiently aware and confident of your work to think of you at the crucial time. You may have no control over the former, but with the latter you should be able to influence the process. After your initial approach you will need to repeatedly remind your new contacts of your existence and your skills, doing so in a way that creates a positive image that will ensure you spring to mind when photographers are being considered. This is much easier said than done, of course. Putting together the right mix of politeness but persistence, calling regularly to check on work but not so frequently as to annoy your new contact, is a tricky process with no set guaranteed-to-succeed formula. You just have to use your intuition and make a guess at how much is too much for each situation.

When editors and others responsible for commissioning photographers do start to respond with work, it could be anything from supplying a few photographs from your file to shooting a huge commission overseas, so be prepared to respond accordingly. It is more likely that to begin with jobs will be small, providing file photographs here and there, for example. Success with these will enable your name to become fixed into the minds of those you have been able to supply, increasing the chance of success when larger commissions turn up later. So, do not be tempted to turn down jobs simply because they are too small – at the beginning every little helps not just in bringing in a small amount of cash but, more importantly, in making your name visible and memorable, thus making the offer of future work more likely. Turning down a tiny job at the beginning is a certain recipe for never being asked again by that particular client.

Because of this, initial jobs may cost you more than you are likely to earn from them. If asked for a few photographs that you happen to

have on your file, all well and good – the amount of effort and expense required to send them in will be minimal. But a common scenario in the early days is where an editor asks for photographs that you do not have but which you know you could get easily enough. Desperate not to turn down a new client you will be strongly tempted to say that you can supply those photographs, and then rush out to shoot them. Only try this if the deadline for submission of the photographs is reasonable and you are quite certain you can get the shots needed – look out of the window to check the weather before saying 'Yes'. If you fail here, you could end up looking a bit silly and may jeopardize your future chances with that client. Even if you are successful, unless a fairly large number of photographs are eventually used, you will probably spend more than you will earn from the single use for which the client will pay, but at least you will have successfully supplied someone with the photographs they need, increasing the likelihood that later they will send more work your way, on top of which you now have a new set of shots on file for future requests.

However, even being commissioned to shoot a photographic project is not an immediate guarantee of success. Commissions from non-media companies will generally come with an agreement to pay a fee and all expenses (more on this later in the chapter), so provided a reasonable fee can be agreed this should not be a problem. But with magazines, newspapers and many book publishers the situation can be rather different. As with the sale of file photographs, early commissions are likely to be small, and publishing companies more likely than not will not offer a set fee. Payment will depend entirely on the material being published, so not only will you not receive any payment until after publication – which most probably will be several months after submission of the work – but you will have little idea how much you will receive as this will be completely dependent on how many of your photographs are used.

Inevitably, and not unreasonably, every publication will reserve the right to refuse to publish any submitted material if it does not come up to the required standard, even if it was specifically commissioned by them. A less acceptable situation, however, is when an editor or photo editor apparently commissions you to photograph a particular subject, only to later decide not to bother using the material you submit, even though it is acceptable in terms of quality. You will almost certainly not get paid, and the only consolation you will receive is that you have at least added some more photographs to your file for later stock sales. This type of problem seems much more likely to happen to new, inexperienced photographers than to well-known, experienced ones, if only because the editors and photo editors feel they need the latter more and are more likely to remember the work they have done. It is partly a question of the power of name recognition.

Those photographers doing a great deal of work for magazines need to plan well ahead in order to balance expense now with reasonably assured income later. I generally find myself planning six months to a year ahead, constantly working to secure commissions that I know will yield a predictable sum up to a year later, depending on such factors as how long it is likely to take me to complete the work, whether

Figure 20 A grey squirrel eating a hazel nut in St James's Park, London. Though regarded in Britain as a pest, grey squirrels nevetheless make good photographic subjects, especially as those in urban environments are so thoroughly used to people. Not only do they not run away, but their lack of concern is evident in their relaxed pose.

the magazine will pay upon submission or publication and, if the latter, whether the magazine is issued weekly, monthly or quarterly.

Setting up your own photo file

I have mentioned the process of providing file photographs to clients several times already, as I have assumed that even before you took the leap to become a professional photographer you were slowly building up a stock of usable photographs. The process of shooting subjects that have no immediate client should continue even after you have become established and are starting to attract commissions. All the photographs you take – including those shot on commission – should go towards your expanding file because the regular sale of rights for the use of file photographs can in the long-term have a dramatic impact on your income.

It is surprising, however, how many photographers never seem to get around to organizing themselves to do this. One of the reasons, it seems, is that it does take a certain amount of office – and indeed personal – organization to make a photo file workable. You need to have a good grasp of what is in the file so that whenever a prospective buyer phones up you can quickly tell him or her whether or not you have exactly what they are looking for and, if not, what you might be able to offer that is similar. You then have to be able to easily locate those photos, as well as efficiently prepare and send them off. Delivery times set by your clients are invariably very short since they usually come looking for photographs the day before their deadline, even if they have had six months in which to think about it themselves. Therefore, to meet the requirements of the job you must have an efficient system.

The first step is to store all transparencies in clear plastic sheets that hold twenty or twenty-four 35 mm slides, twelve 6 × 7 cm transparencies, and so on, and then file them in a clear and consistent manner. They need to be broken down into sections and subsections that are both simple and logical enough for both you and any helper to remember and understand, as well as small enough for any image within them to be found easily. I divide my file up geographically since most of my work is location based, initially by country and then in subsections according to region. Photographers doing mostly species work, however, might be more inclined to divide pictures up by the major plant and animal taxonomic divisions, or perhaps by a combination of location and taxonomy (though this may be starting to get rather complicated). The sleeves of photographs can then be stored either in clip files or, more easily, by hanging them in a filing cabinet.

The next step is to set up an understandable and workable list of

what is in the file. You may think you will remember what you have shot and, indeed, I find that I rarely need to consult my own lists. However, it is easy to forget such details as the date when a particular photograph was taken – something that ought to be recorded – and you may well forget the scientific names of many species (well, I do, anyway). Furthermore, once a photograph is in a file you may leave it there (apart from regular trips to clients, of course) for twenty years, and you really cannot be sure that in all that time you will not forget some of that picture's crucial details. Far better to document it from the start. Finally, and most importantly, if you eventually get someone in to help run the file, especially to cover while you are on the road, the lists will be absolutely essential as there is no way you can expect them to carry the entire file's contents in their head.

How you list the photographs is up to you, but clearly this is a job where use of a computer helps. The lists can be compiled either simply on word-processing software or, if more details are required to be kept, on a database. Alternatively, you can go all the way and buy a specially designed photo library software package (there are several on the market) that will enable complex lists that include cross-referencing, as well as provide facilities to bar code every photograph being sent to a client, thus simplifying the sending and booking back in processes. They also include invoicing systems to tie in with records of photos used.

One more factor should be considered when setting up a file: keep it lean and mean. In setting it up make sure you exclude those photographs that are badly focused or wrongly exposed. There is no need to be as ruthless as when putting together a portfolio, but at the same time there is no point filling your files with pictures that, although you cannot bear to throw them out, in your heart you know are not usable. They can end up taking up a lot of valuable space, and may give the false feeling that your file is large and productive, when in fact parts of it are a drag on your resources. Of course, as your work develops and you become more experienced your definition of what classes as usable may well evolve, so it is a good idea to go through your files every two years to weed out those photographs that no longer come up to your standard. It can be a sad experience, and it certainly is a time-consuming one, but over the years your photo file will expand to fill more and more of your office space, so occasionally reducing it a bit may be a necessary part of basic office management.

Having at last tidied up that growing pile of unfiled photographs, resulting in a fully set-up and functioning file, now you can go out and start marketing it. More on that later in this chapter, and on the day-to-day running of your own library in Chapter 5.

Setting fees

As a photographer you are providing a service, and the fees that you can extract for your time and the use of your photographs depends on a large number of factors. These include the degree to which you value your time, the degree to which your clients value your time, and the extent to which the photographs you have or can take fulfil a market or popular desire for a given subject, issue, concept of beauty or under-

Figure 21 A white gorgonian sea fan with a black feather star attached, growing on a coral reef at a depth of 35 metres off Boracay Island, Philippines. Though white is an unusual colour for a sea fan, the obligatory flash makes it a bright contrast against the gloom prevalent at such a depth.

standing of images. Images are big business and the degree to which you tap into that depends to a large extent on your ability or willingness to make your photographs fill at least some of the niches in demand at any given moment, combined with the not unrelated ability to make your own name one that is in demand.

The amount you can charge for commissioned work will vary according to your level of experience, how well and widely your work is already known and respected, and the general level of fees within both the subject matter and geographical location in which you are working. At the outset this may be extremely difficult to judge, and you may need to find ways to compare your charges with those of other photographers. This is something that may not be so easy as photographers can be remarkably coy about discussing this with the competition, but in various ways you should be able to get a feel for what the going rate is for a particular type of job.

As already mentioned, commissions from non-media organizations will normally consist of a fee plus all expenses. It is often possible to ensure that a proportion of the fee is payable in advance, usually up to about a third, something that is extremely useful both in reassuring the photographer of the client's commitment to the project and in offsetting any initial costs.

However, in the magazine and newspaper world it may be difficult to negotiate a set fee at all, as already described. If you can obtain a fee the publisher will usually have set rates which will be stipulated upon commissioning, but many will negotiate, especially once they have come

to know and like your work. If you have to accept stipulated rates in your early days at least this will give you a feel for how much to charge later when negotiation becomes possible.

Publishers' commission payments only occasionally have an additional expenses element; usually you have to meet all expenses yourself out of the set fee. Worse still, in the case of magazines and newspapers, it is usually not possible to secure an advance payment. In fact, you may receive nothing until after publication of the work, ensuring that the income will be a long time coming. Some publications will pay upon submission of the completed work, especially once they have come to know you, and this is a situation that you should strive for.

The situation in which magazines and newspapers pay only for the photographs actually used in the final published piece, even with commissioned work, is one to put up with as rarely as possible. It is the worst situation of all, since not only is it certain that payment will not come until after publication, but you have no idea how much it will be until the day the cheque or publication drops through the mail box. If five or six of your photographs get used then you may make a reasonable income – in fact you might even do better than with a fixed agreed fee – but if it is only one picture reproduced at a tiny size then you will be badly out of pocket.

While an established photographer should be able to negotiate a fixed fee (hopefully payable upon submission of the work rather than at publication) with many of the more reputable magazines and newspapers, it is a hard fact of life that the newcomer will almost certainly

Figure 22 Trees in the landscape, silhouetted by the setting sun, seen at Calauit Island Wildlife Sanctuary, in the Philippines. Truly successful sunset shots require the inclusion of a subject that looks strong in silhouette, otherwise the image becomes just another, rather boring sunset.

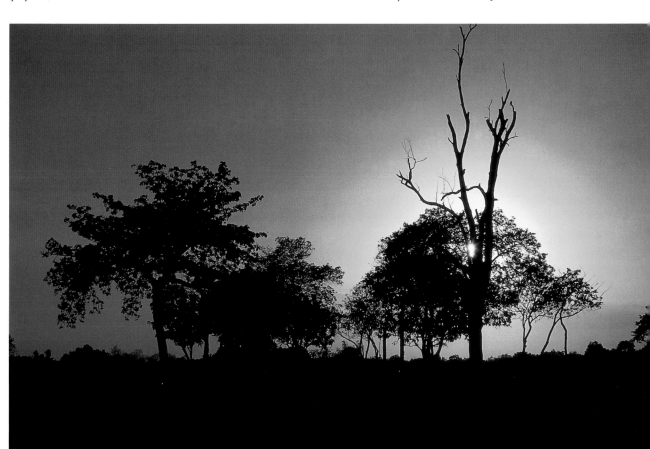

have to put up with accepting jobs with this unpleasant payment-only-for-what's-published system and hence a very uncertain income-to-expense ratio for quite some time. In this situation, the publisher should not expect any extensive rights over the photographs (see below), and you should not be too shy about actively marketing the photographs as part of your file to whomever will pay.

The only situation in which the payment-only-for-what-is-used system may work is if you are providing text and photos as part of a magazine article package; your photos will clearly belong to the article and, provided the text is run at full length, it is certain that a number of your photographs will be used as well, with only a relatively small risk that the photo editor will be tempted to mix in other people's shots. Nevertheless, you may still only receive payment after publication, which could be as much as a year after you submitted the work, so it is still better to aim for an agreed, fixed fee to be paid upon submission.

In the world of book publishing, although there are a few disreputable ones around, fees are much more standardized and are generally fairer to the contributors than in the magazine and newspaper business. Although the fees that book publishers are willing to pay to photographers are for the most part quite inadequate for the amount of work involved, agreements are clear for all to understand, the work you submit will certainly be published, assuming it is up to standard, and payments are usually reasonably well organized.

Book work is usually paid for as either a flat fee, or through royalties on post-publication sales of the book combined with an advance paid before publication but to be subtracted from future royalties. The former system ensures that you know exactly how much you will earn from a project, although if the book turns out to be a best seller you could lose out financially from not having a finger in the royalty pie. The latter system usually results in you receiving a smaller advance than a fixed fee arrangement would afford, but does hold out the hope of further earnings from royalties at a later date, especially if the book sells well.

In either system, the fee or advance is usually paid in three instalments: upon commissioning, after submission of the material, and upon publication of the finished book. The publishers usually like to keep the three instalments of equal size, but with a project that is likely to be expensive for you it is usually possible to persuade them to increase that first instalment to carry you through the initial costs.

Granting rights

What rights will be agreed with any given fee must be considered carefully. It is not uncommon in non-media organizations for it to be assumed that any photographs you take during their commission will belong to them. This is not the case. Copyright for any photographs you take belongs to you, regardless of who is paying the bill, and any rights to be granted to a client have to be agreed, not assumed. If you want to sign your copyright away to the client, that is up to you (but such assignation must be in writing), but unless the client is paying a truly stupendous fee it would be a mistake to do so. You could grant a client the

right to perpetual multiple use of any photographs you give them, retaining the copyright yourself as well as a large number of the photographs taken during the commission, for use in your own file. Alternatively, you could insist on only single use rights, stipulating that they must pay again for further usage, although if you are giving the client transparencies enforcing this could be almost impossible. If shooting on print film, many photographers give the client only the final prints, insisting on holding on to the negatives themselves.

In the media the issue of copyright is generally well understood, and in most instances commissioning publishers only expect fairly limited rights, such as first use in Europe. This leaves you free to make further use of the photographs, selling rights to whomever you wish, especially once the commissioning publisher has used the photographs in question. However, since the early 1990s some publishers have started trying to force photographers and writers to sign away copyright as a precondition for a commission, without any increase in the already inadequate fees most are paying. 'Give us the copyright or you do not work for us' is a powerful threat, especially for a new photographer struggling to generate an income, but in the long term, signing away copyright is a disastrous move, since material that you retain copyright over can be sold again and again, enabling you to make a reasonable profit even on what at the outset might have been a modestly paid job.

You can be certain that publishers attempting to take ownership of your photographs also have their eyes on profit, but not yours. There is far more money to be made for them from your material if they can syndicate it, either down the traditional wire services or over the Internet. Why suffer the problem of having to share it with you? Personally, I have never been faced with this, but I know of photographers who have, and I believe that it is more prevalent in some countries than others. Those photographers wishing to protect their long-term income, in the form of an ability repeatedly to resell hard-won photographs must be sure to resist any attempt to force them to hand over their copyright.

Which brings me to the sale of rights for the use of file photographs. Clients buying the rights to use any of your file photographs rarely ask for any extensive rights, such as world exclusivity, sticking mainly to non-exclusive rights for a given country or region. So the rights issue is normally a straightforward process. The actual amount to charge will vary, first, according to how widely the picture(s) will be distributed – nationally, continent-wide or globally – and, secondly, to how they will be used: what kind of publication (magazine, book, calendar, brochure, for example), what size of reproduction and where they will appear in the publication. This may sound terribly complicated although it does not have to be: it is up to you to make it as complex or as simple as you wish. While at first you may find it difficult to know where to set your fees you will quickly gain a feel for this. Most of your buyers will be in the media business, will know the going rates and will quickly let you know if yours are well above the normal. They may not be so forthcoming if you are too cheap, so do not be shy about gradually pushing your prices up to test where the upper limits may be.

If you are selling through a photo library you will not have any

control over the level of fees. The compensation for this is that, generally, the photo libraries can secure better rates than individual photographers are able to achieve, although of course you then have to surrender a proportion of it to the library. The standard commission for almost all libraries is 50 per cent for every photograph used. Some photographers moan about this apparently enormous slice, but before you dismiss all libraries as a mercenaries, there are a number of factors to consider. First, libraries can reach out to far more clients than a single photographer can thus bringing in more sales and, secondly, all the marketing – at least for this aspect of your work – is taken out of your hands.

One of the biggest worries for photographers is knowing whether any given library is being honest in reporting its sales and hence the money it owes. Most libraries send out sales reports quarterly or monthly and as a rule this is the only guide a photographer has as to how well the library is doing. This is certainly one area where a large amount of trust is required on the part of the photographer, but it is somewhat mollified by the feeling that a library that is short-changing its contributors will eventually be found out. In any situation where suspicion is rife, any photographer signed up with a library has the legal right to view its accounts.

As for the rights the libraries expect, these can vary depending on how badly they want to market your work. As a general rule, however, since the early 1990s they have been getting tougher as competition has heated up and some of the libraries have started to become global operations. It used to be perfectly possible to sign up with a number of libraries in different parts of the world, send them the same images and restrict their marketing rights to just their portion of the globe. This made more work for the photographer in terms of preparing submissions, but also made quite sure that their work was well represented around the world. However, since the early 1990s a precondition of signing up with most libraries has been that you grant them world exclusive rights to whatever images they take from you. In that situation, the only way to legally belong to several libraries around the world is to submit different photographs to each library, a truly awesome task in terms of the amount of photography needed.

One problem that results from global exclusivity is that you are then completely dependent on that one library to sell the use of whichever pictures you give them. This situation can lead to some difficulty, especially if you eventually find that the library is not sufficiently promoting your photographs. This issue will be covered in Chapter 5.

Needless to say, this impinges very much on how you run your own photo file. Depending on the rights you have negotiated with your photo library or libraries, you may have to be careful what rights and to whom you sell the use of some of your file images in order to avoid the risk of a rights clash. Should the same or even a similar image be used by two different clients in the same place at the same time, one supplied by yourself and the other by your library, you could face an irate library manager and even a bill for compensation. It has to be said, however, that the amount of care that many photographers put into avoiding this

legal minefield varies enormously, though my advice would be to err on the side of caution.

In the case of the sale of images to CD producers, the situation is generally clear in as much as they simply will not accept any photographs from you unless you sign a contract granting them the rights to market the images digitally, either for a fixed period or indefinitely. Clearly, this leaves you free to market those images anywhere and in any other way you choose, but be sure that the loss of digital rights on those images selected is not likely to interfere with any plans you may have for going digital later. As for what happens to those images once they are on the market, you have no control and no right to payments for usage derived from the CDs.

The direct selling of images over the Internet is something that is becoming popular with some of the CD manufacturers and photo libraries. If you intend to go this route too, you must be extremely careful because, unless protected in some way, your images could be downloaded and used without you knowing about it, let alone receiving a fee for them. Protective measures are available, along with electronic image finger-printing methods, but with technology (and costs) moving at breakneck speed, this is an area that needs very careful planning and management before any commitment is made. There will be more on the use of websites later.

Flexibility and making deals
If you find yourself working in a situation where fees are uncertain and do not come with an additional expenses component, you will almost

Figure 23 A snowbound landscape in Dartmoor National Park, Devon, UK. There is something very purifying about snow which in a landscape photograph creates clean, simple lines, doing away with the normal clutter and creating strong images.

**PROFESSIONAL
NATURE
PHOTOGRAPHY**

55

certainly find it necessary to start juggling projects, making yourself as versatile as possible, and doing some barter deals in order to maximize the use of time and film and minimize costs. This becomes especially important if you are also trying to combine photo library photography with your commissioned work since, as already pointed out, you most definitely will have to meet all your costs for this work, and the payback will take a long time to materialize.

As described in the previous chapter, if working with magazines and newspapers you can significantly increase the control you have over the projects you work on, as well as greatly increase the size of the cheque per project, by combining your photography with writing, a move that will usually increase your attractiveness to commissioning editors.

Another possible move is to broaden your photography, not necessarily into other highly specialized areas of nature photography, but into a more general field, such as travel. While there is an enormous amount of travel photography about – some of it surprisingly bad – there is always room for someone able to produce high-quality images. If you are travelling to do your nature photography, combining it with travel photography is a natural step and one that will open up a number of new client avenues without a huge amount of extra work. Especially in these days of ecotourism, the travel and nature fields have moved very close together, overlapping in many areas, thus providing a valuable source of work for travelling nature photographers.

Combining fields in this way opens up possibilities for deals that, although not directly earning you an income will nevertheless greatly reduce your costs: barter deals with hotels, travel companies, tourist boards and airlines. Many of these organizations may not feel willing to support purely nature photography, but they can often be persuaded to help with travel- or ecotravel-oriented projects, provided they feel that their market is going to receive some publicity out of it. In exchange for acknowledgements in any articles or books published, or being given a few photographs that they can use without a fee, help can be obtained from these organizations in the form of complimentary or discounted hotel rooms, air tickets and car hire charges. It has to be said that these deals are not often handed out to completely unknown, untried photographers, so once again the new photographer may have to forego this kind of help until a solid body of good, published work has been built up and which can be used to impress such people. It all comes down to the power of the portfolio.

The negative side of making such deals, as well as of becoming a writer, is the amount of extra time they may take up, thereby reducing the time available for your nature photography. Writing can tie you up in research, and hunting for barter deals can consume amazing amounts of office time. How much you are willing to allow these to eat into your nature photography is something only you can decide: it is a question of balancing your photographic output with the benefit of reduced costs, something that will often come down to an assessment of how healthy your cash flow is.

Putting your name about

Otherwise known as self-promotion, one could write entire volumes about this knotty issue and, indeed, spend much of your time doing this instead of getting out there taking photographs.

Photography remains by and large an unregulated business, allowing anyone to set themselves up as a photographer at any time. Long may it remain thus, but in a field that is flooded with would-be photographers competition is ferocious, making it difficult for those responsible for commissioning photographers to spot the best, and leading them to stick with those they already know. So how do you break through this barrier of recognition, and get yourself noticed and, finally, commissioned? This is the stuff of marketing or self-promotion.

Promotion is something that almost all photographers need to do, at least from time to time, throughout their careers. Those that can get enough work without ever doing any self-promotion are the very lucky few. Promotion can take many forms, some of it rather indirect, and I have attempted to divide the process up into some of its main areas, as follows:

- direct mailings
- Internet websites
- listings in telephone and professional directories
- advertising in the media
- membership of professional organizations
- exhibitions and competitions
- personal contact
- employment of a photographer's agent.

Direct mailings

I have already talked about some of the materials you might send to potential clients when making your initial approaches. This is likely to be ongoing, as you will never run out of potential new clients. I have also mentioned the need to keep reminding your contacts of your existence and skill, and this is where occasional direct mailings will be of importance. With non-media organizations, send out a simple brochure or advertising card, ensuring that your skills and what you are offering are clearly visible, together with an up-to-date list of photographs on file, if appropriate. In the case of photo editors, they like to receive updates on your photo file list, thus providing an ideal opportunity to maintain contact. You should not rely on the effectiveness of these lists in directly generating sales, however, as few photo editors ever seem to consult them. Far more worthwhile is the occasional phone call to check on what they may be looking for at any given moment, something that you may well only have the time to do with some of your favourite clients.

Internet websites

The latest 'must have' that everyone is obtaining is a website, a place on the Internet's World Wide Web (WWW) where you can advertise your photography (or even make immediate sales of images if you wish) to anyone who cares to surf their way to you. With the phenomenal

Figure 24 A bed of moss around the base of a cryptomeria tree; Ryoanji Temple, Kyoto, Japan. Sometimes the overall beauty of a view, such as that at one of Japan's most famous Buddhist temples, can distract attention from the details, yet sometimes it is good to virtually get on your hands and knees and just look downwards. When I did that at Ryoanji, I was taken by this interacting pattern of different mosses, lichen and tree base.

growth in this field during the second half of the 1990s, there is a danger that soon anyone without a website will not be taken seriously as a professional.

For a website to be effective you must be sure to link it to other more major ones, such as those of a prominent professional body, a magazine or an index. This will increase the chances that any of the large numbers of people who undoubtedly visit such a major site will find their way to yours. Without such links it would be hard for many people to know your site exists, let alone find it. Registration with search engines is important, too, to ensure you can be found in the electronic jungle.

So, in deciding to set up a website, make careful enquiries to obtain the right provider first. Can they help design your website? How many megabytes and pages can they offer and for what price? (Remember that you will need to include a few photographs on the site, and these will quickly use up memory.) Can they help provide links with any other major sites as well as ensure registration with search engines, and so improve access to your site? How often will you be able to update your site and will this be a straightforward process? Will the provider supply data on such questions as how many people are visiting your site? The list of possible questions that need to be weighed up before choosing a provider is almost endless, but you will find that most will anticipate you, answering many of your questions in their introductory material. Be sure to study this material carefully. Once you have opted

for a provider and have your website up and running you do not want to have to go through the disruption of switching to another provider.

Listings in telephone and professional directories

A more traditional way to help potential clients find you is to get yourself listed in as many directories as you think appropriate. There are, of course, the telephone directories, which are useful for ensuring that local organizations can reach you. For a more national approach, the professional directories may be of use, such as those produced by some of the professional bodies or the industry. In the UK, an example of the latter is The Creative Handbook, a comprehensive listing of the country's photographic and design services.

Advertising in the media

Photographers are not renowned for their mass advertising campaigns, but well-targeted advertisements should be considered from time to time. By 'well-targeted' I mean making sure that your advertisement goes in the kind of place that will be seen by the maximum number of potential clients. If photo editors provide the bulk of your work, then be sure to advertise somewhere most likely to attract their attention, such as in the newsletters or magazines produced for their professional associations. To be able to do this, you should have to hand some completed artwork that is ready to go, which you can simply send off to the advertising departments of whichever publications you decide to target.

Figure 25 A hunter shows off the birds he has shot in one session; Pearl River Delta, China. While I often prefer to photograph the positive side of our natural world, photography of the less happy interaction of the human race with it is essential. I stumbled upon this group of hunters shortly before sunset one day after photographing in the fields that border the Pearl River close to Hong Kong. Several of the group's members were more than happy to display their catch.

PROFESSIONAL NATURE PHOTOGRAPHY

59

Membership of professional organizations

How much direct benefit membership of a professional organization has in a business where such membership is far from widespread let alone obligatory is open to question, but anything you can do to make yourself stand out from the crowd has to be good. One photographer once told me that membership did not put money in the bank. In a direct way this is probably true, but I have found it can help in that the membership is yet another step in putting your name about. In one move membership increases the number of contacts you have within the business who might be able to recommend you to a client in search of exactly your kind of photography. The annual membership fee can be money well spent, recouped in just one additional job coming your way as a result of the organization's contact.

Some bodies offer professional qualifications which, if you can achieve them, help to make a difference to the way potential clients perceive you – provided they know what the qualifications mean. For myself, I have found that achieving some of the qualifications on offer has increased my confidence in the quality of my own work, enabling me to be more bullish about promoting my work to new clients and unafraid to uphold the qualities of my work against those of others. Moreover, these bodies often organize training courses that provide invaluable help in a variety of fields, including such matters as business management and digital imaging. This can be of immense value if you are starting to move into a new area of work but do not really know where to start.

Exhibitions and competitions

Some amateur photographers who consider the process of photography to be part of the art world assume that exhibitions, as with paintings, should be a major avenue for sales. For the most part this would be a serious mistake for a professional to make. Apart from photography targeted deliberately at the art market, exhibitions are not a good avenue for the sale of photographs. For the photographer, the exhibition is usually about publicity, a chance to show off the best work that they can do.

But is it cost-effective? An exhibition can be quite expensive to organize, and unless you ensure that it takes place in the right location and that people know about it and are reminded to come, it can be a fruitless exercise. Once again, it is all about targeting the right people – those whose job it is to buy photography and commission photographers.

For these reasons, the best kinds of exhibition to be involved with are often those organized by the professional organizations. Yet another good reason for joining such a body, most organize an annual exhibition of the best that their members produce. These exhibitions usually tour the country, setting up in some of each region's most prestigious locations, with the organization making sure that all the relevant people know about it and are invited to the openings. Competition to get images into these annual showpieces can be tough, so success can be quite an achievement that in itself is likely to generate positive publicity.

Similarly, the main purpose in entering a competition may be publicity, not simply for the ego or to win the luxury holiday on offer. For this reason, you should concentrate on the biggest events, and for the natural history photographer that undoubtedly means the BBC Wildlife Photographer of the Year Awards, organized by the BBC Wildlife Magazine, British Gas and the Natural History Museum. A massive, international annual competition divided into a number of categories, the winning photographs are almost without exception truly astonishing and clearly among the best the world has to offer. To win here, either a single category or the overall title, is to guarantee major publicity, not to mention assistance and sponsorship from a number of parts of the photographic industry.

Personal contact

This must surely be one of the best ways of obtaining work. Call it getting in by the back door if you wish, but it is often the most successful route, either resulting from your own relationship with an organization that subsequently commissions you, or via the personal recommendation of a mutual acquaintance. For those few photographers who claim they never have to do any marketing, this is their main avenue for securing new work.

I have already mentioned the need to get to know a range of orga-

Figure 26 A wood pigeon in a British garden. People of rural Britain may consider wood pigeons to be both pests and rather boring birds, yet this close-up picture taken from a hide reveals a rather interesting and colourful individual. It also illustrates how close a hide can enable the photographer to approach birds, if set up in the right place.

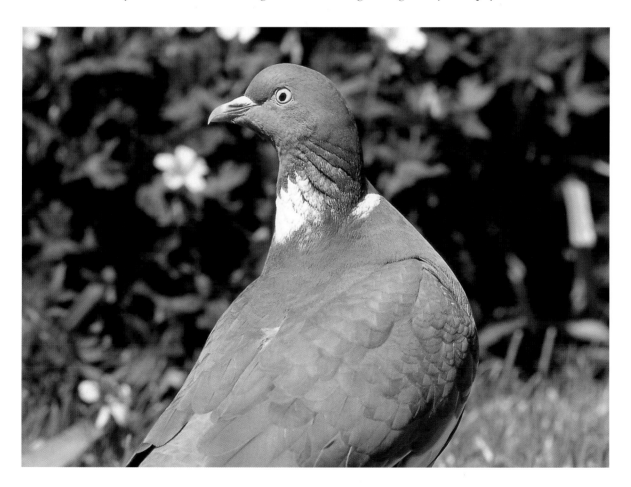

nizations and their relevant staff well in order to maximize your chances of obtaining work from them, and this is what it is all about – the personal touch.

This kind of contact may come about purely by luck, in some kind of social setting for example, or it may result from a long process of marketing and nurturing. With an environmental organization, for example, you may have done a job for free, and so established the goodwill and recognition of the staff. Another possible avenue is via those companies with whom you might do occasional barter deals to help reduce your travel costs. Being able to make a few of these deals, however, is no guarantee that eventually any of those bodies will give you a fee-paying commission. If they can keep getting something – no matter how small – out of you for free, that might be enough for them. However, you will probably have established a good working relationship with the staff concerned, if not actually a certain amount of bonhomie, so you are in a good position to apply a little friendly pressure to remind them that you are also available for commissions.

The photographer's agent

A surprisingly underutilized service, a photographer's agent can, in theory, lift the worries, hassle and expense of much of this marketing off your shoulders. It is their job to hawk your portfolio around all the likely clients, securing whatever commissions they can obtain. It comes with a price of course, which is 20 per cent of all fees, which to me seems quite fair considering all the hard work they, hopefully, will be putting in on your behalf.

Their offices are usually located in capital cities, or the very major regional ones. Although, as I said, this is a generally rather underutilized service, it does not mean that agents are desperate to take on any photographer that happens along. Most specialize in certain kinds of photography, and understandably are choosy about picking only those photographers whose work they believe they can sell. The agent may or may not be the answer for you.

Expanding your field

In the first year or two of working you will probably have been concentrating on selling to a few chosen areas, for example, magazines, photo libraries or conservation organizations. You may also have restricted yourself to a fairly narrow band of nature photography, as well as a limited geographical distribution. But as you gain confidence and competence in the way you run your business there should come a time when you feel the need to start expanding. You may want to move into additional areas of nature (and perhaps travel and/or digital imaging) photography, widening your target client base, and expanding your horizons, quite literally – going global.

Obviously you should not try to do everything at once, but make it a gradual process of research and experimentation. Moving into new areas of photography may need a period of additional study, and in this regard the training courses offered by professional bodies may well be of great help.

Going global is not the massive leap that many might imagine. Those already involved in the publishing world may be halfway there without really realizing it. Publishing is one of the best examples of a truly global market, especially when it comes to books. Admittedly, if you stay with national magazines and newspapers, the global reach of your work will be more limited, but the culture of internationalism is present here too, and you are only a short step away from dealing with international publishers. The majority of large book publishers are international in outlook, largely because books are so expensive to produce that they need a world market just to be sure of selling enough copies to make a profit. If you are involved with photo libraries, the world is already your stage because even a relatively small photo library is likely to be pushing your pictures all over the globe via a network of similar libraries acting as subagents. The only step remaining to you is to start marketing your wares directly to publishers and agents across the globe, and with modern communications this is no problem at all.

If you have already set up a website, then whether you intend it or not the world is already your market, and from this resource you could be approached by potential clients from anywhere on the globe.

Summary

Your business is gathering momentum and jobs are starting to come in. Initially, they are likely to be small ones, perhaps providing just a few file photographs here and there or going out to shoot some straightforward subjects. Do not be tempted to turn down even the smallest job, as these can lead to major commissions later. Getting the right kind of fee for a commission can be a problem, and it may be necessary to combine jobs and do some barter deals to minimize costs and maximize the use of time and materials. You will become expert at juggling and moulding projects to dovetail together. You should develop an efficient system for filing all your photographs, so that it becomes a simple matter to market your file and send off photographs to clients. Develop a feel for how to set your fees, and under what situations you can negotiate or have to accept what is offered. Tied in with all this are the rights that you are able to grant to clients, or which they demand from you, as well as the use to which each photograph will be put. You will need to continue promoting your work through a variety of channels, from the Internet to personal contacts. Take a long-term view and do not necessarily expect every promotional activity to immediately have a positive result; the effects may be cumulative. Once you have become confident and competent in what you are doing, it is time to start expanding your field of work, both in terms of the types of natural history photography you do, and in your geographical distribution.

5 TAKING ON THE JOB

In taking on photographic work there are a number of issues to be considered, ranging from the highly practical ones tied to each specific job, down to the harder to define but nevertheless critical psychological matters that affect all your work and how you relate to it. These latter factors include your own attitude to your photography and how it relates to the business of selling it, how you think clients view your photography and how it relates to their business, and – in relation to these two points – in what light you present yourself and your work to the world. Let us consider these psychological aspects first, since they will underlie virtually your entire approach to photography and to whom you try to sell it.

You as a service provider

As I have already mentioned, many amateur photographers view photography as an art, something that a large proportion of those in the process of switching from amateur to professional are tempted to carry over into their work. Unfortunately, for the most part it is not a very helpful attitude when trying to make a living from photography as you will have to become very businesslike in your dealings, marketing your photography like any other saleable commodity. In stepping from amateur to professional, a photographer almost always makes the leap from art to the commercial world. Realizing this can be a painful process.

The reality is that as a professional photographer you are a service provider, meaning that you must produce what the market demands rather than entirely what you would like. Of course, these two should overlap as much as possible because if you are constantly shooting subject matter that does not interest you there is a serious danger of not producing your best work. And even though your photography is no longer an art, that does not mean that you should no longer strive to be artistic. After all, it is that flair for the stunning, artistic image for which the client is paying you, otherwise they could go out themselves and get a flat, dull image that acts purely as a record. So, although you are no longer in art, your work – tailored to the needs of the fee-paying client – must remain artistic, as well as technically excellent.

It is worth asking yourself why you are in photography as a business. Do you really want to provide a service to photography buyers, shooting just about whatever they ask for? Are you shooting purely for

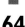

your own love of photography and/or nature, considering clients as a necessary evil, there just to provide a means to pay your bills? Or – as can often be the case in nature photography – are you on a crusade, using your photography as a weapon in the cause of conservation and the protection of the natural world? Your answers to these questions will have implications for your attitude towards both your clients and your photography. If your views tend towards the former then not only will you be happy to accept work from whichever quarter it may come, but the marketing, meetings and discussions leading up to projects will all be taken as part of the job, one that should be enjoyable.

If your ideas coincide more with the second, then the marketing and negotiating aspect of your work could present a serious problem, perceived by you as detracting from your concentration on the photography. It may well reflect in the way you treat your clients, having repercussions for your ability to attract work. If you do find yourself in this situation think about ways to become more amenable and flexible towards the demands of clients. Failing this, a move towards a heavy reliance on photo libraries and/or a photographer's agent might be the solution. This will divorce you to a large extent from the need to involve yourself directly with clients, although you will still need to shoot what is in demand and hence saleable.

If you are a crusading photographer, although you may be perfectly good at marketing and negotiating, your aims will clearly affect to whom you will aim your marketing and from whom you will accept work. Presumably, you will not be afraid to vet the clients that approach you, and will turn them down if necessary, even to the detriment of your own financial wellbeing, if you find the work they need you to do runs counter to your conservation ideals. This can be a handicap to the development of your business, but it also helps to define at least one aspect of nature photography in which you specialize – only those projects that in your eyes promote the cause of conservation.

Most photographers stick with doing much of their own marketing and negotiating of projects, if only so they can retain some control over who their clients are. The aim of marketing, of course, is to sell a potential client your work or, more accurately, your ability to produce good new work. This involves not only letting them know that you exist and are a good photographer but also that, from the point of view of their needs at least, you are better than the competition. It is quite definitely a selling job, and as anyone who has ever bought anything will know, marketing tactics are not always as honest as they ought to be. Yet if you have any respect for yourself, your work and your potential

Figure 27 A crested serpent-eagle, a raptor that is seen from time to time across South and Southeast Asia. A portrait of a captive bird, taken with handheld camera and flash, the result is a picture that lifts the colours and feather markings, while the highlight in the eye pupil gives added life.

PROFESSIONAL NATURE PHOTOGRAPHY

65

clients, you will maintain honesty at all times, making it clear what your skills are but without making any outrageous claims. A job sealed on the back of a bunch of lies may secure an income now, but in the long run it is likely that the truth will out, and then you can be fairly sure of losing a client. Better to be honest from the start, and use this as a basis for a long-term relationship built on trust and mutual respect.

Being honest does not mean being excessively modest, underselling yourself and too afraid to take on challenging work. No one will want to use a photographer who appears to lack confidence and seems unwilling or even unable to point up the strengths of their work. Furthermore, there will always be plenty of occasions when you are asked to do something you have not tried before. There is a first time for everything, and having not attempted something before does not mean you cannot do it. Your skills and career must always keep moving ahead, and accepting jobs that push your experience to the limit is one of the best ways of ensuring that this happens. Admittedly, the line between taking on a challenging new project involving approaches and techniques you have not used before, and agreeing to work on something that you are clearly not qualified for is an extremely blurred one. A decision on which side of the line a new job lies is very subjective, and one that you will have to make according to such factors as your own confidence, the amount of time available before the deadline, how much extra equipment you may need to buy in or hire, and how much study the new work may need.

Taking on a commission

A commission could be anything from a few quick snaps close to home, to a major overseas trip covering one or even several countries. The subject matter could be similarly broad, depending to some extent on what areas of nature photography you specialize in, from shots of a single species, to a habitat and a few landscapes, some environmental issue or conservation programme, a new ecotourism venture that needs to be promoted, through to the nature of an entire country.

Similarly, the commissioning organization could be anything from a newspaper, magazine or book publisher, to an environmental organization or government department, a travel company or tourist board, or any kind of company that has an impact on the environment, such as those involved in forestry, landscaping, water supply, mining, quarrying or construction. How you relate to all these bodies will, as described above, be affected by the way you feel about your photography; whether it is simply a service, a creative process done for the joy of photography and nature, or a tool in the conservation movement.

So, when the real possibility of a commission from a client arises, one of the first questions to answer is, can you provide the service they need? The first steps to finding the answer to this question include knowing exactly who your client is and what their aims are. This may sound absurdly obvious, but it is amazing how vague it can be, especially a client's aims, most particularly if you are approached by their advertising agent or public relations consultant instead of the company or organization for whom the photographs are really intended.

Once you have established what a client wants to have pho-

tographed and to what use the pictures will be put, you should have a good idea whether the project lies within your area of skill and specialization and, hence, whether you are at least technically able to meet their needs. There will still be a host of other matters to be agreed, and these will be discussed below. For some photographers keen to vet the environmental correctness of every new project, there will also remain the question of whether the work is desirable.

The staff at many non-media organizations may have little understanding of photography or of images in general and, therefore, may have only a rudimentary grasp of the kind of photography they need to fulfil their aims. In this situation, you will need to talk through with them just what it is they are trying to achieve, suggesting to them the approaches and kinds of images that would work, thus building up a plan of the project with them. On the other hand, they may have very set ideas on what images they want, but little understanding of what could be involved to get them. In this situation, you may find that their ideas entail a project on a scale they had never imagined, necessitating that you find a polite way to either upgrade their view of the project needed or, if this is not possible, to reduce their overambitious goals.

With publishers, particularly those specializing in nature, this is less of a problem, though you will still have to ensure that their goals are something you can meet. Whoever your client is, and no matter how conversant they are with photography and the business of images in general, before any agreement is made you should be absolutely sure that both you and the client understand and have agreed what the goals of the project are and what kinds of images the final body of work should contain. Try to avoid any uncertainty over this, as a misunderstanding that leads to you submitting at the end of a long project what the client believes are the wrong photographs could be costly and embarrassing for you.

Almost inevitably, deadlines and budgets will be too tight. Part of the negotiating process that should occur before you commit yourself to a project will involve attempting to secure the best deal possible for yourself. Obviously the degree to which you push for the best deadline and payment conditions depends on how badly you want or need a particular job. The ease and degree to which a client gives way will depend on how badly they want you to do the work, and this will depend on a number of factors such as your reputation for excellent work, whether they think anyone else might be available and whether or not they simply like you at a personal level.

Whatever agreement you do finally make, ensure that it is quite clear and that everyone understands it. Ideally, you should not even so much as pick up a roll of film until a contract has been agreed and signed, but in the real world this is not always the case. Magazine and newspaper commissions are often only verbal affairs, or at best the subject of a few lines in a letter, fax or e-mail message. This is fine in a situation where you and the staff know and trust each other well, keeping things on a friendly, non-legalistic level. However, it does make for insecurity as you cannot be sure until well after submission of the completed work whether or not it will be published and, hence, whether you will get paid.

Even with book publishers, although contracts are almost universal, if you wait for the contract to drop through your letterbox before picking up a camera, you could be in for a long wait, using up much of the time available before the submission deadline. Pushing on with the work regardless may be the only practical option – I usually wait until I have received any agreed advance payment, which sometimes arrives long before the contract. Although this is often the only practical way ahead, you could be burned since the contracts are usually very detailed, dealing with all kinds of rights aspects from the book itself to the electronic dissemination of excerpts and even films, and if there is anything in this with which you disagree you could have a hard time renegotiating, especially once you have already committed time and money to the project.

Working with photo libraries

In Chapter 3 I discussed how to go about finding yourself a photo library. In this section, I discuss how to work with a library once you have signed up with it.

By the time you have signed on the dotted line and become a bona fide photo library photographer, you should have gained a reasonable insight into the types of photographs that the library sells. However, after making your first submission and subsequently seeing what has been selected and what rejected you may feel that insight to be not as accurate as you thought. The selection of photographs, even for an experienced library editor, can be very subjective, and after a picture has been assessed for focus, exposure, composition and subject matter

Figure 28 Detail of the polyps on a translucent soft tree coral, *Dendronephthya* species, at about 25 metres off Balicasag Island, Philippines. Scale is impossible to judge; this image covers just a few centimetres.

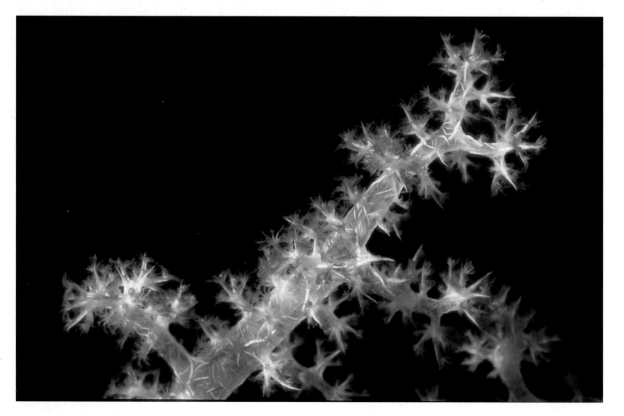

there are still various unquantifiables that simply come down to intuition. Will this image grab the buyers' attention and thus sell? No one really knows for sure until it has been on the library's files for a while, but an editor has to make a snap decision when going through your photographs, and sometimes the decisions reached can seem rather arbitrary.

Obviously, you want to minimize the number of shots in each submission that get rejected by the library. Work hard to find out what the library wants before committing yourself to significant amounts of time and money in shooting. Talk to the library manager about subject and style requirements, study the 'wants' lists that most libraries produce from time to time for their photographers, and take a long hard look at the catalogues they have produced. One library manager once uttered a somewhat depressing but inescapable truth when she told me to study her library's catalogue and 'then copy it!' Keep watch on these catalogues, as well as on any publications that are clearly using library pictures, for popular styles in terms of subject matter, composition and lighting, and then go all out to reproduce those kinds of images.

Before you can start to make a reasonable income from a library

Figure 29 A mixed larch and spruce forest in autumn; Haldon Hills, Devon, UK. With this view I set out to generate an abstract pattern, a type of image always to look out for in nature. This picture was captured using a telephoto lens to home in on the interacting forms of golden larch, deep green spruce, and long shadows cast by a low sun falling across the rolling countryside.

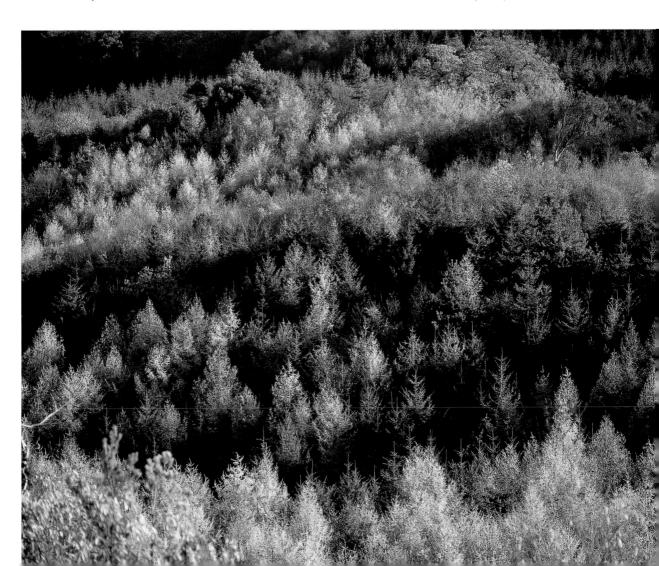

you need to build up a solid bank of work in their files in order to max-imize the chances of some of your photographs being extracted each time a client comes to view. Exactly what constitutes a large enough body of work is open to question, but a minimum of 2000 photographs is a usually accepted number. It can take a long time to build up such a large file with a library, especially if 50 per cent of all your submitted photographs end up being rejected. Furthermore, that 2000 must be the right kind of photographs. The library will give guidance here, rejecting submitted photographs that are clearly inappropriate, though it is still possible for you to end up with a file in the library consisting of 2000 brilliant photographs of a very narrow range of subjects. What is needed most often is a wide-ranging file that covers a multitude of subjects, thus increasing your chances of being viewed by the maximum number of clients. With a narrowly based file you may completely dominate one or two of the library's sections, virtually guaranteeing that your pho-tographs will be selected by clients in search of images covering those subjects, but you will completely miss out on all those other clients searching for photographs in other areas that you have not covered. So, when planning your photo library shoots, aim to photograph broadly, not necessarily in depth.

When you first join a library it is impossible to know whether the library's staff will do their best to market your work with at least as much energy as any other photographer's. There is always the fear, and indeed the very real possibility, that in a library holding perhaps half a million photographs, your shots will just get lost in a sea of celluloid, rarely surfacing to see the light of day. With most libraries now operat-ing complex computerized file lists, this is less of a problem than it used to be but it still exists. The only effective solutions consist of:

■ staying in regular contact with the library, such as by making personal visits if possible or through regular photo submis-sions, so that the staff come to remember your name (hope-fully in a positive way)
■ maximizing the number of your photographs the library is holding.

Many library contracts stipulate that photographers must make regular submissions, often requiring at least one submission per year. This is a fairly minimal task, and if you are not doing considerably more than this, especially in the early days when you are trying to build up your file at the library, you will never have any hope of making a reasonable income. Up until the mid-1990s it was normal practice for photogra-phers to submit, and for libraries to accept, multiple copies of the same image, thus requiring the photographer to shoot the same subject several times over (a process of making what is known as in-camera duplicates). This was so that whenever an image was sent out to a client for viewing, even if the client held on to the image for some consider-able time there would still be more copies of that image in the library for other clients to view. Since the mid-1990s, however, the libraries' need for in-camera duplicates has, for the most part, declined due to a great increase in the use of CDs and international standard digital

network (ISDN) lines to market images, thus ensuring that original photographs often do not leave the library until a client has made a very short list of possibilities to choose from, thus greatly reducing the amount of time any photograph will be away from the library's files.

Even for a library that no longer requires multiple in-camera duplicates, it is a good idea when making a submission to include two copies of the same image, if only to give the editors a choice of slightly different exposures. Exposure is quite an important issue with photo libraries, as there is a clear difference between them and publishers. Whereas publishers will generally be willing to work with an underexposed image provided it is a really good photograph, a photo library will not. Every image you submit must be correctly exposed, at least to within half a stop. And remember that all images in this field are transparencies, which means a very poor film tolerance to overexposure or underexposure. So make sure your images are accurately exposed.

In preparing submissions, some photographers submit darkroom duplicates instead of original photos. While this might be necessary occasionally, for example in a situation where, for one reason or another, you were able to obtain only one or a very few frames of a given subject, in general it is bad practice. Send in originals as much as possible. This makes it important when out on a photographic trip to shoot in-camera duplicates of each subject to ensure you have enough images to cover all your potential needs. Originals are preferable to darkroom duplicates because, not only is duplication a relatively expensive process, but even in the duplication of medium format images the resulting copy may not be quite as good as the original. Furthermore, despite what I just said about the reduced need for the submission of multiple copies of the same image, if you are working for a large library they will duplicate every image they accept many times over and send the copies out to each of their branches and/or representative sub-agents. It is better if they are able to make duplicates from an original transparency rather than having to duplicate a duplicate.

Another step towards maximizing the uptake of submitted images is to ensure that those you send in are well presented. Thirty-five millimetre slides should be mounted in good-quality glassless plastic frames (the kind that can be easily opened for the image to be used without the frame being destroyed), and medium or large format images in clear plastic sleeves. Your name, along with the copyright symbol should be on each and every picture frame or sleeve, and captioning should be according to the library's instructions; either on a label stuck to every frame/sleeve, or with each photograph numbered and captions given on a separate sheet. Keep the captions clear and succinct, but containing all the relevant information.

Be sure to keep accurate records of all images sent to a library, as well as records of all those accepted. If there ever comes a time when you need to pull out of the library, you will need these lists to ensure that every photograph is returned to you.

In the early days you will have to be incredibly patient about waiting for financial returns. From the time you make a submission it can be several months before any of those images even start going out to clients let alone earn anything. The library's process of photo selec-

Figure 30 Chinese hemlock silhouetted against the sun; Taroko National Park, Taiwan. High in the mountains of Taiwan are ancient coniferous forests, gnarled by the weather and draped in old-men's beard lichens. This silhouette provides an opportunity to show off the jagged outlines of one old tree, standing right on the tree line at an altitude of 3200 metres.

tion and subsequently putting the photos into the files can be a long one, and is not always as efficient as it might be. Once your photos are in the files it may be some time before clients start viewing them, and then they can be very slow in making final picture selections. Needless to say, even when this stage is over the clients can be even slower in making their payments to the library.

Once your images do start to sell, you will receive sales reports from the library, usually on a quarterly basis, or monthly if it is a large library. Payment may come with the report or sometime afterwards, but only for those images for which the library has been paid by the client.

Running your own library
Even if you sign up with a photo library, you may still want to market your own file photographs yourself. In this case, try to sign a non-exclusive deal with your library. If this is not possible, the library insisting on exclusivity, be careful to avoid infringing the library's rights by signing up with one that covers a different geographical region from your own, or by marketing a different set of photographs from those held by the library.

Once you have set up your file, as described in Chapter 4, you will need to let a large number of people know that the file exists, and then you will have to keep reminding them about it. Even people who become regular users of your file are not likely to be knocking on your door every week, so in order to keep the sales coming you will need to market over a wide area, reaching virtually every relevant organization you can think of. Your marketing will need to be quite repetitive since editors, for example, seem to forget quickly about the photographs held on individual photographers' files, in the panic of the moment when searching for pictures often opting to go for the first names that spring to mind – usually the big libraries. Once you have come to know a few of your buyers, regular reminders can become a simple matter of phoning them to check on their current needs.

It may be necessary to move very quickly on some picture requests, sending off photographs by courier or fast mail the same day that the request comes in. Nevertheless, you should not cut corners in preparing the pictures. Everything must be properly captioned, with your name and copyright symbol on every slide. Pictures should be captioned individually, with the captions stuck to the frame or sleeve of every transparency. This makes it easy for photo editors and designers to quickly identify each picture, more so than is possible when captions are listed on a separate sheet. If you do use the latter system, you will probably lose out to photographers supplying pictures that are individually captioned.

How you attach the captions and your name to the slides is up to you, although obviously the quickest and most efficient method is desirable. Handwritten captions are very much a thing of the past, computer-generated labels having almost completely taken over. There are a variety of ways of proceeding here, either typing new captions, or copying the captions from your file lists, on to a label template each time they are required or, if you have a library software, using a barcode system to generate the captions automatically.

All the pictures should be sent in clear plastic sheets that will enable the buyer to view up to twenty-four photos in one go – never send the slides in boxes from which they have to be laboriously laid out on a lightbox and then put back after viewing. Wrap them well so they cannot be bashed or bent while in transit, and be sure to send by some secure, rapid means, i.e. courier or registered post.

Be sure to keep complete lists of all photographs sent out, log them back in as and when they are returned, and refile them immediately. Record how many are used, make sure you and the client have agreed a fee, and be efficient in issuing invoices and recording when payment is made. If photographs are lost or damaged, do not be shy about asking the client for compensation, charging the usual going rate.

A record of the photographs being sent out can be made by listing the captions alongside unique file codes that identify every picture in your library. I use a system that links every photograph with its own pocket on any sheet within a section or subsection. This not only clearly identifies every photograph but also makes it very quick and simple to refile any picture when it is returned. Again, a library software will generate unique codes for every photograph, automatically linking captions and the pho-

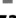

tographs sent out, as well as helping with refiling and invoicing.

Many photo libraries charge clients for a search through their files and for sending out photographs for viewing, regardless of whether or not a final photo selection is made. In order to remain competitive with the libraries, many photographers running their own files do not charge search fees, but if you become especially busy it may be something worth considering.

If your business becomes very successful, you may want to consider upgrading yourself to a full-sized photo library. While everything entailed in that process is beyond the scope of this book, you will need to greatly expand the range of photographs available (though not necessarily spreading beyond the definition of nature photography) and, of course, increase your marketing to widen your client base. If working from home, you may now need to consider moving to an office, since the operation is clearly going to take up much more space, and you may want to consider employing staff. Look into the need to join an association of photo libraries, and if you have been supplying a photo library you may now need to decide whether you can remain with them.

Speculative work

All photo library work comes under this heading since you can never be certain that photographs will be accepted by a library. In the world of publishing, too, you may well find yourself having to do a great deal of speculative work, working on projects for which you have no commissions, but which you feel quite sure will sell once completed.

Ideally you would not commit yourself to work without a firm commission to be sure of paying the bills, but this is not always possible. You may have a terrific magazine project in mind, for example, but for some reason find it impossible to convince any editor of its value. If you are quite sure of your ground, you may be better off pushing ahead with the work, using the power of the finished product to show the editors they were wrong and thus persuade one of them to take it up.

In many situations you may have one or two project commissions, but with a prospective fee that does not cover expenses for essential trips as well as the necessary profit. You may secure a few more commissions before starting, but if the combined fees are still inadequate you will need to push ahead and simultaneously work on whatever speculative ideas come up in the course of doing the commissioned work. It can be difficult to know what projects might be possible before travelling to a region that you have not visited before, thus making it almost impossible to put together a coherent proposal to a magazine, let alone get a commission. In this case, during your visit you have to be alert to any opportunities for marketable stories that could be sold once you return home. Similarly, one way to help pay for photo library work is to combine any trips you might be making for this work with magazine projects, either speculative or commissioned.

If you are considering a round of speculative work, plan well first. Ensure that you establish clear goals and a defined list of projects to be tackled, that you know your market well and that the projects to be undertaken are most definitely saleable. If travel is involved – especially if overseas – plan an itinerary that will enable you to maximize the use

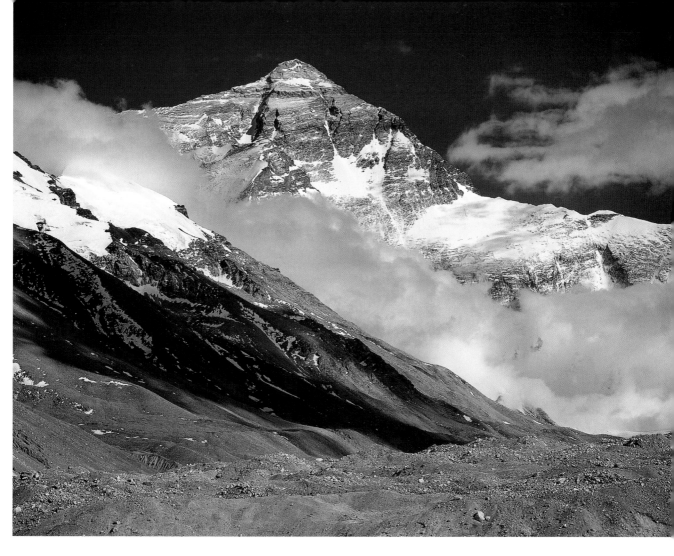

of your time: you cannot afford to lose a couple of days while on the road wondering what to do next. If you need to put together several jobs to make the whole project financially viable, try to ensure that they overlap or at least dovetail together well, so that a single round of shooting may have a couple of final uses. Again, if travel is involved, try to secure a few barter deals to help reduce your costs. This will be difficult if you are intending to do only photo library work, which is another good reason to combine this work with magazine projects as these are more likely to attract potential 'sponsors'.

Finally, remember that you will have to bear all the upfront costs, something that can be quite formidable, especially if international travel is involved. Be sure that your financial situation can take the strain, as income from such projects will take at least six months to start filtering through.

Submitting your finished work

Take your agreed deadline dates seriously and make sure you meet them, as a reputation for timely delivery is worth a great deal. Indeed, a photographer with a reputation for reliability combined with work of even a relatively modest quality is at least as valuable to a client as a

Figure 31 Mount Everest seen from the Tibetan base camp. It has to be admitted that a lot of the drama of this image relies on knowing that this is Everest. For me the majesty of the mountain is fixed into this image by the low cloud and the detail picked out in the rock walls by the low evening sun. To my disappointment, the client was unimpressed with this shot, choosing instead one taken in the middle of the day when the high sun meant that much of the detail on the mountain was lost, but probably going for it because there was not a trace of cloud in the entire picture. Incidentally, on the day this picture was taken five climbers made it to the summit.

photographer known for flashes of absolute brilliance but who rarely delivers on time.

If it looks as though you are going to overrun on a project for some unavoidable reason, be sure to give your client plenty of warning. Never simply go on past the deadline date without keeping them informed of what has happened. As ever, communication is the key to avoiding misunderstandings and conflict.

In terms of submitting the finished work, I have already talked about how to submit your file photographs to clients and the submission of photographs to photo libraries. In sending in photographs – almost certainly slides – to any type of publisher, things will be pretty much the same. Every picture should be captioned and identified with your name and copyright symbol, 35 mm slides mounted in reusable plastic glassless frames and medium format transparencies in clear plastic sleeves, all presented in clear plastic sheets, wrapped well and sent by some secure means.

In submitting photographs, especially prints, to a non-media client who wants the pictures for display purposes rather than publishing you should consider maximizing the quality of presentation. Prints should be attractively mounted on card and stored in some kind of album or folder, with your name attached somewhere in an attractive style. Many photographers have custom-printed mounting cards, folders and albums, and you may well consider the cost of this fully justified by the fine presentation this produces and the good impression created.

To whomever you have submitted pictures, it is a good idea to follow up a few days later, to show your concern, check that the photographs did at least arrive safely, and make the most of one more excuse to make personal contact with the buyer and impress upon them your existence as a photographer.

Self-publishing

Finally, this chapter would not be complete without a word about self-publishing. While I would not recommend anyone to start publishing their own work as soon as they become a professional photographer, it is something that some might want to consider once they have gained some experience of the market and have a reasonably sound financial footing.

The attractions of self-publishing are that you get to decide which of your photographs are published and in what form, and a greater slice of any profits that may eventually be earned find their way to you. The potential rewards, then, are greater than if just supplying photographs to established publishers, but then so are the upfront costs and the risks.

Start small, perhaps with just two ranges of postcards or greetings cards, distributed over a relatively small area. Gain experience of how to produce and then market your products, and do not think about expanding until your initial start-up costs have been paid back and you are making a profit. Congratulations! You have started to succeed in the dizzying world as a publisher.

Summary

As a service provider you should be aware of your attitudes to your photography and your clients, as these will greatly affect your approach, to whom you market your work and the way you relate to clients. Realize that as a professional your photography has become a business, and that if as an amateur you viewed your work as an art you may now need to change this attitude. Nevertheless, this does not mean there is no need for your work to be artistic and, of course, the work should be of a very high level of technical skill. Market yourself confidently but honestly. Do not be afraid to take on new and challenging work, but be ready to recognize when a project may take you into a kind of work for which you are not qualified. When asked to work on a new project be sure to discuss the aims and required photographs with the client, and make quite certain that everyone is clear on whatever agreement is made, especially in terms of the photographs to be supplied, the deadline and the fee agreed. Ideally, you should not start work until a contract has been signed, but in the real world this may not be practicable.

In working for a photo library, do everything you can to maximize the proportion of submitted photographs that get accepted. Make sure you understand the kinds of images the library needs, shoot a broad range of material, make frequent submissions, and present your photographs in the style laid down by the library. You will need to build up a large body of work with the library before a reasonable income starts to flow, so you will need to be patient. If marketing your own photographs you will need to contact a wide range of potential buyers, and

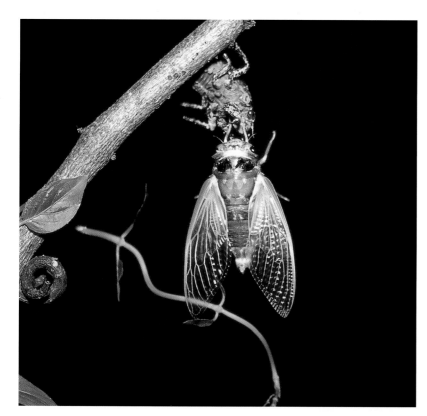

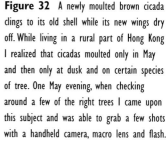

Figure 32 A newly moulted brown cicada clings to its old shell while its new wings dry off. While living in a rural part of Hong Kong I realized that cicadas moulted only in May and then only at dusk and on certain species of tree. One May evening, when checking around a few of the right trees I came upon this subject and was able to grab a few shots with a handheld camera, macro lens and flash.

in responding to requests you may need to act quickly to be sure of making a sale. Keep a careful record of all photographs sent out, returned, used, invoiced and paid for.

If launching into speculative work, set clear, achievable goals, and combine a number of closely related projects that will both enable you to make the most of your time and provide sufficient fees to make a profit on the venture. If travel is involved, try to make barter deals to reduce costs. Be sure you can bear the upfront costs that need to be paid, and afterwards be patient in waiting for the returns.

Do everything to complete each project within the deadline. When the work is completed, and you are submitting your transparencies to publishers make sure the pictures are well captioned, wrapped properly and sent by a secure means. When submitting prints intended for display, mount them carefully and store in an album or folder, preferably with your name attractively printed on the material.

Photographers who want to control exactly which of their photographs are published and in what form, and who want a bigger share of the profits, may want to consider moving into self-publishing.

Having dealt with the means to get a job started and then how to submit the finished work, the next chapter will look at how to actually get on with a photographic project, focusing most closely on those that require travel away from home.

6 ON THE ROAD

A large part of a nature photographer's work will entail travel, and whether this is to the next county or halfway round the world it needs to be planned and executed carefully to ensure an efficient use of time and resources. Bad planning and organization can lead to wasted effort, the need to repeat expensive trips and a less than rosy reputation among your clients. Making it all come right is a combination of well thought out advance planning and, during the trip itself, a well-controlled approach that enables you to stay focused on and enthusiastic about the work throughout. This chapter will look at some of the ways to achieve this twin goal.

Initial steps

When planning trips associated with any project, whether self-initiated or commissioned, you must first be clear as to your goals. As outlined in Chapter 5, before committing yourself to any job you should be quite certain of its overall objectives, and when planning trips associated with that job you should not only remind yourself of those but also look at the specific aims of each trip.

The first matter to be clear on is the number of trips that will be needed to complete the photography for any given job. The second matter is whether each trip will entail work for just the one project or several. A project that entails just one trip, during which you will be able to concentrate on that job alone, is the simplest situation of all; the journey's goals will be pretty much the same as the entire project's. But the more trips that are needed for each project and the more projects that get mingled together on the same trip the more complicated your arrangements will become, and the greater the need for perfect organization.

Aim to keep a trip's goals as simple as possible. That way not only will you reduce the length of the journey but you will also be able to keep a clear head and one that is focused fully on the work. The more projects combined in a single trip, the greater the number of goals to be fulfilled and the more confused will be your priorities. This can lead to the very real danger of your head becoming so befuddled with 'juggling so many balls' that you cannot concentrate properly on the photography for any one of them. The result is that you could end up dropping all those 'balls' in the mud of confusion and failure.

For each project you have in hand that will need some travelling

**PROFESSIONAL
NATURE
PHOTOGRAPHY**

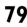

79

you will have to ask several questions, as listed below:

1 Is this a self-initiated or commissioned project?
2 How high a priority does this project have compared with the others?
3 How many trips will be needed to complete the photography?
4 How far do I need to travel and how long does each trip need to be?
5 What kind of photography will be needed?
6 What time(s) of year do the shots need to be taken?
7 How much equipment and film will I need to carry?
8 What constraints do the budget and deadline (if there is one) impose on the ideal way of carrying out this project?

The answers to these questions will give you initial ideas of how to carry out each project and which, if any, can be combined together into the same journeys. At one extreme a large, high-priority commissioned project with a tight deadline is not going to lend itself well to being combined into the same trip with others. At the other end of the scale it may be the only way to make small, self-initiated projects financially workable, provided they have similar travel needs and goals.

For the large commissioned project requiring several trips, it is likely that even if photography for other projects can be combined with it these will very much take a back seat, leaving the needs of the larger project to dictate such crucial factors as timing and itinerary. Working out just how many trips will be needed to complete the photography for such a large project can be difficult to do in advance, yet it is an important element in resolving problems such as which parts of the project need to be photographed at what time of year, how weather patterns will affect your ability to photograph or even travel during any given season, and how to combine different locations to make best use of your time.

Resolving such issues for a region you already know is one thing, but for a place you have never visited before is quite another, especially if, for example, it is to a country for which information is sparse. Plenty of homework will be needed long before you are able to proceed with the practical planning for each trip.

Timing

As already mentioned, one of the first crucial decisions you must make in setting up a trip is to decide what time of year your project needs to be photographed for the best results. To do this you have to decide what constitutes 'best results'. Often this would take the form of opting for the safest time of year, the period when you are most likely to get dry, sunny weather. Sometimes, however, this may not be the time to get the results you need for a particular project. If shooting wildlife, the dry, sunny time of year might be the wrong time for a particular form of animal behaviour, or even to see certain species in your chosen location. With landscape photography, dry, sunny weather will of course give you good, well-lit views – postcard-type images, which may be exactly what you want. These images can be rather stereotypical, however, especially

if the landscapes to be photographed are already well known. So, for something rather more dramatic – for example with low sunlight before or after a storm – you may need to consider visiting when there is some bad weather about. All this assumes, of course, that you will be photographing in a region where seasonal weather patterns are reasonably predictable and can be planned for. In those regions where this is less easy, you will have to opt for the best time – or rather the least bad period – and hope the weather co-operates.

A major nuisance comes with the commissioned project the deadline for which does not allow the luxury of waiting for the best time of year. Many clients – even those involved in tourism and nature, who you think should know better – seem to revel in packing photographers off to a region during the height of its rainy season. Or there are the clients who, although initially commissioning you at the right time of year, then take so long to finalize the project's details that – despite your frequent polite warnings about the seasons – lead to a crucial dry season being missed. Such problems arise from a combination of the excessive workload often borne these days by company staff, and the fact that many projects that involve photography are created in the marketing department, whose office-bound staff have not even considered the possibility that the weather might not co-operate.

I am not sure that there is such a thing as the ideal solution to these problems, other than to fight tooth and nail for the longest possible deadline in order to maximize the chances of having the right

Figure 33 A pompadour green pigeon, in the Philippines. Most of the world considers pigeons to be rather boring birds, but in Southeast Asia some species are among the most colourful of birds. A photographer should be prepared for this surprise and ready to produce some stunning pictures.

PROFESSIONAL NATURE PHOTOGRAPHY

81

weather. This can be combined with a careful explanation of seasons, in the hope that the client will still be impressed with the photography that you do eventually return with despite the lousy weather, and that they will not inflict you with the same problem again.

Practical planning

Once you have finalized all the details of a given project, in terms of its goals and deadline, for example, and have worked out how many trips may be needed and when, you should then be able to put the project into motion.

Among the first matters to be considered is the question of how much help you might need in getting to locations, finding plant or animal species that you want to photograph, or in securing accommodation. On a commissioned project, depending on who your client is, they may be able to set you up with all the contacts, drivers, guides etc., that you need. More often though – and certainly with self-initiated projects – you will have to make your own arrangements, contacting conservation organizations, tourism departments, hotels, and any other bodies or individuals you feel might be able to help you along your way. If you will not be able to claim expenses from the client, now is the time to work on possible barter deals with airlines, hotels, travel agents and tourism authorities – people who certainly can get you to the area you need to be in, possibly for free if you can give them something in return.

In looking for such deals you will have to be able to present a well thought-out proposal essentially outlining why you should be supported and what the sponsor will receive in return. The points that need to be covered include:

1 Who you are and what you have already done.
2 Why you are such a great photographer that you deserve to be supported.
3 What you intend to do on this project and why.
4 Exactly what it is that you want from a sponsor.
5 What you will give the sponsor in return for their help.

Items 1 and 2 of the above list are essentially your résumé presented as part of the background to the project and why you have been selected to be involved in it. Item 3 describes exactly what the project is, what the end result will be, who it is intended for and how a sponsor is likely to benefit from it. For item 4 you should detail exactly what you want from a sponsor. If you want help with just one trip you should give a detailed itinerary, pinpointing where help is needed. If you want sponsorship for a series of trips, there may be no need to give an itinerary for all of them, but details of their overall plans will be needed. Do not be vague; most potential sponsors are not interested in giving assurances of support 'in principle' based on an outline proposal, but in giving a clear yes or no to specific, detailed requests. Item 5 can be a crucial yet rather difficult section for the photographer. What can you give in return for sponsorship? Donation of photographs to the company's marketing file is one of the more obvious suggestions, along

with acknowledgements in whatever books or magazine/newspaper stories are to be published, or public relations photo opportunities if you yourself are to be photographed by the local media doing your work, with the essential help of ABC & Co. (the sponsor).

From all this it can be seen that although barter deals can be extremely useful in reducing your costs – only for projects in which no one else is picking up the expenses bill, of course – searching for them can be rather time-consuming, and unless you can come by them quickly and easily the effort may be more trouble than it is worth. With photography depending so much on the weather, you may find it very difficult to work out in advance the exact itinerary that many sponsors, especially those supplying plane tickets and hotel rooms, will require. Yet at the same time it is a good discipline, forcing you to really think about just how much time it is all going to take – usually far more than expected – and also helping to ensure that each trip does not keep getting longer and longer. You are now running a business and while it is essential to obtain the photographs needed for each project, it is also important to ensure that the time spent away from your base is controlled and predictable.

Making contacts, securing offers of help and, if needed, setting up barter deals may well take up the lion's share of the effort entailed in getting a trip organized, but there is much more that must not be overlooked. There is the mundane paperwork, such as travel tickets and entry permits for restricted areas. If undertaking international travel, there are the inevitable passport, visas, health needs and foreign currency to organize; almost all small matters by themselves, but collectively more than enough to be getting on with.

Then there is all the hardware to gather together. Buy enough film, make sure your equipment is working and invest in any new items you may need. If using new equipment, buy it well in advance of any trips and make sure you fully understand how to use it before setting off. This is especially important if heading to a region where it will not be possible to process any film, the results being unknown until after you have left the photographic location or returned home. Bad photographs resulting from a wrongly used piece of new equipment can lead to expensive and embarrassing reshoots. If taking your own vehicle, make sure it is up to the trip and is itself properly equipped – especially if you will be heading into remote locations where no help will be on hand.

And then, if going to an unfamiliar area, there is all the general research to be done. Consult travel guides, tourist office material and maps to gain as great a general background knowledge of the place as possible, as well as all the necessary conservation and/or wildlife data you will need specifically for your photography.

Finally, you are ready to go. Bon voyage and happy shooting.

Photographing to a brief

On any trip you undertake it will not be possible to photograph everything and anything encountered along the way. For one thing this could result in the trip going on forever, and for another may well result in you missing the point of the project's goals – the photographic brief to which you are supposed to be working. Photography of the tribes living

on the slopes of some forested volcano, for example, along with the devastation wreaked by loggers, would almost certainly make a great piece of photography, but if you have been commissioned to photograph only a sample of the fauna and flora of that volcano, and have only a very limited time in which to do it, you had better make sure you concentrate on the commissioned work. The tribes and the loggers would make for an extra bonus, but if they are not in the brief then they must take second place to the primary goal, being photographed only if there is some spare time.

Obviously, if your trip is purely for work on self-initiated projects then you can afford to be more flexible, changing the priorities as you go along according to what you find. In that case, the tribes and loggers may prove to be more attractive than your original goal, the volcano's flora and fauna. However, even if you are working on your own projects be careful not to get carried away with a few ideas that you hit on while on the road. Remember that in the end you do have to make a profit, so try to avoid becoming overly engrossed in topics discovered while on the road which, though very interesting, may not be as saleable as projects you so carefully formulated before leaving home. Nevertheless, if you do chance upon a really good marketable topic make sure your plans are flexible enough to enable you to jump at it.

Presumably, self-initiated projects will cover subjects that interest you the most, with a photographic brief and timetable that you have formulated yourself to suit your style of photography and way of

Figure 34 *Hedychium* species flowers growing on the forest floor in the mountains of Taiwan. Most forest flowers are quite small, so their photography requires a keen sense of observation, coupled with some luck in finding specimens that are photographable: are in good condition, are accessible, have reasonable lighting and are sheltered from any wind. Successful photography requires macro equipment, flash and a tripod that will allow the camera to come very close to the ground.

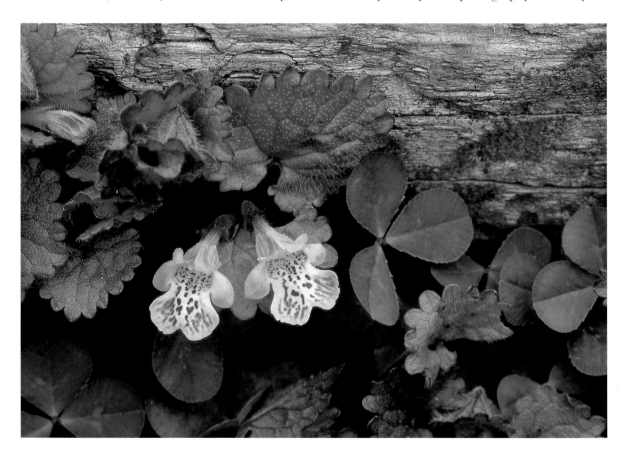

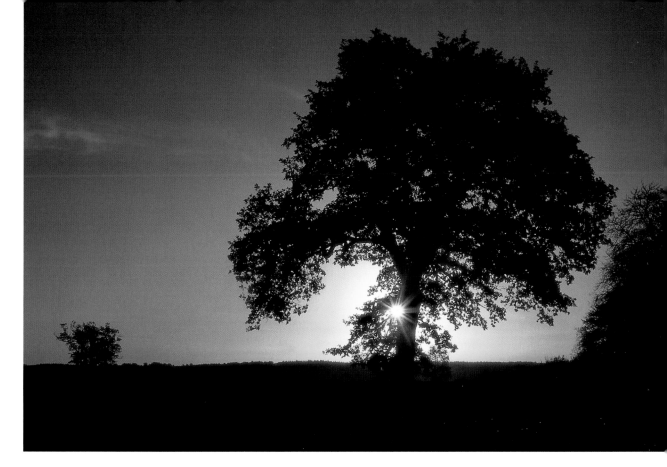

working. Your plan may well include compromises to ensure that what you end up with – whether magazine stories or a set of photo library photographs – will be saleable, but essentially this is your project and – finances permitting – you are in control of everything you do.

Things may be very different if you are working on a commission. On the one hand the client, while asking for photographs on a particular subject, may have given you free rein to shoot in whatever manner and style you choose, limiting you only to budget and deadline. On the other, they may go so far as stipulating photographic style, almost down to the very images needed, though such a narrow brief would be unusual. The former kind of brief will probably give you plenty of scope to work in your own way, shooting the subject required but in your own personal style – something for which the client may well have specifically commissioned you rather than another photographer anyway. There is the danger, however, especially with a new client, that the reason for the very general brief is that they do not really know what they want. Hopefully you cleared up any such doubts during discussions with the client before taking on the commission but, just to be sure, on a long multitrip project you can regularly show to the client sample photographs taken as the work progresses. This will give you the opportunity to really test your client's liking – or otherwise – for your style and content well before the project is finished, enabling you to fine-tune your work according to their reactions.

With the really tight brief at least you should know exactly what the client wants from you. However, in order to satisfy their needs you

Figure 35 A lone oak tree silhouetted against the rising sun, seen in the English Midlands. Oak trees are a common feature of British farmland and I came across this one while in search of a subject that would form a strong silhouette against the sunrise. The resulting image is both an attractive landscape and a comment on the graceful strength of the oak.

**PROFESSIONAL
NATURE
PHOTOGRAPHY**

85

may find yourself having to work in an unfamiliar way, shooting a style that is not really yours. This can easily lead to you producing work that is far from your best, leaving both you and your client dissatisfied. To successfully take on such a commission you must be sure that you can work flexibly, changing your style easily and comfortably to suit the client's needs. If you find yourself in a situation where a client is trying to make you photograph in a style with which you are either quite unfamiliar or with which you actively disagree, the only route forward – short of actually resigning from the job – is to push ahead with what they have asked for while at the same time photographing in your own style. You will be happier, making it easier for you to finish the project in the client's stipulated style as well as your own. When it comes to presenting the finished work you can then show the client two products; one shot to their requirements and the other your own interpretation. You can leave the client to choose which they prefer.

A common scenario with a large project is that although overall the brief is an attractive one there are components that are problematic for you, for any of the style or subject matter reasons already mentioned. The commission may have come to you as a multicomponent package – such as photographing several different aspects of an entire country – and you had a choice only of accepting or rejecting the entire package. You took it on because the majority of the package was fine, convincing yourself along the way that the less attractive parts would be all right in the end. Inevitably, it seems, those problem parts come to dominate the entire project, at least in your own mind, sometimes requiring far more effort and time to work through than is really justified from their relative importance to the project as a whole. It is not surprising, of course, that subjects and styles with which you are not so familiar or comfortable will require more effort from you than normal, but in planning your work – especially trips away from home – you must remember to build in the extra time needed. You should also be sure to avoid the temptation to keep putting off those less pleasant parts of the job until later: tackle them early on while you are still fresh, enthusiastic and have plenty of time before the deadline to correct any mistakes.

Camera equipment and aeroplanes

Putting together a relatively local trip lasting a few days is not the most arduous task in the world, providing you remember to confirm such details as where you are supposed to be going, that you do have access to the location (with permits if necessary), that you are going at the right time to be able to photograph whatever it is you are after, that accommodation is available and that any local helpers-cum-guides (if needed) are ready for your visit. Throw everything in the back of the car and away you go.

Life is more complicated with longer trips, especially if you will be flying and most especially if – when you eventually reach your destination – you will not have the luxury of your own vehicle. Under these circumstances the art of how to carry all your gear comes into its own, something that can take some considerable practice to perfect.

Getting equipment and film on to an aeroplane is a major problem

these days. With strict limits on carry-on luggage and security rules for the most part rigidly enforced, there is sufficient reason to worry about film safety, the accuracy and gentleness of luggage handling systems, and the size of any possible excess baggage charge you may incur.

Rule number one is that film always goes in the carry-on luggage. Work on the assumption that the X-rays used to examine checked-in luggage are more powerful than those used on carry-on bags, therefore you must ensure that film goes through the latter. I used to insist on my film being hand-checked, refusing to allow any of it to go through X-rays. However, tests carried out at London's Heathrow Airport in the early 1990s showed that 50 and 100 ISO films could be X-rayed nearly thirty times without any apparent damage. Since then, I have stopped worrying, allowing my bag full of film to go through the X-rays whenever requested. I am glad to report that so far I have suffered absolutely no damage.

Having said that, however, as of the late 1990s new X-ray equipment has started to be introduced that the British Airports Authority has admitted can damage film, even film as slow as 100 ISO. This is a worrying development and may require a return to hand searches of film. This, however, is getting difficult to secure, the BAA for example now insisting that hand searches will only be allowed if requested in advance, such as when checking-in.

Two hundred rolls of film (as I often carry on a trip) can take up a large portion of your carry-on baggage allowance. To save space and weight, take all the films out of their boxes and carry them loose. If travelling internationally, this has the added advantage that customs officials at your destination will be less inclined to conclude that you are importing the film for resale.

Later in the trip, or right at its end, when much of your film has been exposed, the rule about carrying the film on to the aeroplane with you becomes even more important, and not just because of X-rays. Any luggage that is checked-in can, and occasionally does, go astray. If there is a choice between losing your equipment and losing your exposed film, choose the former every time. The cameras should be insured and can always be replaced. Many of the images stored inside those rolls of film are completely irreplaceable, and after an arduous trip the mere thought that you might have to repeat it all could make you feel quite ill.

If your film is in your carry-on luggage most of your equipment will have to be checked in, unless you are travelling with only a very small amount. Be sure to pack camera bodies and lenses in a purpose-made hard case filled with foam padding and secured with a padlock. These cases can take any amount of pounding, and in over six years of travelling with one I have not had a single item damaged.

Despite checking-in most of my camera equipment I usually carry at least one camera body and lens on to the aeroplane with me. These may fit in the carry-on luggage along with the film, or in the classic multipocket jacket that is so much a part of the photographer's 'uniform'. This jacket is ideal for ensuring that a few more items can be brought on to the aeroplane as it is treated as clothing, not luggage, and so its weight is not scrutinized as your carry-on luggage might be. It

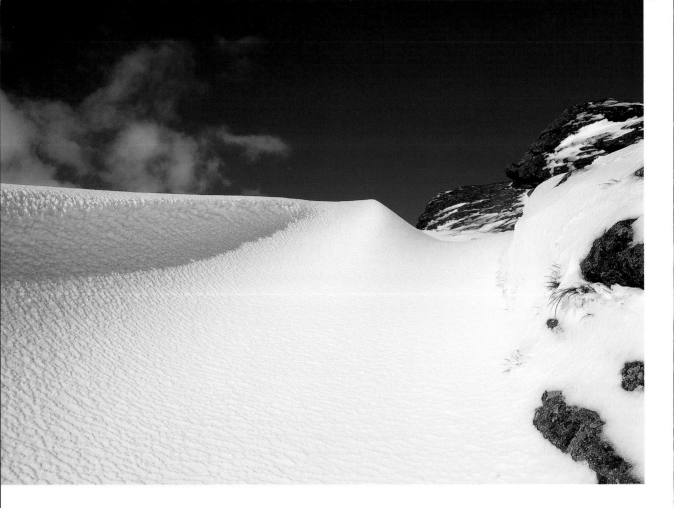

Figure 36 A hilltop snowdrift in Dartmoor National Park, Devon, UK; clean, simple lines with no clutter and unsullied by human footprints. In this shot the height of the snow was exaggerated by using a very low camera angle.

will, however, need to be X-rayed along with your carry-on luggage.

Tripods can usually be carried by hand on to an aeroplane, although in the confines of a crowded cabin they can become something of a lethal weapon. On occasion I have even had it confiscated due to 'hijack regulations' (I was curious to imagine how I might hijack an aeroplane with a tripod). To play safe, try to fit your tripod into your check-in luggage. This can be problematic with a large tripod, of course, but some makes can be quite effectively dismantled into conveniently small pieces. Just be sure to take the screwdriver, spanner or alun key required to reassemble it at the other end.

Moving on the ground

In many countries car hire is affordable and widely available, making it easy to pick up a vehicle straight after flying to your destination. However, in some countries this may not be an option, at least initially, or the cost may be beyond your budget. In this situation, unless local help includes providing a vehicle, you will need to use public transport.

This raises the issue of the security of your equipment. I generally follow the same principles that I apply to aeroplanes – keeping film (especially exposed film) and a minimum of equipment close to me at all times, and storing the main luggage in whatever way is possible on the bus or train. And then I generally just keep an eye out for what is going on around me.

Inevitably, nature photography can involve having to penetrate into some remote areas. A four-wheel drive vehicle might get you most, or even all of the way to your intended location, but there will certainly be many occasions when hiking is necessary. Do not over-burden yourself on such hikes. Make hard decisions on just what you really need to take along in terms of equipment and film, and leave unnecessary items at some safe base; a hotel or national park office, for example. Even so, you may still need some helping hands, especially if taking food and camping equipment in addition to camera gear, so do not be shy to accept offers from willing volunteers, such as park rangers, or to hire one or two people if necessary.

When out on foot shooting, it is important that your equipment is carried as comfortably as possible, yet at the same time is easily accessible, enabling lenses to be changed, filters to be added and swapped, and a tripod to be set up quickly and efficiently. Many photographers carry their gear in a shoulder bag, but for the nature photographer out walking all day, often over rough terrain, this could be a medical disaster, quickly leading to a chronically damaged back. Respect your body; look after it because you will need it for many years to come. Be sure that the often not inconsiderable weight of equipment is distributed evenly about you.

For 35 mm gear, I often use a multipocket jacket, with lenses, flash gun, filters and film arranged in the pockets all around and within easy reach of my hands. The system works quite well for me, especially when coupled with a small rucksack to carry one or two other items, such as a long telephoto lens and the all-important snacks, although of course it does have problems. First, the weight in the jacket can hang rather heavy on the back of the neck, which can be unpleasant, but occasional realignments will easily shift the weight on to both shoulders. Secondly, in tropical climates, although the jackets are well ventilated the heat and sweat build-up can be quite horrendous, leading not only to overheating and serious discomfort, but on occasion actually some concern for the lenses due to the amount of salty water seeping through the jacket. An alternative method is to use a waist pouch instead of the jacket, big enough to hold a couple of lenses, filters and film, coupled with the small rucksack to carry a few more of the larger items. In that situation you may have to cut down on the snacks, but if in the tropics, never leave base without water. You will not get far without it.

If using medium format equipment as well as, or instead of, 35 mm gear, a well-designed, purpose-made rucksack is a must. Never carry such heavy gear in a shoulder bag: you will certainly damage your back. Several makes are on the market, well padded and big enough to hold not only your medium format kit, but also much of the 35 mm gear too, such as a long telephoto lens. There will still be space for that all-important bottle of water.

Another thing you should never head out into the wilds without is a tripod. A real nuisance to carry around all day, a tripod is nevertheless essential for most images requiring a telephoto or macro lens, and even in 35 mm format it is useful for producing pin-sharp landscapes, especially in those many situations where maximum depth of field is a

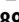

must. For medium format photography, a tripod is absolutely essential for every kind of photograph.

The long and weary road

There have been occasions when I have found the effort of reaching a location itself so exhausting that the idea of then carrying my camera gear any further while I search for things to photograph is almost more than I can bear. Yet, more often than not, if the weather is right when I arrive, and with one eye on my itinerary I force myself into action and get shooting as quickly as possible.

It can all be quite tiring, something that can be easily handled on a relatively short trip, say up to about two weeks long. But what about the really long trip? How do you maintain stamina, the energy, even the level of interest needed not only to keep going, but also to keep producing great photographs? It is not easy.

The ideal solution, of course, is to ensure that none of your trips is more than two weeks long and that even then there is sufficient time for rest incorporated into the itinerary. Such a plan is a rarely affordable luxury, however, most itineraries becoming packed to the hilt to make full use of the time available, and all too often extending into four- or six-week trips. I have found that six weeks is my limit, with four weeks a more comfortable maximum. Beyond this time both my enthusiasm and energy levels fall below some critical level, and all I can then think of is going home. Admittedly, this time limit is based on my experiences of travelling over rugged terrain in Third World countries and with no possibility of getting the film processed to judge how the work is going. In gentler conditions perhaps I could last longer.

The most obvious drains on the photographer's stamina include the long working days that are often needed when on location, starting before dawn and finishing after dusk, the sometimes rough terrain and the often less than ideal food. Yet one of the biggest problems is often overlooked and is rarely talked about – loneliness. This can be one of the most damaging problems for the photographer on the road. Location photographers generally expect to spend much of their time working alone, and for most of them this is fine for most of the time: photographers tend to be individualists rather than team people. But anyone can have too much of a good thing, and working alone for weeks at a time can be quite a drain, especially if overseas.

It is important to combat loneliness as it can quickly sap your energy and the will to work hard, thus having a dramatic effect on the quality of the photography produced. Obviously anybody providing help along the way can be a very valuable source of companionship, especially if you are able to spend an extended period with someone with whom you have a lot in common. All too often, however, acquaintances last just one or two days, especially if the project you are working

Figure 37 The silt-laden Kanas River, pouring down from Youyi Glacier, snakes its way through primary coniferous forest; Kanas Lake Nature Reserve, Xinjiang, China. In one of the remotest regions of China, up against the borders with Russia, Mongolia and Kazakhstan, the river's snaking motion, cutting a path through dense forest, somehow catches the mood of the wildness and remoteness of the location.

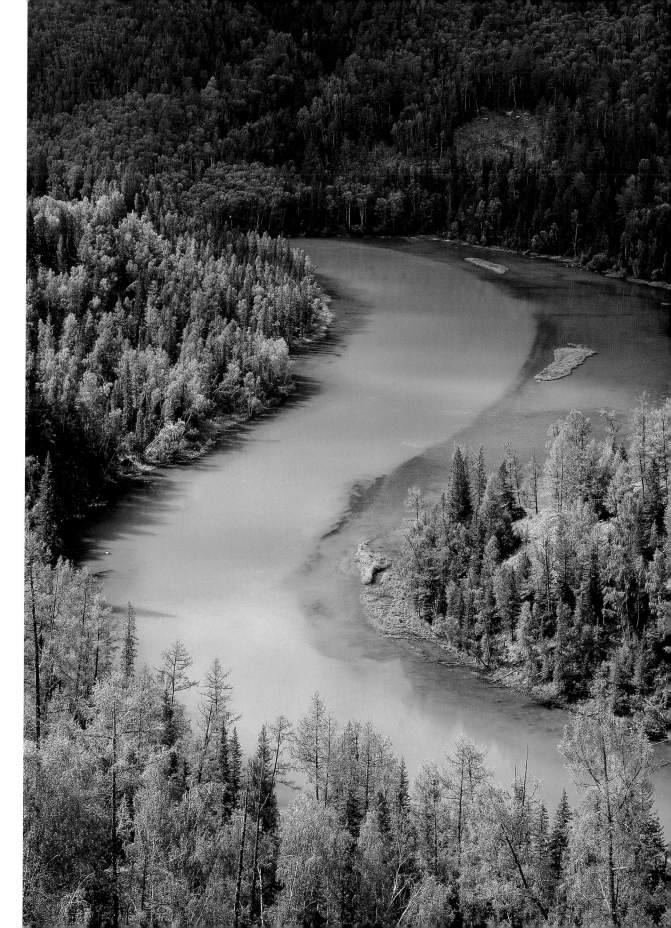

on has a wide-ranging brief, requiring you to shoot in a large number of locations but not in any great depth. You will have to keep moving from place to place, perhaps meeting many different people, but never for very long. This in itself can be tiring – at least I find it so, as I get fed up of having the same introductory conversation over and over again.

I suspect that for the married photographer this problem of loneliness may be worse than it is for one who is still single; the former ever conscious of the family back home waiting for his or her return. There is often the problem of not being sure whether all is well at home, leading to an unease that can be stressful. One experience I had was highly instructive about this. I was in a remote city on the edge of the Tibetan Plateau in China, just about to start travelling up into the wilds of the plateau. After numerous unsuccessful and increasingly worrying attempts to phone home, I eventually managed to glean from a series of calls made to friends that my two-year-old son had been hospitalized with suspected meningitis. I was overwhelmed by a wave of guilt and panic that had me hating my life on the road. Somehow, despite that Chinese city's inadequate phone system I eventually managed to reach my wife, the hospital and my sister-in-law, discovering in the process that the crisis was already three days old, and that everything was fine. My son had just cricked his neck. I continued my journey but with a guilt-laden conscience.

Even for a young unattached photographer, however, for whom a period on the road may be a welcome challenge and adventure away from the confines of the home base, loneliness is still an issue if working on a project to a deadline; he or she will still have to keep moving in order to meet that deadline, unable to rest up for a few days to enjoy the companionship of people met along the way. He or she will still need to cope with the solitary life.

How can these problems of exhaustion, loneliness and perhaps guilt be overcome in order to optimize the photographer's ability to concentrate on the photography during any trip? As already mentioned, one obvious choice is to strictly limit the length of each trip. A second is to ensure that you rest as much as the itinerary will allow; do not go on late night drinking binges and expect to be able to get up before dawn the next day. Do not neglect to eat properly, something that can be a problem when constantly on the move. Maintain your health at all times – part of this of course is getting enough rest and eating properly. Take every opportunity to accept companionship, although only so long as it supports and does not interfere with your ability to work. Even with a tight itinerary, be sure to have a bit of time off now and then to relax; some light entertainment will help to keep your batteries charged up and the enthusiasm running. Stay in touch with your home base as much as possible, and be prepared to abandon your trip if problems at home need your urgent attention.

Another major reason to limit the amount of time spent away is the simple fact that as you are now running a business you should aim to remain contactable by as many clients, actual or potential, as possible for as much of the time as possible. Spending long periods on the road may be productive for certain aspects of your work, but if you are a one-

person operation it will be detrimental to the overall wellbeing of your business. Many contacts, especially new ones, but even well-established ones too, may simply give up trying to contact you, and any work that they may have been inclined to send your way will go elsewhere. For this reason, if for no other, it is as well to keep the longer trips away from home to a minimum, opting as much as possible for shorter, more manageable absences.

The advent of the mobile phone has greatly eased this problem, even for photographers working overseas or in generally remote areas within their own country, but there are still plenty of situations for which there is no substitute for having someone at the home base. For a photographer making frequent and/or long trips it is worth seriously considering employing someone to do this. For a married photographer the obvious choice is the spouse, who can be made a partner in the business, but if this is not possible it may be worth employing someone, even if only part time.

Summary

Travel is an important part of many natural history photographers' lives, so it is important to know how to plan and execute trips efficiently. For the time spent on the road to be well used each trip must be well planned, starting with a complete understanding of each trip's goals. For each project work out how many trips will be needed to complete the photography, and for each trip be clear on how many projects

Figure 38 Tropical lowland rainforest in Bukit Timah Nature Reserve, Singapore. This photograph illustrates two points: firstly, that even close to major cities there can be some very beautiful wild habitats, sometimes making it unnecessary to penetrate deep into remote areas. Secondly, a very high sun can give a better illumination of a forest than a low one, due to its greater ability to penetrate right to the forest floor (even in a rainforest), leaving smaller shadow areas.

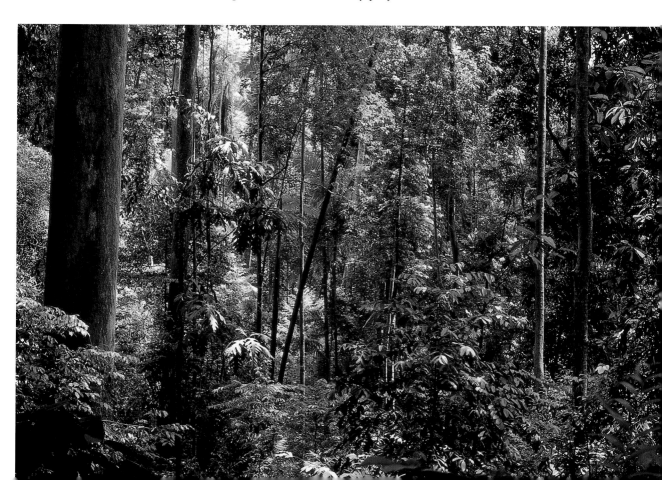

you will be able to work on simultaneously. Optimize the use of time but do not try to do too much: keep the goals clear in your mind.

Ensure that each trip is made at the right time of year. Try to arrange well in advance whatever help you may need, including – if there is no one paying your travel expenses – some barter deals to reduce costs. Make sure all your equipment is functioning, and be fully familiar with any new pieces well before undertaking any trips.

If flying, be sure to carry all your film on to the aeroplane, but do not be shy about having it X-rayed. Most of your camera gear will have to be checked in: pack it in a sturdy, purpose-made case. A tripod can usually be carried on to the aeroplane, but for convenience try to pack it into your luggage.

If using public transport once on the ground, keep an eye on your equipment at all times, but do not be too paranoid. When it is time to do some hiking do not overburden yourself; take only what you really need for that part of the job. Use volunteers to help carry equipment, or hire porters if necessary. When roaming around looking for subjects to photograph, carry your camera gear so that it can be reached quickly and easily to allow for rapid lens, filter and film changes. However, protect your back by carrying your equipment in a well-balanced way – do not use a shoulder bag. Always take a tripod.

Try to prevent your trips becoming too long in order to avoid such problems as exhaustion and loneliness. Try to pace yourself; get plenty of rest and accept offers of companionship (although only provided they do not hinder your work). Look after your health at all times. Stay in touch with your home base, and if you are travelling a great deal recruit your spouse or consider employing someone to look after the office side of the job. Clients will not remain long with a photographer who always seems to be away.

7 MANAGING THE OFFICE

The reality of being a professional photographer is that you have to run it as a business, meaning that you need to manage some kind of office. That of course means handling correspondence, issuing invoices, paying bills, controlling the flow of photographs in and out of the office, and generally just trying to keep a track of everything that is going on. At the start of a career, many a photographer might be tempted to dismiss this aspect of the work as unimportant relative to the photography itself, yet its role is crucial to your ability to make a living. The art comes in managing the office effectively without it completely taking over, gobbling up all the time that ought to be devoted to taking photographs.

Management from day one

The first step in setting up an office is to decide where it is going to be. As outlined earlier, you need to weigh up the pros and cons of being based at home versus renting or buying office space elsewhere. The decision you make will depend very much on such questions as space, cost and whether you will be employing staff. There will also be important personal priorities, such as your own assessment of the kind of environment you need in which to concentrate, how you feel about commuting and how close you want your workplace to be to your family. Another important consideration will be whether or not you need space for a studio and/or darkroom. If you do, assuming you would want to keep office, studio and darkroom together, unless you have a large house you will probably need to rent or buy space.

Next, you will need to equip it properly. Equipment will be looked at in detail in Chapter 8, but as the basics of any office you will want to install desks, chairs, shelves, filing cabinet, telephone, fax machine and a computer. Do not be tempted into kidding yourself that you can do with anything less – not for very long anyway. A fax machine is a fundamental need, and a computer, usually equipped with a modem, is equally vital. You will need at least two desks, one for the computer and another for viewing and handling photographs – it is very rare to be able to buy a desk that is big enough to manage both. And then there is storage space, first, for the rapidly growing pile of photographs, for which the filing cabinet is invaluable, secondly, for the accumulating records of correspondence and, finally, for the burgeoning piles of research material, brochures and other documents that

PROFESSIONAL NATURE PHOTOGRAPHY

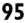

95

seem to gather. Do not be fooled by glowing stories of the paperless office: it is a myth. Indeed, computers, far from doing away with paper have enabled us to create far more of it even faster than ever. Think ahead with your shelving and other storage space, and attempt to keep ahead of the game. You will be amazed at how quickly materials accumulate.

Be sure to store your photographs vertically, as horizontal storage may result in damage to those at the bottom of the pile. Thus slides, for example, are most conveniently stored in plastic sleeves suspended in a filing cabinet. Stored in this way, a large file of pictures can be kept in a relatively small space, safe from dust, light and physical damage.

Once your office is all set up and running, rule number one is keep every scrap of correspondence. Letters, faxes, e-mails; whatever your prospective or real clients send you, or you send them, hang on to. Make sure you set up a workable filing system, with correspondence to and from each client filed, clearly labelled and easily to hand. No message is too small or unimportant to keep. You can be sure that the one time when you forget to keep an e-mail, letter or fax will be the occasion when things go wrong, and that the missing correspondence will be the one document that could clear up any misunderstandings.

With e-mail, there is a culture that believes one does not need a printout of your messages, but remember that if you do not print them out and unless you download every message on to your computer, after a short time you may not be able to access them. Personally, I would advise against storing your correspondence, whatever it is, on the computer. Even a very large hard disk will rapidly get cluttered with copies of multiple messages sent out to, or received from, clients over a long period of time, and it will become very difficult to ensure that everything is efficiently filed. It is far easier to store letters, faxes and e-mails as hard copies, cluttering up your shelves and/or filing cabinet instead of the computer's hard disk. Of course, you cannot be expected to keep all your correspondence forever: I keep mine for about three years if associated with average projects, much longer only for big projects that go on for a couple of years.

In comparing the pros and cons of faxes with e-mails, inevitably e-mail is much cheaper to use, especially if working internationally, even given the fact that – unlike with a fax machine – you have to pay simply to see if you have any mail. On the other hand, despite what computer maniacs might say, e-mail messages rarely get to their intended recipients any faster than faxes. In fact they often take longer since few people bother to check their e-mail more than twice a day, whereas a fax will land on the recipient's desk immediately. Furthermore, if a fax transmission goes wrong you will know about it right away and will be able to resend your message. With e-mail, you will not find out at least until the next time you check your own e-mail box, and sometimes not until a day or two later. Occasionally, you will not find out at all. Although there is supposed to be an automatic feedback system that will tell you if an e-mail message fails to get through for some reason, on several occasions I have had messages simply disappear, never reaching their target and no warning of a failure coming back to me. This once resulted in an embarrassing incident, with me accusing a client of not

responding to my urgent messages, and the client accusing me of not keeping them informed.

E-mail is definitely here to stay and, indeed, it is rapidly taking over from faxes. It is easy to use, convenient and cheap. But it is not foolproof, so do not place a blind faith in the technology.

Keeping track

Life would be simple if we could make a living by working on just one project at a time. Sadly, this is not the case, and it is inevitable that you will have to handle many projects simultaneously if you are to have any hope of bringing in a sufficient income. At any given moment in time each ongoing project will be at a different stage, some requiring large amounts of your time, others at a point where they tick along with only a little helping hand, and yet others being more or less dormant. Some will be just starting, some will be in full flow, and others being finished off. A couple of projects may be temporarily out of your hands, awaiting someone else's contribution, or they may be fully your responsibility, with success or failure utterly down to you. The clients being supplied may be big companies or an individual, based just down the road or on the other side of the world, and they will all have different wants, needs, opinions and agendas. It is unlikely that you will be able to juggle all this in your head, not for very long anyway, which is why you need to have an efficiently run office.

Hanging on to all your correspondence is obviously a good first step to ensuring that you can keep track of every project, but even this may not be enough. For example, if you are supplying file pictures to publishers, photographs will be frequently going to and fro between yourself and clients, the latter often returning only part of each submission, hanging on to the few they are likely to want to use, often for quite a time. Some will probably get used, but then again they may not. For those that are used, a fee must be agreed, the invoice issued and a track kept of when, and indeed if, payment is made. If doing this simultaneously with, say twenty publishers, things can be very confusing. I have found it necessary to set up a tabulated record of each and every project, which lists all the relevant details; requirements, deadlines and all the various stages arranged on a grid, which get ticked off or filled in as the project progresses. Assuming I do actually manage to keep this table up to date – never an automatic given – I then have a simple at-a-glance record of every project, right down to whether or not I have been paid.

So what exactly are all the various steps involved in your various projects that will require your presence at a desk for long hours? From the very beginning there is the issue of marketing; preparing your advertising, researching and writing proposals to go out to magazines, book publishers or other prospective clients, promotional work that will be needed at least from time to time throughout your career. Then there is the organization of your photo file: make sure it is workable and enables you to lay your hands on any needed photograph quickly and easily. Setting this up and keeping it running smoothly can in itself be a gargantuan task. Editing and filing newly taken photographs is a never-ending process, and in addition there are the frequent selections

Figure 39 An ornate soft tree coral, growing on rocks at a depth of about 15 metres in El Nido, Philippines. These soft coralline structures are the most exquisite of natural sculptures that come in a variety of colours. The absence of familiar landmarks makes it difficult to judge scale and thus hard to realize that this subject is only a few centimetres tall.

of file photos to go out to clients. Getting together the right set of pictures (whatever they may be), captioning them and making a list of exactly what is going out, and to whom, can be a remarkably time-consuming process. Even logging-in photographs that have been returned from clients and then refiling them can take more time than one would expect.

Then there is all the work that may go into planning a new project or preparing for the next trip: contacting people who might be able to help or who can supply information, getting access permissions, securing tickets, accommodation, discount or barter deals, film, equipment and insurance. All these jobs require phone calls, letters, faxes and e-mails to be written and answered, often several times over before everything is arranged. Do not forget the desk work required to keep a project going or finishing it off: keeping the client informed of what is happening, replying to their queries, submitting the finished work, preparing invoices and, all too often, chasing for payment.

There can be a lot going on all at the same time, and to ensure that you do not sink in a sea of confusion, it is important to maintain an effi-

PROFESSIONAL NATURE PHOTOGRAPHY

cient office filing and tracking system, and to keep on top of all the records and desk jobs associated with each project.

Copyright

Copyright is one of the most important issues for any photographer attempting to market his or her work and ensuring that he or she is paid for its use. Copyright laws around the world almost universally agree that the photographer owns the copyright for any and all photographs he or she takes, and that the only way he or she can give up the copyright on any photograph is by a written, signed agreement.

Keeping control of your photographs is important to ensure a long-term income, as the best of a photographer's pictures can go on earning royalties for many years. Yet, it is extremely easy for your pictures, especially if they have been published widely or are on the Internet, to be scanned or downloaded and reused without you ever knowing about it. For any photographer that cares about this kind of abuse of their work, it is important to try to keep monitoring the media, but the more widely disseminated your work the more impossible this becomes. In this sense it helps to be selling the rights to your photographs through a photo library, as they will have greater resources to watch what is going on, and greater influence to take on those who do breach your copyright.

You are always welcome to sell your copyright to any photograph, but you would not be doing yourself any favours if you settled for a price that did not take into account the loss of any earnings potential. More usually, you should opt to license the rights to your photographs, allowing for single or multiple use rights, for a given period over a certain geographical region – nationally, continentwide or globally, for example.

While in writing the above I have thought mainly about licensing the use of file photographs, essentially the same still applies to photographs taken on a commissioned project. Although some clients may think otherwise, and try to claim as much, the photographer still owns the copyright for all the photographs he or she takes. In drawing up a contract for the commission you may grant the client all kinds of rights, such as first use or the right to retain images indefinitely for their own use, but the fact remains that you still own the copyright and can do anything you like with the pictures. If it is intended that you will let your client retain a set of photographs indefinitely, be sure to shoot in-camera duplicates so that you will have a complete set for subsequent marketing of the shots as file pictures.

Of course, it is easy to say that you own the copyright and no one can force you to give it up, but if a client insists that you sign over copyright or not work for them, then you may be in a dilemma, especially in the early days of your career when every job counts. My advice is – as outlined earlier – to refuse to hand over copyright, no matter what this may mean for each individual job. If you do it once, it will be expected of you again and again, and you will never be able to market your own photographs to make a reasonable living from royalties built up from your own hard work. Instead these royalties will go to someone else. This may well make for some short-term difficulties in terms of main-

taining an income, but it will ensure that when you do get work it will be with clients that respect your ownership of your own work, and will enhance your long-term prospects.

Your legal status

When you first set out on the road to becoming a professional photographer you may think of yourself as just an individual with a camera, and not as a business entity at all. However, depending on the country in which you live you may be faced with legal requirements stipulating you give yourself some kind of business status as quickly as possible. You will have a choice of possible structures, the exact form of which will vary from country to country, though as a rough outline these will be:

- sole proprietorship
- partnership
- limited company.

Most photographers will go for the first on this list as it is the simplest to establish, has the fewest legal requirements and quite simply is the most appropriate format for someone working alone. However, a partnership may be appropriate for photographers intending to work on an equal basis with their spouse or perhaps with another photographer. The one drawback with these two setups is that there is no limited liability: if you incur heavy debts and then go bankrupt you could lose absolutely everything trying to pay off your creditors. If you are concerned that this could happen in the work you will be doing, a limited company may be the answer. There are far more stringent rules to the setting up of a limited company, such as auditing of accounts, the payment of salaries etc., which may be too daunting and unnecessary for a one-person photographic operation, especially in the early days, but it does have the benefit of a limited liability for the company's debts.

Assuming that you will be setting yourself up in either a sole proprietorship or a partnership, the steps you will need to take are very simple. In some countries you will need to formally register with a government body, buying a certificate before business can legally commence. In others all that is required is to let the income tax department know of your new venture, something that may be done for you if using an accountant. In the latter situation, the only time that you may become aware of any legal constraints in the early days is when you come to set up a business bank account, something that is outlined below.

Keeping the money under control

Anyone entering professional photography should be aware that they are getting themselves into what, for a one-person operation, must be one of the most expensive self-employed occupations around. Camera and ancillary equipment, film purchase and processing, repairs, insurance and travel all cost an arm and a leg, rendering the whole business a bottomless pit of expenses.

Admittedly, when setting up you can usually manage with a certain basic minimum of equipment, but as you become either more

specialist and hence need ever more specialized equipment, or broaden your approach and skills and so need a broader range of equipment, a much heavier investment will be needed. As for film, you will need plenty of this from day one, and of course in the early days when building up your portfolio and file, you are much less likely to have clients picking up the bill than might be possible later. The threat of spiralling film costs can, however, enforce a good discipline, ensuring that you make quite certain that composition, exposure and focusing are exactly right before the shutter is pressed.

The bank account

One of the earliest steps in starting any business is to set up a bank account. Initially, it may be tempting to keep going just with a personal account, but as already outlined you may be under legal obligations to establish yourself more formally. Unless you are setting up a limited company the process is just as straightforward as setting up a personal account, although with a few restrictions on the way the account is used, and – in the UK at least – giving the bank the right to charge you for just about everything imaginable. Once the business account is set up, you must get into the habit of using that account only for business expenses, personal expenses coming out of your private account. The latter can be supported by occasionally transferring money from the business account.

Figure 40 In low, early morning light, the greens in this forest vegetation of tree fern and wild yams, taken in the mountains of Taiwan, have been intensified with the help of a polarizer and 81A filter.

Figure 41 On a steep east-facing slope the glow of sunrise is able to penetrate the canopy of this broadleaved forest in early summer, giving a warm glow to both leaf and trunk. Photographed in Chichibu-Tama National Park, on the edge of Tokyo, Japan.

Keeping accounts

Be sure to keep up-to-date records of all your accounts, both business expenses and income. Back up everything – or at least as much as possible – with receipts, stored safely for each year's tax accounting. Divide the expense lists and the receipts up into several sections, such as:

- books and magazines
- consumables
- utilities (except telephone)
- entertainment
- equipment purchase, repair and hiring
- film purchase and processing
- insurance
- local/national travel (subdivided into car maintenance, fuel, accommodation, subsistence etc.)
- overseas travel
- postage and courier services
- stationery and printing
- subscriptions and fees
- telephone, fax and Internet services.

This list is given simply as an example; you or any accountant employed might think of a system of division more appropriate for your personal needs, but this does at least give you an idea of how to get started. Listing can be done on a computer, using a database, a spreadsheet or a specially designed accounting software, or manually in a standard book-keeping ledger.

Business advice and borrowing money

One service that banks often offer to business account holders is free business advice, via both frequent newsletters and personal consultations. Such consultations are likely to be aimed at finding ways to make the most of your limited resources, as well as how to make a business plan that will predict the growth of your business and so identify how to borrow money with the least pain and make sure it is used to the greatest benefit. In some countries similar services are run by local government business development bureaus, though with their main aim being the creation of as many jobs as possible, they may not be so interested in someone intent on working alone and from home.

I am a believer in avoiding debt if at all possible, so I would say that if you can set up your business without having to borrow money, so much the better. However, if you have extensive equipment needs it may be better to borrow money in order to get yourself properly equipped and running efficiently. The alternative could be struggling by with no debt but unable to offer an adequate range of photographic services due to a dearth of the right equipment. Before borrowing money you will probably need to work out a business plan, a scheme, as already mentioned, that predicts the growth of your business and the likely flow of cash in and out of it in the coming few years. This may seem an awfully big diversion of energy away from photography, as well as a rather arbitrary and artificial exercise, but help may be available

Figure 42 Sunset over the estuary of the River Teign, Devon, UK. One does not need to travel halfway round the world to discover some glorious landscapes. Almost literally at the bottom of my road lies this estuary, yet getting the right combination of low tide, calm weather and a sun setting in just the right position on the horizon took several months of waiting.

from local government business development bureaus and certainly from the banks themselves. Depending on the amount to be borrowed few banks are likely to lend money to a business without such a plan.

Clearly, the amount you feel able to borrow will depend to a large extent on the current interest rates and the length of time over which you will be allowed to pay back the money.

You might well be able to greatly limit your debt by checking around the major equipment suppliers before going to a bank for help. In the UK for example, many suppliers offer very attractive finance deals to soften the blow of a major purchase, allowing payments to be spread over a year or more, with either very low or even zero interest rates. It may also be possible to lease the equipment, either from the dealer or, if they are unwilling, from a leasing company. The latter will buy the equipment on your behalf and then lease it to you for a number of years. At the end of the leasing period you can either return the equipment to the leasing company or pay a final sum that gives you possession of the equipment indefinitely. Such deals, if available, are obviously much more attractive than borrowing money from a bank at the standard interest rates.

Cash flow: paying bills and getting paid
Borrowing and spending money is, of course, tied up with the knotty problem of cash flow; ensuring that money comes in regularly and at a sufficient speed to allow all the bills to be paid. A poor cash flow rather than simply insufficient business is said to be the biggest killer of small

businesses. As a one-person operation you are at the bottom of the pile in terms of priority and clout. On the one hand, clients may be tempted to put off paying you – in order to protect their own cash flow – while on the other it will be very hard for you to delay paying most of your creditors. Be sure to run a tight ship, for example in consumables expenses, limiting your stockpiles of such items as film, fax paper, printer cartridges and (if you run a darkroom) processing materials, foregoing the benefits of discounts on bulk purchases in order to restrict the immediate outflow of cash. Try to build up a cushion of money in the bank account that can absorb periods of negative cash flow without causing too much stress, either to the bank balance or yourself! This could be achieved with money borrowed from the bank, but remember this would be only a temporary solution and one that would also cost you more money.

It may be necessary to delay payment of some of your bills occasionally, but do not make a habit of it. Remember you do not have too much clout and suppliers will drop you if you are constantly in debt to them. Conversely, you must do everything in your power to ensure that clients pay you on time. One client who can be relied on to pay on time is worth two that are unpredictable but always late. The former needs to be nurtured, coddled and held on to for job after job if possible. The latter should be chased remorselessly. You may feel you still need the business even of habitually late payers, and so are reluctant to tread too heavily, but a series of polite but insistent reminders are definitely not out of order in securing payment. Very often the person that you have been dealing with at the client company, such as an editor, is not the one responsible for the delay in payment, and they may well fully support your case. The problem will almost certainly lie with the accounts section, whose staff often specialize in payment avoidance. Do not take out your frustration at not being paid on your contact person – he or she may well be the one to commission you for the next job – but recruit their sympathies to persuade them to lean on the accountants. They may be as irate at their own accountants as you are, because after all having to chase them adds to their work burden and is a waste of energy that should be going into productive work.

If all else fails do not be afraid to take legal measures. For most of the work that you will be doing the amounts of money owed will be covered by the small claims courts, a system that is easy and cheap to use, avoiding the cost of a full legal battle. If, after waging a war of frequent reminders, you have still not been paid, start the process of legal action by formally announcing that if payment is not made by such and such a date you will commence legal proceedings. This will often be sufficient to persuade the client to part with payment, but if they decide to call your bluff you must decide to either proceed or write the debt off. You may feel reluctant to take a client to court because obviously you can wave goodbye to any chance of working with them again. But do you really want to work with someone who refuses to pay for work done? The initiation of proceedings is usually a simple matter of filling in and submitting to the court a couple of forms and then awaiting developments. The courts will notify your client, who may then pay up if they do not wish to contest the issue. If they do contest, a date will be

set for a hearing, something which you had better attend if you want to have any chance of winning. At the hearing both sides will be able to put their case and a decision will be made on the spot. If you lose, you will of course not get your bill paid and you will lose the relatively small fee you had to pay for the proceedings. You may also have to pay your client's costs. If you win, not only will your client have to pay the bill, but also your costs and often interest, an amount set by the court.

Taking on staff

Right at the outset of a photographic career it is unlikely that you will want to consider employing anyone. After all, you may have a hard enough time bringing in a sufficient income to support yourself let alone an additional person. However, as time goes by and the work accumulates you may start to wonder if it might not be such a bad idea. After all, taking on help could free you from the administrative work to get on with what you are supposed to be doing – creative photography.

The most likely role for the first person you might want to take on is running the office. Needless to say, recruiting the right person will be crucial to the success of the employment venture. Not only should they be interested in the media in general, and photography in particular, but they should also understand the need for the office side of the business, and have the ability and interest to handle that aspect of things. For married photographers, their spouse is the obvious first choice if at all possible, and indeed there are many successful husband and wife teams. If this is not an option it will be necessary to go through the search and interview process to find that right person.

If you are working from home, employing your spouse has one very significant benefit; you will not have to put up with someone who initially is probably a stranger and who may never actually become a friend, coming into your home every day. If you do take on staff from outside your family, you may well want to consider setting up office space outside the home, an added major expense and change in lifestyle for a photographer used to working from home. A spouse will also presumably be as committed as you are to making the business succeed and should already be reasonably familiar with the way things are run at the time they start. A photographer who has been working as a sole proprietor and who then employs his or her spouse, may want to consider whether it is better to change status and become a partnership or maintain the status quo, listing his or her spouse simply as a member of staff.

Of course, anyone else you employ will be completely new to your business, and perhaps to photography altogether, so initially there will be a training period in which the new person could actually be a drain on your resources and time. Make sure that your business calendar and your bank account can handle this likely difficult early period. Assuming you have recruited the right person and that they are able and allowed to work in the best way to push your work along, within a couple of months they ought to be improving your business's efficiency and productivity to the point that they more than pay for themselves, provided of course that there is sufficient additional business actually available for the taking.

In addition to the inevitable uncertainty as to whether or not

employing someone will pay off in terms of enabling more work to be done and new business generated, there are a number of other discouragements to making the employment leap. These discouragements come mainly in the form of bureaucracy. The laws concerning employment of staff vary enormously from country to country, but there will certainly be a great deal of paperwork involved, mostly concerning more taxes, insurance payments and so on. It all adds up to an increase in the office work that needs to be done – the very thing that you are probably trying to reduce. Couple this with possible labour laws that may restrict your movements, such as in instances where it is necessary to sack your staff, and it is quite possible that you will feel the added problems and responsibilities to be too much of a headache to take on.

Where the balance between the advantages and problems of employing people lies will depend very much on your assessment of such factors as:

- how much you hate office work and to what degree you feel it is dragging down your ability to get on with photography
- how much additional work you perceive is available if only you had time to chase it
- the general state of the economy
- whether you think you can recruit a competent and experienced person
- what level of salary you will need to pay
- how much employing someone will affect your office setup, especially if you work from home
- the level of bureaucracy involved in recruiting people.

Even after weighing up these factors, a final decision on whether or not to employ may come down to your own personal feelings about such subjective matters as the way in which you want to work, how much you want your business to expand and how big a risk you are prepared to take.

Insurance

Insurance is understandably often seen as just another means for financial companies to extract money from hard-working people. Yet, any photographer would be mad to avoid insuring at least their equipment. Even with all the care in the world, accidents and burglary are a fact of life and your business could be decimated by the loss of a large amount of expensive, uninsured camera equipment. So make sure it is insured from day one for its full value and that cover is kept up to date.

If working from home, in some countries it is possible to have your equipment insured as part of a home contents policy, though if you attempt to go this route be sure that the policy will cover the high value that a professional photographer's equipment is likely to reach, and that business use is included.

It is usually better to arrange a specialized insurance policy geared specifically to professional photography, and available through brokers who specialize in this area. These brokers advertise regularly in the photographic media and so are not difficult to track down. Their poli-

cies will cover all your equipment, along with options for national, regional or worldwide cover for all or parts of your equipment. There will also be options to cover such likelihoods as costs incurred if you have to reshoot a job, film lost in transit, the value of any photo file you may hold, other people's property held in trust by you, office equipment, staff injuries and professional third party liability. Such policies do not come cheap, it has to be said, but they do cover all a photographer's likely problems, so they are a very convenient catch-all package.

When setting up a policy be sure to declare absolutely every relevant detail, and then carefully check the policy to make sure everything is correct and reasonably watertight. If you do one day need to make a claim, you may find that the insurance company will try every tactic to avoid paying, or to reduce the bill, so anything you can do at the outset to minimize their opportunities to do so could be well rewarded. An expensive insurance policy that is so riddled with 'get out clauses' that the insurer can wriggle out of just about any claim is of no use to any photographer.

'The tax man cometh'

Wherever you live, one day the Inland Revenue (or its equivalent overseas) will catch up with you. At times there seem to be so many taxes to pay it becomes a wonder that anyone can make a living, yet somehow most people get by, often rather well. It is only right, of course, that we should pay our fair share towards having good roads, schools, healthcare, and so on, but still it hurts to see the government take away chunks of cash which you had to fight so hard to earn.

In terms of income tax, as a self-employed person it is unlikely that you will be part of any pay-as-you-earn scheme, so you will need to make an annual tax return and then pay your tax bill as a lump sum. This can be particularly painful, not to say dangerous if you have not been saving up in the preceding months. It could be positively disastrous to be presented with an income tax bill that you cannot possibly pay. That cushion of money in the bank that I mentioned earlier could be become a vital protector of your cash flow when the income tax bill becomes due. So be prepared for the annual need to pay income tax; set up a separate bank account if necessary in which you can save for that day.

If working as a sole proprietor it may not be essential to take on an accountant, in which case you can save on their fee and fill in your own tax returns, making your own assessment of profit, loss and tax due. However, a good accountant is usually a very worthwhile investment for at least three reasons:

1 Tax returns can be daunting documents to work your way through and it can be a bonus to have someone else do it, keeping at least this piece of bureaucracy at arm's length.

Figure 43 Pearl Shoals Waterfall, Jiuzhaigou Nature Reserve, Sichuan province, China. One of the greatest attractions in this stunning corner of China, this image only catches a tiny portion of the 100 metre-wide waterfall, but it still succeeds in encapsulating its drama and beauty.

Figure 44 The Emei liocichla is a kind of thrush unique to Mt Emei, a holy mountain in China's southwestern Sichuan province. A side-on shot like this is not always the most dramatic kind of image, and it will not win any photographic competitions. However, its importance lies in its usefulness in a species identification key, which is exactly the use for which this picture was taken.

2 Your accountant will prepare complete annual accounts reports for you, all laid out in the format and couched in the language that only they seem to understand and yet which seem so important to financial matters. If and when you find yourself needing to borrow money, not just for the business but also for such private steps as buying your own home, your potential lender will almost certainly want to see these audited accounts to assess the health of your business and hence your ability to repay a loan.

3 Income tax laws in the Western world are for the most part very complicated, and only an experienced accountant will have any hope of really understanding what is required. They will know exactly what you can and cannot claim for as expenses, the best ways to handle your business's financial year relative to the tax year (which may not be the same) in order to minimize or at least delay your tax payments, and any possible tax breaks that may be available for new businesses. Much of this involves knowledge that you are not likely to be familiar with, meaning that were you to fill in your own returns you could very well miss opportunities to quite legally reduce your tax bill.

Of course, there is a danger that the money an accountant might be able

to save you in tax will be more than lost in their fee. Accountants do not come cheap, so be prepared to shop around, but be warned that the cheapest may not be the one able to get you the best tax deal.

Photographers working internationally should be especially vigilant in ensuring that their accountant remembers to allow for tax you may pay on money earned in other countries. If you are selling through photo libraries overseas, for example, royalties earned may be taxed at source in that country. In that case, you may find that country has a double taxation agreement with yours, such that tax paid overseas can be offset against your income tax liability at home. Be sure to get an annual tax statement from your client in that country, which can then be passed to your accountant for inclusion in your audited accounts and your income tax return.

Value Added Tax

Photographers working in countries where Value Added Tax (VAT) is applied will need to consider whether or not to register. Value Added Tax is a tax added on to the price of almost all goods and services sold within that country, whether retail or wholesale, and registration is compulsory for businesses earning more than a certain minimum. In the early days of your business you will almost certainly come nowhere near this minimum threshold, so there will be no need to become involved with this tax. However, in certain circumstances you may still wish to register.

If you register for VAT you will have to charge all clients that are based in your country VAT in addition to the agreed fee, and then pass it on to the government's VAT agency. Conversely, you can reclaim the VAT you have to pay on all your costs. Your clients, for example, provided they are registered for VAT, will be able to reclaim the VAT they pay you. If the VAT you have paid on purchases is greater than the VAT brought in on your earnings, the government's VAT agency ends up paying you.

If the majority of your clients are based in your own country it is likely that the balance will be in favour of the government and that you will have to hand over the net excess of incoming VAT over outgoing VAT every three months or so. In this situation, if your income is below the compulsory threshold for VAT registration, it is probably not in your interests to register. However, if most of your clients are overseas you will not have to charge them VAT. In this case, the VAT you have had to spend on purchases in your home country may well be considerably greater than VAT brought in with your fees, and if registered you will be able to reclaim it.

If all this sounds like a horribly complex money-go-round, with tax payments simply circulating between companies and government, you are not far wrong. Presumably, governments do make a profit from it, otherwise one supposes that they would not persist with the system, but with it continually becoming more and more complex as to what is and is not taxable and claimable, I cannot help wondering whether it is just a ploy to maximize civil servant employment. Still, for a small operation such as a photographer, it is not as difficult a system to operate as it may at first appear.

Figure 45 Tsaihung Waterfall, Yushan National Park, Taiwan. As with previous pictures of waterfalls, the drama of this tall ribbon of cascading water was best caught by concentrating simply on the bottom, and once again the diagonal rocks help instill a dynamic feeling. For some observers the blue cast, caused by the waterfall being in shadow on an otherwise sunny morning, would be a major flaw in this image, but for me it enhances the coldness of the water.

A photographer working extensively for overseas clients can benefit financially from VAT registration. There are also two hidden and rather intangible benefits that may make it worthwhile even for someone working largely within their own country to register. First, with VAT registration comes an absolute necessity – and indeed a legal requirement – to keep your accounts up to date: it would simply be impossible to fill in your regular VAT return if you did not. Thus, there is no excuse for laziness in keeping a close record of all your expenses and income, and hence no danger of you being faced at the end of the financial year with a huge chaotic pile of receipts and no records of what went on throughout the year. Everything should be neatly arranged, all income, expenses and VAT listed, ready for an accountant to plough through to work out your income tax liability.

Secondly, in the battle to impress clients VAT registration is a good ploy. It gives the impression of a serious, efficient and successful business, one that is making a steady and reasonable income, which by implication is above the compulsory registration threshold. It makes you look truly professional.

Summary

Being a professional photographer means running yourself as a business, and that means having some kind of office. This is the centre of operations, where photos and equipment are stored, records kept and correspondence handled, and is where clients can reach you. In setting up your business think where you want your office to be – at home or an outside office space – and set it up and get it running as quickly as possible.

Keep all your correspondence and store it as hard copies. This material will be a great help in keeping a track of what is going on. You will need to have a number of projects on the go simultaneously and there is no way you can hold it all in your head, so keep accurate records of the progress of each project. The general management of your business can take up far more time than expected; try to ensure that things are run efficiently but without the management side taking over.

You own the copyright to all photographs you take, including those taken during a paid commission. You cannot surrender your copyright verbally, but only via a written, signed agreement. Avoid handing over your copyright for any pictures since these will be important in earning royalties for you in years to come. Resist pressure to hand over copyright, even if it means losing a few jobs.

In starting your business you will need to establish yourself as a legal entity, most usually as a sole proprietor. This affects your income tax status, the kind of bank account you will need to set up, and your legal liabilities should the business go bankrupt. Once established, be sure to keep accurate records of all your expenses and income.

You may need to borrow money in order to properly equip yourself, and to do this you may need to create a business plan to present to potential lenders. To reduce the size of the loan, first check to see if equipment suppliers are offering finance deals that spread payments with low or zero interest rates. Make sure that you are properly insured right from the outset of your business.

**MANAGING
THE OFFICE**

Photography is an expensive business and you will need to be careful about your cash flow. Try to ensure that clients pay on time, and chase those that fail to do so. Tread politely if you wish to work with the same client again, but all the same be determined to obtain payment. If all else fails take the company to court.

As your workload grows you may feel the need to employ help, especially in the office. Anyone you employ should enable more work to be successfully taken on quickly, thereby more than paying for their expense. Obviously, this is of great benefit to you, but there are a number of considerations that may make the decision to employ a difficult one.

Eventually you will have to pay income tax. It may be of great help to have an accountant, who will understand all the ways to reduce your tax bill and who can present your accounts in a professional way. If you live in a country which has VAT, think about whether to register and whether it will be beneficial either financially or in terms of your business's image.

8 EQUIPPING YOUR BUSINESS

It may seem a rather obvious thing to say that getting together the right equipment for the job you intend to do is one of the essential prerequisites for launching into a career as a professional photographer. Yet in my own experience one never seems to have all the right equipment: there are always at least a few more gadgets you feel would make your work that bit easier or more successful. The process of accumulating equipment seems to be never-ending.

However, at the outset of a career it is definitely better to avoid being tempted by the advertising literature into buying every little gizmo that might just be handy, and concentrate on the fundamentals. For one thing many little bits and pieces that look so enticing in the brochures or on the shop shelves do not live up to their promise when put to the test in rugged conditions. Moreover, always remember that the more bits and pieces you have, the more you will have to carry in the field. Time and again while on the road I have found myself abandoning all but the barest essentials at my base before venturing out, and only on a few occasions have I cursed myself for leaving a gadget behind. Concentrate on the main items to start with, and only pick up handy little gadgets later when experience indicates their likely usefulness.

So perhaps it is rather fortunate that when equipping at the start of a career, financial constraints are likely to be of paramount importance, ensuring that you focus clearly on the most important pieces of equipment. Even, or perhaps especially, if you borrow money to buy all your equipment in one go or over a relatively short period, be sure to keep your mind firmly on the necessities – good lenses, a couple of camera bodies, essential filters, tripod and office equipment. Keep your feet on the ground, use your money wisely and ensure that you can clearly distinguish the absolute essentials, from the useful add-ons, from the extra toys and luxuries.

The following sections will hopefully assist you. One could easily fill an entire book describing all the pieces of equipment that might be useful, but in the spirit of keeping to fundamentals I have concentrated on the most necessary items.

The office

Before looking at cameras it is definitely worthwhile first considering that less glamorous and sometimes rather neglected aspect of the job,

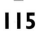

the office. I have gone to some lengths to stress that an efficiently run office is essential to successful work, and this inevitably means having it properly equipped. Desks, chairs, shelving and filing cabinets are all essential and easily available items that form the basis for any office. Before making any purchases draw a rough plan of how each item will fit into the space available, and how they will be used. You will need to have an idea of the likely relative arrangements for work surfaces and storage systems, whether for cameras, research materials, correspondence files, negatives, slides or prints. Be sure that the desks you buy are appropriate for their intended uses, such as for a computer (and all its ancillary pieces) and for examining and working with photographs. Storage shelves and cabinets should be appropriate for the methods of storage you intend to use, and may need some adaptation for your climate. If you are in a warm, humid climate, for example, and the office is not likely to be air-conditioned much of the time, to avoid damage due to fungal growth all camera equipment and photographs (whether negatives, prints or slides) must be stored in airtight containers that also contain some kind of dehumidifier such as silica gel.

Communication with the outside world is absolutely paramount, not just via telephone but also fax and – if you have a computer – modem. The most economical way to run a telephone and fax is to buy a combined fax/phone, perhaps also with a built-in answering machine. This not only saves on hardware but also allows you to work with just one phone line, saving on costs with the telephone company. There is a range of machines on the market, but probably the best kind of product to aim for is a mid-range plain paper fax/phone machine. The plain paper version has the advantage over the older thermal paper machines in that whereas with the latter printouts of incoming messages fade after a few months, printouts with the former are more or less permanent. The same applies, of course, if you use the fax machine for photocopying. Do not buy the cheapest models available as these are often unreliable and not very sturdy. It is definitely worth paying a little more for a machine that will run for several years with little or no maintenance.

A cellular phone is not an essential prerequisite at the start of your business, but it is something that might be well worth considering later on. This may be especially so if your work relies on being able to respond quickly to requests even while away from your office, and indeed for staying in touch with the office, family and clients while working for days or weeks on end in remote locations or overseas. Running a cellular phone can be expensive, however, especially if using it overseas, so when choosing your supplier look carefully at the charges and any special offers available.

A computer is no small investment and you may be tempted to conclude that it is not a necessary purchase at the outset of your business. However, you will certainly need some kind of typewriter from day one if only for writing letters to prospective clients, and since computer-generated correspondence is so completely taken for granted these days, letters produced on a typewriter could give a bad impression. So, my advice is to be sure to get a computer from the beginning, even if your finances allow for only an older secondhand one. This will at least be sufficient to get you started and will quickly prove its worth in terms of

the ease with which letters can be run off, lists created and photograph captions made.

The majority of people opt to buy an IBM-compatible personal computer (PC) rather an Apple Macintosh (Mac) simply due to the vast choice available and because these are what most other people/companies use. They are after all cheaper than the Macs, and if you start exchanging disks, for example if you combine your photography with writing, you might think yourself less likely to have any compatibility problems with the majority of clients. However, it should be borne in mind that Macs still dominate the world of publishing and digital imaging, so as someone involved in this field you are likely to be working with Mac users far more often than people in other fields of business would. If you opt for a PC, you may find some compatibility problems, though these days these have been mostly ironed out, usually allowing disks and digital files to be swapped between the two types of machine.

Whichever kind of machine you opt for, it should be equipped with a modem, allowing you access to the Internet and to communicate with clients via e-mail and, if you have a voice modem, Internet phone. The Internet is a vast resource of research material – provided you know how to find what you are looking for – and e-mail is a fast and very cheap way to communicate with people, even those on the other side of the world. It is an important business tool. While you could run this off the same phone line as you fax/phone, you would not be able to use the

Figure 46 A young rock python in Hong Kong. Snakes are difficult to photograph in their entirety, unless coiled up, so a more satisfactory approach is to create a portrait. A flash shows up the snake's beautiful markings, and puts a nice highlight in its eye, while the tongue flickering as it tastes the air adds an element of action and the snake's individuality.

latter while on-line, so it is often much more convenient to install a second dedicated line just for the modem.

If at the start of your career you buy a cheaper or older computer it is unlikely that it will be able to handle digital imaging. However, since the mid-1990s this field of photography has become extremely important, affecting businesses from the largest advertising firm to the individual photographer, and it is likely that eventually you will need to consider upgrading your computer equipment in order to incorporate this skill into your work. This aspect goes well beyond a consideration simply of office equipment and so will be covered in a later section of this chapter.

Camera equipment

The basics: 35 mm cameras

As outlined at the start of this chapter, obtaining the right camera equipment is a constant struggle of balancing your perceived needs against both cost and the weight and bulk of the gear you will have to carry in the field. My rule of thumb is, be a minimalist – do not over-burden either your kit bag or your bank account with unnecessary equipment. Having said that, your equipment must enable you to shoot subjects as diverse as wide-angle landscapes to telephoto shots of birds or mammals, to macro images of insects, all in a variety of lighting conditions and terrain. It is no small challenge to be able to do this with minimal gear and at a low cost.

Your main workhorse is likely to be a 35 mm single lens reflex camera. Intense competition for the consumer market has ensured plenty of high-quality choice for everyone, including the professional and, whether when choosing your camera system you opt for Nikon, Canon, Minolta or some other brand, your decision will come down to a number of personal assessments such as the choices of lenses available, the efficiency of any autofocus features and ease of handling of the camera body. Take your time and make sure you get what is right for you, regardless of any pressure from the photographic press, brochures or the salesperson standing in front of you.

If your budget is limited, concentrate on putting your resources into the best lenses you can afford, settling for a cheaper body. It is after all, the lens that determines the sharpness of your pictures. It does not matter how fancy your camera body is, if the lenses are cheap your pictures may end up being inferior. The lenses you need must cover the full range from wide angle through to super telephoto, plus a macro facility.

In minimizing the number of lenses you will need to carry, as well as maximizing flexibility in terms of focal lengths available, you are likely to choose zoom lenses. It is tempting to go for lenses with the widest possible zoom capability, but this should be resisted for at least two reasons. First, the optical quality may not be the best and, secondly, the minimum focusing distance for such lenses may be unacceptably long: being unable to focus on anything less than 3 metres away with a zoom lens set at 28 mm is not a very useful situation. Thus, aiming for relatively modest zoom ranges, you should be able to get full coverage with four lenses, using, for example, such focal lengths as 18–35, 28–80, 80–200 and 200–500 mm.

The price of zoom lenses varies dramatically with the maximum aperture. Many have a maximum aperture of f/3.5 or 4 and these not only have perfectly adequate optics but are also generally quite affordable. Chasing after one or two extra stops, say to f/2.8 or wider can add significantly to the price and weight of a lens, especially as you go further away from the standard 50 mm view. Even an 18–35 mm lens can become quite large with all the glass needed to get its aperture down to f/2.8, and at the super telephoto end of the market you are looking at truly monstrous lenses. It is very tempting to go for the fastest lenses available, and at short focal lengths I would recommend photographers to do that, but when it comes to super telephoto lenses I baulk. The difference in size, weight and cost between a 500 mm f/5.6 lens (whether a zoom or fixed focal length lens) and one that goes down to f/2.8 or even f/4.5 is truly enormous. The former is portable, manageable and affordable – and, incidentally, has a slightly greater depth of field, an important factor in super telephoto lenses – while the latter would put a serious strain on your ability to carry all your gear in remote locations and its purchase might need a very understanding bank manager. So, in my opinion, while a fast super telephoto lens might be desirable from the point of view of being able to shoot in poorer light conditions, it is not a very practicable choice for anyone working on foot in the field, or who has limited financial resources. Go for the slower, more portable, affordable lens. Finally, any super telephoto lens must have its own tripod mount, to ensure that the lens-camera assembly can be fixed to it with the centre of gravity over the tripod.

Relative to zoom lenses, fixed focal length lenses suffer some inconvenience problems in that you have to carry around several more lenses than are necessary with zooms. Furthermore, it is difficult to change your focal length quickly in response to a changing situation or angle of view – by the time you have finished fiddling around in your bag for another lens the subject may have disappeared. However, they do have a number of advantages over zoom lenses that make them seriously worth considering. To start with they are cheaper, so you can build up a good coverage of the working range for about the same price as with a zoom system, though of course with considerably more lenses to cope with. Secondly, they are usually significantly smaller and lighter than zooms, partially compensating, in terms of weight and bulk, for the increased number required. Moreover, and most importantly, they usually have shorter minimum focusing distances and wider maximum apertures, all for a more affordable price per lens, than are normal with zooms. If these two factors are important to you (and they ought to be) it is truly worth seriously considering having at least a couple of fixed focal length lenses in your kit.

For macro work, you could ensure that one of your normal telephoto lenses has a built-in macro facility, but this is usually less than satisfactory, often allowing at best a 50 per cent life-size magnification of small objects. The most flexible solution is to buy a purpose-made macro lens allowing up to 1:1 magnification although, if you are put off by the extra expense and the weight of one more lens, extension tubes are an excellent alternative. These small and inexpensive tubes fit

■

between the camera body and lens, allowing it to perform macro work. They work well with any standard to telephoto lens, and while not as versatile as a macro lens, to my mind the huge saving of weight in the kit bag more than compensates. A disadvantage with extension tubes is that, because the lens is moved further from the film, some light is lost, usually about one stop per tube. An even cheaper solution, which overcomes the loss of light problem, is a close-up lens, which screws on to the front of the camera lens like a filter. Available in a range of magnifications they allow for very inexpensive macro work, but mainly at low magnifications. Generally, however, close-up lenses are not popular with professional photographers as many feel that their image quality is inferior, although my experience suggests that this is not necessarily the case.

Assuming you are buying your equipment new, it will almost certainly be autofocus. This is fine, of course, and in many situations where rapid focusing is needed it is quicker and more convenient than manual focusing. However, it is essential that all your lenses have a manual override since there are situations in which autofocus does not work or is unreliable and you will have to take over.

Some people may prefer to use manual focusing equipment, but if you intend to do this you will probably need to buy secondhand as the choice of new equipment is limited. There are certainly a number of attractions to having manual focusing equipment, not least the price, with many optically superb lenses available at very reasonable prices. Furthermore, many very affordable manually focused lenses go to much

Figure 47 On a bitter, frosty winter morning a new oak forest starts to take shape, a sign of hope for the landscape of the future. Photographed in the Midlands of England, in the new National Forest.

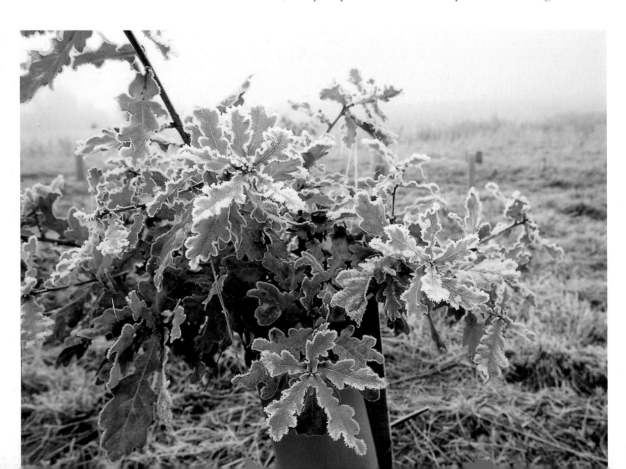

wider maximum apertures than are generally available with autofocus lenses, f/2 or f/1.4 being not uncommon. On top of this some of the best camera bodies ever produced belong to the manual focusing world. As a start-up system on a limited budget, you could do a lot worse than go for a good manual focusing system, but you will need to bear in mind that eventually you will probably have to make the switch to an autofocus system, if only due to the steadily shrinking availability of manual parts and accessories. Regardless of whether you go for autofocus or manual, the above discussion on the pros and cons of the different types of lenses applies.

And so to the camera body. In choosing a new camera system many people will base their choice on the body – after all this is the camera as such – yet as I have already pointed out, the lenses are more important. So the brand name that will be eventually associated with your name should be based on your choice *vis-à-vis* the different manufacturers' lenses rather than their bodies. Nevertheless, some aspects of the different bodies available will inevitably help to sway your judgement; a small, light and easily used body by one manufacturer is likely to be more attractive than a big, cumbersome one with similar features from a different manufacturer.

It should be borne in mind that a camera body is little more than a light-tight box for holding the film, and for ensuring that each frame gets exposed to the right amount of light to produce a usable photograph. Beyond that, all other features are gimmicks – some of them, admittedly, highly useful. The means by which the essential controls are

Figure 48 A rainbow spreads across the base of Senri-no-lo-Taki Waterfall, Kirishima-Yaku National Park, Japan. This beautiful waterfall set in dense forest was a long, narrow ribbon of water cascading down a vertical cliff. Shooting the entire waterfall required a wide angle shot that greatly reduced its impact in the final image, and I felt much happier with this kind of shot that put over the majesty and energy of the entire falls by concentrating on just one small part of it, the very bottom, where the water finally crashed into the rocky base, the spray creating a rainbow effect that went diagonally across the image.

achieved, from metering, to shutter and aperture operation, to film winding, have become more and more complex over the years. Add to this the explosion in clever little options and features that supposedly make picture-taking ever easier, brought on by the advent of computerized electronics, and it is easy to be blinded and distracted by all the high-technology. If buying an older, manual focusing camera system you may be spared all the high-tech electronic wizardry associated with the autofocus world. If going for the latest kit, however, you will be exposed to the full force of the camera manufacturers' research and development creativity. Keep your mind focused on the basics of what the camera body is supposed to do, and ensure that through all the gimmicks the essentials are easy to operate. You will almost certainly find that you will never use 90 per cent of the body's little gadgets.

As for autofocus lenses, make sure that there is absolute and complete manual override on all the camera body's exposure controls. Most of the time while shooting you will be happy to let the camera work out at least part of the exposure for you (I nearly always work on shutter priority, so that I get to choose the shutter speed), but there will be occasions when you want to override everything the camera metering is telling you. Before you buy a camera body make sure it will let you do that.

Medium and large formats

A 35 mm camera makes a good starting point for your work, but you will almost certainly find that many clients, and especially photo libraries, will request pictures on larger formats. Landscapes and garden pictures are especially suitable for this kind of work, and while 35 mm photographs are more than adequate for the great majority of work, the extra detail that can be brought out in a 6×7 cm or 5×4 inch transparency is quite stunning and can really bring a photograph to life.

If your work concentrates mainly on animal wildlife you may feel no pressure to use anything other than a 35 mm camera, but if engaged in any amount of landscape, garden or plant portrait photography, you will sooner or later feel the need to invest in the larger cameras and use 120 mm or sheet film. The first thing you will notice when investigating this field is the greatly reduced choice of products and their generally simpler nature. These cameras are limited to professionals and very keen amateurs so there is not the huge commercial competition to develop either many different models or a mass of gadgets for each body. Furthermore, these cameras are usually expensive, and increased gadgetry would only drive up the price still more. With many professionals preferring simplicity anyway, medium and large format cameras have generally remained free of electronic wizardry.

Initially your main choice will be which format to go for. The first step up into the medium format world is the 6×4.5 cm camera. This is often considered the halfway house between 35 mm and 'real' medium format cameras, but it offers significant benefits over both. First, it produces an image size considerably larger than the 35 mm, greatly facilitating viewing and improved enlargement. Secondly, the cameras in this range are still highly portable, can often be used handheld, and come

with a wide range of accessories, including good macro facilities. Also, due to the generally simpler level of development – although 35 mm-style electronic wizardry has crept into this format – a 6×4.5 cm system can be put together for the same price as a 35 mm system.

The next step up is the 6×6 cm format, largely the preserve of the Swedish Hasselblad. Again light and portable, easily used and with a mass of accessories but being in the highest echelons of photographic quality and prestige, it is expensive. Photographers seem divided over the attractiveness of the square format. Generally, it is not suitable for landscapes but is very good for plant, animal and human portraits.

Beyond this, one comes to the 6×7 cm and 6×9 cm formats, the real workhorse formats of the photo library world. Producing superb images, these cameras can be hard work to use in the field due to their bulk and weight, and the absolute necessity for a tripod. However, the attractiveness of resulting images, especially landscapes, and the degree to which photo libraries encourage pictures on these formats means that often it is worth the slog in the long run (although you may not think so at the time), especially on shoots where you will not need to hike too far from a vehicle or over excessively difficult terrain.

So far, in describing these cameras I have thought mainly about reflex cameras, which by their nature are rather heavy. There are also a number of rangefinder cameras available that have proved popular with professionals due to their greatly reduced weight. These include the 6×4.5 cm and 6×9 cm cameras made by Fuji. Very popular due to their lightness, ease of use and competitive price, they are limited by their fixed, unchangeable wide-angle lenses. Mamiya produce 6×6 cm and 6×7 cm rangefinder cameras. The 6×7 cm camera could well become the standard workhorse for location-based general photo library photographers, but its use in nature photography is limited to landscapes and general shots due to the low power of its strongest telephoto lens, long minimum focusing distance and limited macro facilities.

Larger formats that still use 120 mm film are mainly the panoramic cameras, shooting at 6×12 cm and 6×17 cm formats. This is a rather specialized kind of photography, but one producing stunning images when used with the right types of landscape.

Beyond this come to the sheet film cameras, of 5×4 and 8×10 inch formats, the descendants of the original plate cameras of the nineteenth century. Used extensively in advertising and commercial photography, these cameras do not enter the 'must have' list for nature photographers. Nevertheless, they are used in landscape and garden photography to great effect. Apart from the larger image size, the major advantage they have over most medium format cameras is the facility for tilt and shift of the lens and film back relative to each other. With close-up subjects, such as clusters of flowers, this can greatly increase the depth of field, and with walls and buildings can allow the whole structure to be shown in the picture without tipping the camera backwards, thus ensuring that vertical lines remain parallel instead of converging, as happens with cameras without this facility. Shift also makes it possible to remove excess sky or foreground without tilting the camera body, again allowing any vertical lines in the picture to remain

parallel. For those photographers not keen on the expense and bulk of sheet film, but keen on having the tilt and shift features, most of these cameras will also take 6×7 cm and 6×9 cm 120 mm roll film backs.

Studio versions of these formats are very heavy and rather expensive, but simplified versions, called field cameras, are lighter – especially wooden versions – easier to use and affordable. The much simpler lens constructions used in these formats helps compensate for the weight of the body.

In choosing which format to go for, you have to assess what is most appropriate for your kind of work and hence acceptable to your clients. The above section is intended as a description of the main products available; there are others, and obviously any purchase should be preceded by thorough research of the field.

Accessories

The first accessory to consider is a flash system. For working in the field you will need to carry a flash gun (or guns) that packs the biggest possible punch for the smallest size and weight available. It must be usable for both telephoto and macro work, with a head that can be rotated and turned, with fittings for a diffuser and/or reflector to allow for soft and/or indirect flash. It must also have accessories that allow for off-camera operation. In short, in order to minimize the amount of kit you have to carry, a single flash gun must be capable of doing just about everything. For accurate exposure control an automatic through-the-lens (TTL) metering automatic flash is obviously the most convenient. If you intend to use two flash guns in your work, for instance to ensure shadow-free photography in plant and animal portraits, the most convenient means of firing the secondary flash is via a slave cell. Be sure to buy one that is reliable and will not let you down in the field.

Perhaps the biggest problem of all the accessories is the tripod. Big, cumbersome, slow to use, how we would all love to be able to work without one. Yet the tripod remains an absolutely essential piece of equipment, to be carried to the remotest ends of the Earth no matter what. Inevitably, the advice has to be, make it sturdy and as vibration-proof as possible. The bigger your camera, the bigger the tripod must be. For medium or large format work this often means quite a hefty piece of metal, but for work out in the field entailing a great deal of travelling on foot, you may be tempted to go for one that is as light as you can get away with. Remember, however, that the lighter tripods are likely to be less rigid, and certainly not vibration-proof – even a light breeze could be enough to set them humming. In 35 mm work a fairly sturdy tripod will be needed for super telephoto work in order to cut to the minimum the risks of vibration.

In most tripods the weakest point is the connection between the head and the tripod's legs. Here there is often some play, creating a chance for vibration to creep into the structure. Another weak point is the plate connecting camera to tripod, especially in models with quick-release plates. Quick-release plates, allowing the camera to be removed or fitted to the tripod in seconds, are generally a very good idea but if the bolt holding the plate to the camera, or the clamp holding the plate to the tripod, are not absolutely rigid this can be another serious source

of vibration. Before buying a tripod check that all these connections are absolutely rigid.

In choosing your tripod's head you usually have two main choices: a ball and socket head in which a single clamp will release the head to move in any direction, or a three-arm system in which three separate clamps each control movement of the head on one plane only. The latter is certainly the more rigid – and less likely to result in a disaster if you accidentally let go of the camera when one of the clamps is loose – but it is also extremely slow to operate, making it difficult to use when photographing moving wildlife. I have tripods with both systems, but when shooting wildlife I almost always use the one with the ball and socket system; the frustration of losing so many good shots due to the slowness of making adjustments with the three-arm system makes the risk of increased vibration with the ball and socket version worth taking.

Finally, buy only tripods in which all three legs can move independently of each other, allowing as wide a spread for each leg as possible. Tripods with linked legs may be a little more rigid, but their usefulness is seriously limited on rough terrain where it is necessary to spread the legs at all kinds of strange angles in order to gain a firm and stable grip on the ground.

When discussing telephoto lenses you may have noticed that I went no further than 500 mm. Yet there are many situations where such a focal length simply is not enough, such as when photographing birds. There are more powerful lenses available, right up to 1000 mm, but once you go over 600 mm not only is the choice very limited, but also

Figure 49 A full moon rises over a sand dune on the edge of the Taklamakan Desert; Dunhuang, China. The moral of this picture is that you should always keep an eye out for the unexpected and be ready to grab it. As the sun started to set I finished shooting some views across an immense stretch of dunes, standing atop one of the highest in the area. As I was hiking back towards the edge of the oasis town I looked over my shoulder, only to see the moon just starting to break the ridge of this dune. I scrambled into position and had the camera set up in time to fire off a few shots. The front of the dune itself was lit for a few minutes by the last glow of light from the dusk sky.

**PROFESSIONAL
NATURE
PHOTOGRAPHY**

125

the weight and cost of even a f/5.6 lens start to get quite considerable. The solution is a converter. Coupling a 1.4× or 2× converter to a 500 mm lens creates a truly powerful, yet still highly portable lens. There is a price to pay of course. Some makes definitely have inferior optics, so you must be sure to get the best available for the lenses you intend to use it with – which by the way is not necessarily the most expensive. Furthermore, converters take away quite a lot of light – one stop for a 1.4× converter and two whole stops for a 2×. If you are not using a f/2.8 lens with such a converter you really are starting to look at some serious limitations in the kind of light in which a converter could be used. The solution is to compensate by either using a faster (but grainier) film or by pushing a slow film to a higher rating. Personally, if using slide film, I prefer the latter.

A small number of filters is essential to good photography. The most important is a polarizer, a filter that cuts out extraneous reflections and, partly as a result of this, strengthens and saturates the colours. A washed-out sea or sky and vegetation rendered bluish by too much reflection can be completely transformed by a polarizer. Another essential filter is the pinkish 81B (or the slightly weaker 81A), a filter that reduces the blue tones in shadow areas on sunny days (such as in a forest), or the general blue cast generated in bright but overcast conditions. Other highly useful filters are graduated ones, those that are clear in one half and coloured or darker in the other. The most important for nature and landscape photographers are the neutral density graduated filters. These are clear in one half and dark (but with no effect on colour) in the other, and are generally used to tone down a sky that is much brighter than the land below. The use of such a filter will help to bring the exposures for the land and sky closer together, enabling both to be correctly exposed instead of one or the other. They can also be used in a forest, in situations in which the forest floor is rather dark, but the view up into the trees is flooded with light. Graduated neutral density filters usually come in two forms – gradual, in which the dark half gradually fades into the clear part of the filter, and sharp, where the transition between clear and dark is sudden. The latter is useful in situations where the horizon is sharp, giving a sudden transition from dark land to bright sky, while the former is used when the transition is more gradual, such as in a forest.

Filters are available in two forms: circular, screwing on to the front of the lens, and square or rectangular, sliding into a special holder that fits on to the lens. Polarizing filters are probably most conveniently used as the former type, and uniformly coloured filters such as the 81A and 81B may be either square or round. The graduated filters, however, are only useful as the square variety as it is only in this form that it is possible to alter the position of the graduation to fit the position of the horizon in the view. Another advantage of the square variety, regardless of the type of filter, is that you need have only one filter for all your lenses, regardless of their size; the filter holder usually comes with a variety of adapters to enable it to fit on to almost any lens.

If you are using only 35 mm cameras a handheld light meter may not be of any importance to you. However, medium and large format cameras often come with no metering facility, so in this situation you

will need a handheld light meter. There are many excellent brands on the market, almost all useful for both incident and reflected light readings, some doubling up as flashmeters too, and a few with optional fittings to convert the general meter to a spotmeter. This latter feature may seem quite convenient, but there do seem to be problems with some of these in terms of flare and accuracy of the spotting. If you need a spotmeter it may be safer, although more expensive, to invest in an additional, dedicated device.

Finally, to the means to carry it all. As described in an earlier chapter, carrying lots of camera gear around with you can do terrible things to your back, so be sure to get the right bag. Shoulder bags are not really appropriate, except for carrying very small amounts of gear over relatively short distances. Even then, I prefer to use either a jacket or a waist bag. For field work involving long distances or times on foot, a combination of jacket and rucksack is useful, the former for items needed frequently along the way, and the latter to carry medium format gear and any less often used items of 35 mm equipment.

When checking-in equipment at airports, avoid using even a padded rucksack. All checked-in gear should be in a specially designed hard case, either plastic or metal, filled with foam padding in which all the items are embedded.

When buying a jacket, be sure to get one with sufficient ventilation but which at the same time can be worn under a coat in bad weather, and which is strong enough to withstand long periods of carrying heavy lenses. Also ensure that there are as few protrusions, flaps

Figure 50 Tibetan macaques are among the biggest of the macaque family. A large population lives in the forest of Mount Emei, a holy mountain in China's southwestern Sichuan province. Here they are used to hikers and so are quite approachable. This baby I found learning to climb just a few metres from its family group, in trees below the level of the mountain path.

PROFESSIONAL NATURE PHOTOGRAPHY

Figure 51 Tree ferns in the forest of Yangmingshan National Park, Taiwan, photographed during rain. The light was very dim but fortunately there was no wind, allowing me to shoot with a very long shutter speed, the camera fitted with a polarizer to remove reflections and brighten up the greens. The camera was protected with an umbrella.

and so on as possible for the camera to snag on and tear. Rucksacks need to be well padded, for your protection from the cameras inside as much as to protect the cameras from being bashed, with lots of adjustable compartments inside, along with plenty of pockets for all those little bits and pieces. Straps need to be broad, padded and comfortable, and the filled rucksack needs to sit on your back easily. It must also be absolutely waterproof, something that the right kind of padding should help to ensure.

The darkroom

Generally speaking, having your own darkroom is not one of the 'must have' requirements, especially if you are based somewhere with good professional laboratory services close to hand. For many photographers, however, the added creativity enabled by having one's own darkroom, coupled with the cheaper and more flexible processing, make the added cost, space and time requirements of a darkroom worthwhile.

The first step in setting up a darkroom is, of course, to ensure that you have a room that can be made light-proof. One of the main investments is the film processing kit, such as a drum or slot processor. Although simple developing tanks can be used, drum and slot processors are more convenient in that they are completely self-contained units. Before processing begins they are loaded up with the film to be processed – whether slide or negative – together with all the chemicals that will be needed for all the steps, including the washing water – and are then sealed. These steps should be carried out in the dark (remember, most nature photography work is done in colour, so darkroom lights appropriate to black-and-white work will be of no use here), but once the unit is closed the lights can be switched on. Temperature and timing are controlled automatically, so the various steps can be followed through easily and reproducibly. A great advantage of both drum and slot processors is that they do not have to be plumbed into a water supply or drainage, greatly saving on darkroom setup costs.

When it comes to printing, whether from slides or negatives, the single most important piece of equipment is the enlarger. Be sure to buy one that can handle all the film formats you use, or are ever likely to use, can print colour and has a lens the quality of which is at least as good as, if not better than, your camera lenses. It is pointless spending vast sums of money on expensive camera lenses if you then ruin the final prints by using a cheap enlarger lens.

Processing the papers, again whether printed from negatives or slides, can be carried out in the same drum or slot processor that you processed the film in, loaded up with paper drums instead of film tanks.

Computer imaging: the digital darkroom

It is tempting to think of computer imaging as a non-essential luxury. Yet, this field is having such a fundamental impact on all aspects of photography that at least a rudimentary ability to handle images on a computer is rapidly becoming an accepted norm, more important than the standard darkroom. So it is very likely that sooner or later you will feel the need to develop computer imaging facilities, to create your own digital darkroom. Whether you do this by upgrading your existing com-

Figure 52 The active crater of Mount Aso, one of the world's largest volcanoes; Kyushu, Japan. Not all landscapes that a natural history photographer shoots are filled with vegetation or attractive colour. This very harsh view reveals the raw power of the planet, a volcano and one of the ways in which land is both destroyed and built.

puter or by buying a completely new system will depend on such factors as the age of the computer you already have, how many add-ons will be needed to make digital imaging possible with it and, as usual, the state of your own finances. While upgrading an existing machine will probably work out cheaper than starting from scratch, it may turn out to be a false economy, for it may be found that older components will not work well with new pieces of equipment, resulting in the need for numerous irritating and possibly increasingly expensive modifications. Going for a completely new machine may be the most efficient and least painful way of making the move into digital imaging, and one made less financially painful if a lease purchase deal is available.

In this section I am assuming that your photography will continue to use a standard camera with film that can subsequently be scanned into a computer, rather than a digital camera directly producing digital

files. The minimum equipment requirements for digital imaging are a PC equipped with at least a Pentium processor, or a Power Mac, complete with a large hard disk, CD-ROM, scanner, photo imaging software, and some kind of system for exporting digital files, such as a zip or jaz external hard disk drive or a CD writer. You will also need a photo-real quality printer if you intend to make prints. If you wish to output your digital files back on to film, a film recorder is needed, but since these are prohibitively expensive it is better to send this aspect of your work out to a reliable laboratory – one good reason to have a zip or jaz drive or a CD writer.

The kind of scanner you use will depend on whether you will be scanning from prints or from negatives and slides. If the former then you will need a flatbed scanner, whereas the latter – although it is possible to use a flatbed equipped with a transparency adaptor for negatives and slides – are better handled by a dedicated film scanner. If you shoot only on 35 mm film then a 35 mm film scanner is all that is needed, machines that are highly affordable. However, if you also use medium or large format film then strictly speaking a multiformat film scanner is needed, something that for an individual photographer is generally prohibitively expensive. Photographers with this problem may find it better to either use only a 35 mm film scanner, duplicating any larger format images down on to 35 mm film to allow scanning, or equip themselves with both a 35 mm film scanner and a flatbed scanner, using the latter to scan from prints taken off the larger format slides or negatives.

Until the mid-1990s making high-resolution prints from the computer was a difficult and expensive process, relying on the use of dye-sublimation and thermal transfer processes that were largely the preserve of laboratories. Since then, however, highly affordable high resolution inkjet printers with finely controlled inking have come on to the market, along with high-grade papers to use with them, enabling individual photographers to produce good photographic quality prints. If you think you might want to produce good prints from your digital photo files, a photo-real printer is a good investment.

In terms of facilities to export digital images, the zip drive, an external hard disk drive that holds removable disks usually having a capacity of 100 megabytes, is a cheap and convenient method for carrying images. The jaz is a similar device, though with a higher capacity up to 1 or 2 gigabytes. The industry standard, however, has become the CD-writer, a machine that has become relatively cheap and easy to use. If you intend to send digital images to clients via a modem you will need to install an ISDN line, a fast, high-capacity phone line link. Talk to your telephone company about this facility.

Finally, the all-important software. There are a number of digital imaging software packages available, but by far and away the most widely used industry standard is Adobe Photoshop, the all-singing, all-dancing miracle software. To be up there with the competition and to be certain of having no compatibility problems if you start sending digital images to clients be sure to use this. It is expensive to buy, although it comes packaged (admittedly often in a limited version) with many of the scanners and is certainly an automatic inclusion if you buy

a complete digital imaging computer system from any supplier specializing in digital photo systems.

Once you have got the equipment installed, there is only one thing left to do – start practising.

Summary

Your initial camera needs will focus on 35 mm equipment. Make your choice of system based on the quality and usefulness of the lenses available, bearing in mind the need to produce high-quality images ranging from landscapes through to super telephoto and macro images. Zoom lenses will give greater flexibility than fixed focal length lenses, but may be inferior in such areas as minimum focal length and maximum aperture. If you buy new camera equipment it will most likely be autofocus in nature, but manual focusing equipment – mostly bought secondhand – can also be a good buy. In choosing your camera body concentrate on the essential functions and do not be blinded by all the clever little extra features. Make sure that all functions have complete manual override.

In super telephoto work, the fastest lens is not necessarily the best, simply due to the massive increase in size, weight and expense incurred in striving for an extra one or two stops. For portability and a manageable cost, a slightly slower lens – with a greater depth of field – is often better. To further increase the power of your telephoto lenses add a 1.4× or 2× converter, though beware of the loss of light.

You may well eventually feel the need to invest in medium format equipment. Start the process by choosing exactly which format you wish to go for and then select one of the few cameras available. Such a camera is not important in wildlife photography but is important in landscape and plant portrait work.

One of the most important accessories is a flash system. For field work ensure that your flash gun or guns are versatile, and that one or two guns are able to cover all possible uses, from macro to telephoto work.

A good tripod is essential. It must be sturdy, vibration-free and, if limiting yourself to carrying just one while in the field, able to support your biggest camera. Choose between a ball head and a three-arm control and be sure to use a type whose legs move independently of one another. Quick-release plates are a good idea, but watch out for vibration weak points.

Some filters are also essential items, especially a polarizer and 81A or 81B pink filters. Graduated filters are also very useful.

For carrying it all, use a specially designed and well-padded rucksack. This can be combined with a photographer's jacket to allow the most frequently used items to be constantly within easy reach. For checking equipment in on aeroplanes be sure to have a very hard case packed with foam padding.

A darkroom is not essential, but does give added flexibility. The main pieces of equipment are the processing unit and enlarger.

Computer imaging is now very important in photography. Sooner or later you will need to invest in a computer that has the capacity to handle photographs. This is a serious investment in terms of cost, so be sure to research the necessary hardware properly and purchase what is right for you.

9 SOME SPECIAL SKILLS

It should be pretty clear by now that professional nature photography is, alas, not merely a matter of going out and clicking away at your favourite subjects. If only it could be, life would be so much simpler. This book has concentrated on the theme that, beyond being a competent photographer, success as a professional lies very much in preparation and management – whether of the thoughts and ideas in your head, your skill and persistence in approaching potential clients, the efficiency of your office filing, or the possession of the right equipment for whatever job you may need to do.

I have deliberately steered away from a discussion of all the photographic techniques you will need – there are already plenty of techniques books on the market – and have assumed that you already own or have read many of those most commonly used. However, there is room for a review of some of the specialist skills that a nature photographer may well need, hence this chapter. Depending on your specialities within the field of nature photography, it is unlikely that you will need to use all these techniques, not at the same time anyway. Nevertheless, it is useful to be at least conversant with a number of them should you decide to switch or expand your speciality areas at any time.

See what your film sees

One of the most important skills that any competent photographer needs to master, regardless of their speciality, is to be able to predict how film will respond to different situations. The processes by which the human eye and brain work together to see the world, and those used by the camera and film to record it are radically different. The former is a combination of electrical, chemical and psychological steps, while the latter (at least in traditional, non-digital photography) is purely chemical. It is truly a miracle – and a great tribute to the skills of film chemists – that two such completely different processes can come up with any images that are remotely similar. And yet they do, and with quite remarkable reproducibility. However, there are many occasions when the results on film do diverge quite markedly from what the photographer sees, or rather thinks he or she sees.

When in a forest, for example, a person knows that they must be looking at green vegetation, and so that is what they see, regardless of lighting conditions. Film, on the other hand can only record what is

Figure 53 Ferns growing on a sloping forest floor on Mount Emei, Sichuan province, China. Dim evening light just before sunset, coupled with a polarizing filter made the greens of this forest floor vegetation very vivid. Absolutely windless conditions were needed for an exposure that was nearly a minute long.

actually there. Daylight does not always consist of the same mixture of the different colours. The relative proportions of red and blue, for example, can vary greatly depending on the time of day and weather conditions. These variations will greatly affect the colours recorded by film. If the light is rich in blue, then the film will record that excess blue and, unless this is corrected, the final photograph will show vegetation that looks remarkably blue. On the other hand, if the light is rich in red the final photograph will show stunningly rich green vegetation. Similarly with reflections, if left uncorrected the film will record all the reflections bouncing off a variety of surfaces, resulting in a picture showing a confusing mish-mash of light and weak colours.

So it is important to learn how film will respond to different lighting conditions and be able to correct for any likely negative effects, even if they are not visible to the human eye, before pressing the shutter. Most photographers use just a couple of film types, for the simple reason that different films respond in a variety of ways, and it is difficult to grapple with the nuances of a whole range of films. Once you have become used to a few film types, it becomes much simpler to use only these.

A detailed discussion of film chemistry is beyond the scope of this book, but a brief summary is timely. Daylight film is balanced to give correct colour rendition under 'normal' daylight conditions that have a colour temperature of 5500 Kelvin (0 Kelvin being Absolute Zero, i.e. -273° C). Any change in these lighting conditions will result in a change to the way the film records colour. Thus, under bright, cloudy conditions, or in shady areas on sunny days, or at dusk or dawn away from that part of the sky where the sun is rising or falling, the light is rich in blue wavelengths, giving an overall colour temperature much higher than 5500 K. The result will be a blue cast to any uncorrected photograph. This is usually an unwanted change as blue casts are normally unpleasant to the human perception due to the connotation with cold and the obviously unfamiliar appearance, for example, of rather bluish vegetation. The solution is to add a pink (81A or 81B) filter to the lens to help counteract the blue light. The addition of a polarizing filter will also help.

Conversely, when the sun is low, or in very gloomy conditions, such as during rain, the light is rich in red wavelengths, giving an overall colour temperature below 5500 K and resulting in any uncorrected photograph having a rich red look to it. This is often seen as a desirable effect, enriching images of sunset, sunrise, dusk and dawn (the last two taken towards the sun), and producing stronger greens in vegetation.

Many of these effects are generally not visible to the conscious

Figure 54 A mountain stream rushing down the sides of Mount Yangming; Yangmingshan National Park, Taiwan. Taiwan is an island of intense contrasts, polluted crowded cities giving way to wild forest and stunning landscapes. Such is the situation here, for this forested river scene was just a few hundred metres from the very abrupt edge of Taipei, the capital city. It is a clear example of how one often does not need to look very far to find great beauty.

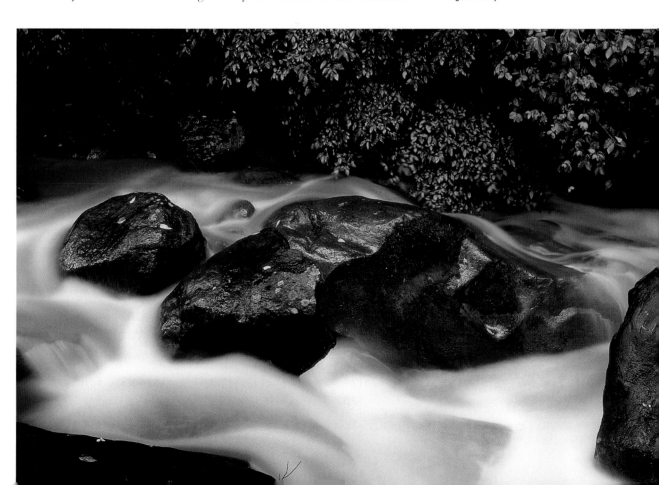

Figure 55 Low sun filters through mist in a larch plantation in the English Midlands, its rays split by the lines of trunks, creating a moody silhouetted image of the forest.

human mind, becoming visible only in the final photograph. So you must be able to predict them in advance, before you press the camera's shutter. Simply knowing about a film's responses to different conditions is a good step to being able to correct for, make use of or enhance their effects in a final image. Yet, with practice it is possible to develop an intuitive response to conditions, becoming able to sense the excessive blue in the shadows or your subject's vegetation, or the real amount of enriching red light in the gloomy, rain-soaked forest, and thus more easily able to predict and respond to the likely effect in the final photograph.

When it comes to reflections, whether they be from vegetation, water, windows, or wherever, these are all perfectly visible to the human eye; the mind usually simply ignores them and your consciousness just does not bother to 'see' them. A photographer must overcome this mental filter and learn to see what is actually there, getting into the

habit of using a polarizing filter to remove as much unwanted reflection as possible.

Incidentally, the need for a photographer to see what is actually within the view he or she intends to photograph, rather than what he or she thinks is there or would like to have there, applies not just to reflections but to all manner of unwanted items that might creep into a photograph, such as general clutter, litter, contrasting areas of light and shadow, and even such horrors as power lines, eyesores that the human mind seems able to filter out with surprising ease. The film, alas, will record it all with depressing clarity and faithfulness.

Landscape photography

It may be hard to think of landscape photography as much of a specialist skill. After all, anyone can point a camera at a view and get a decent shot, one that is at least a reasonable record of the sight. However, a professional photographer should be aiming well beyond a simple record, instead producing an image that evokes the mood of the place and the moment. Indeed, in the best landscape photographs the actual location may be quite secondary to the emotional response that the final image is able to trigger in a viewer. Admittedly, a bland photograph of a famous view may still sell well simply because it is a famous view, although a moody picture of it is likely to sell even better. For unknown views you have only the image's evocative beauty to generate sales.

So, how do you get that extra special image? As usual, much of it is in the preparation. For one thing, if landscape photography is a serious component in your work you really need to invest in a medium or large format camera, to be used exclusively on a sturdy, steady tripod. Photo libraries as well as calendar and greetings cards publishers generally expect landscape images on this format and, although usually less critical, so do a good many book and magazine publishers.

Much of what remains is down to timing. It is well known that you should never take landscape photographs when the sun is high, and as a general rule I would heed this. There are some occasions, however, when a middle-of-the-day shot is useful. One example is in the tropics when you may want to put over the feeling of heat and blinding light. For it to work, your main subject must be a strong image in the fore or middle ground, there should be little or no haze, and it is absolutely essential to use a polarizing filter. Another example is when shooting in a forest. In this situation you will often need a high sun to ensure that the forest floor is receiving almost as much light as the tree trunks, reducing the contrast range between shadow and sunlit areas and so producing an image where just about everything is visible. Low sun is useful for dramatic starburst images of it shining through (usually silhouetted) trees or for photography of selected highlights, especially if much of the background is in shadow, but it is a disaster for wide angle views that are meant to show details of the trees and forest floor. In this situation the contrast range of light and shadow is too great for film to handle, especially slide film, resulting in everything becoming a confusing tangle of light and shadow.

For most landscape photography, however, you will stick to shoot-

Figure 56 Rocks and cliff silhouetted against a setting sun; Cornwall, UK. Silhouettes such as this are always highly evocative, and from a practical viewpoint have the immense benefit of being wholly generic; this shot could be almost any coast anywhere in the world.

ing when the sun is low and the light rich in red; early in the morning or late in the afternoon or early evening, or – in temperate areas – at just about any time of day during winter. Inevitably, two of the most atmospheric times are dawn and dusk, though for images taken at these times to work you need a main subject that stands out well as a silhouette against the sky, such as a lone tree or dramatic outcrop of rock. You also need a pretty dramatic sky and, sad to say, despite years of practice I have yet to find a foolproof way of predicting when the perfect dawn or dusk is coming up: I can only pick what appears to be a good day, set myself up at the selected viewpoint, wait for events to unfold and pray. Even when all the right kinds of light seem to be developing things can be ruined at the last moment by an overly thick cloud moving into just the wrong spot, taking up a prominent position in the view and blocking out all the sky's colour at the crucial moment. Many are the times that I have walked away from a dawn or dusk that at the final moment failed to live up to its promise. It is a frustrating experience but one more than compensated by those occasions when the sky does perform to perfection.

Incidentally, I rarely photograph the actual sunrise or sunset. On most occasions the rising or falling sun ends up dominating the view so the landscape itself becomes quite secondary. And since one sunset or sunrise ends up looking pretty much like another I can quickly tire of shooting them. For me, dawn and dusk are far more rewarding. As far as dusk goes, in the tropics the best time starts about 20 minutes after the sun has dipped below the horizon, and will last only a short time, 15 minutes at the most. In temperate latitudes the show begins 30–45 minutes after sundown and may last up to an hour. Similar timings should be allowed in advance of sunrise.

Unfortunately, views suitable for shooting in low sun or at dawn or dusk do not always jump out at you. Most require some advance planning and often a long wait. There have been plenty of occasions when I have had to wait as much as a year to get the right light on a subject, especially in terms of the relative positions of the sunrise or sunset. Of course, when on a commission, and especially far from home, you do not have the luxury of such a long wait and you simply have to take what presents itself. Even so, sharp eyes and advance thinking will help you spot suitable views at any time of day and under any weather conditions. I always carry a compass, which enables me to assess the likely position of the sun relative to any promising view, regardless of when I actually first get to see that view. I can then allot time to make a return visit to shoot at the right time of day. The only aspect I am still unable to control is the weather.

The assumption so far has been that your landscape photography is being done in sunlight, or at least during a clear dawn or dusk. Of course, this need not always be so. Misty conditions can result in very atmospheric images, provided of course that it is not so thick as to cut out all the light and your subject. The addition of coloured filters can enhance still further the atmosphere – blue (80B or 82B, for example) to increase the feeling of cold (one of the rare occasions when this works in a positive way with human perception), or pink (81A or 81B) to create a false dawn or hidden sunrise feeling. It should be remembered

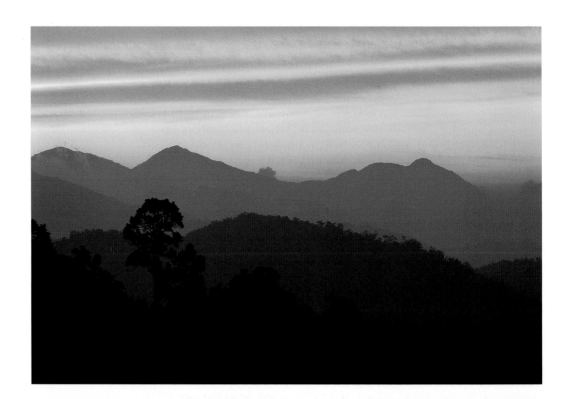

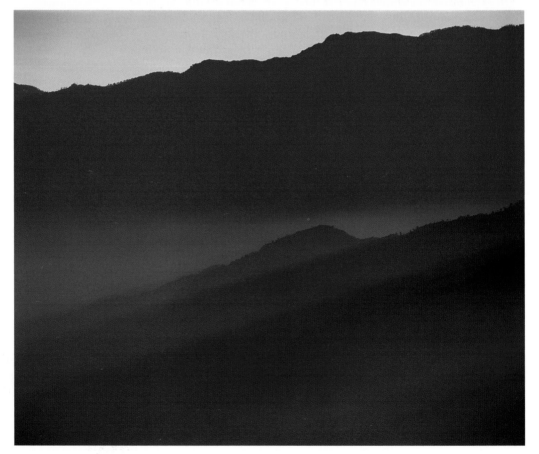

that these filters are only effective when the mist has wiped out any details within your subject, leaving only their fundamental outlines. It is very hard to predict when and where the right misty conditions will occur, and so getting yourself in the right place at the right time can often be a matter of luck. The nearest you can usually get to a prediction, at least in temperate climates, is to acknowledge that early morning in autumn or winter, especially close to low-lying water, represents one of the best opportunities to catch mist. As with any landscape photography, check out possible subjects in likely locations well in advance, wait for the right conditions and then make a dash for it: but be prepared for disappointment and the likely need to make repeat trips until everything comes together just so. But then, as with dusks and dawns, there are occasions when you simply stumble upon an utterly perfect view, one that will most likely never be repeated. Even if you are busy doing something else, do not be tempted to say 'I'll come back later' because it probably will not be there later. Be flexible enough to be able to divert then and there and get the shot in the bag.

Then there are just cloudy or, worse still, rainy days. Even under these conditions landscape photography is not impossible, provided you go for only certain kinds of images. On very dull, rainy days, as already mentioned the light is often rich in red wavelengths, making the greens, yellows and reds of vegetation astonishingly vivid. Provided there is no wind, this can create ideal conditions for forest photography; be sure, however, you have some way to protect the camera from the elements. Use a polarizer to remove most of the reflections from the wet leaves and to strengthen still further the colours, and consider adding a pink filter on top of this just to give even more strength. By the time you have done this and then stopped down to f/16 or f/22 to maximize depth of field, your exposures could easily be in excess of 30 seconds, or a minute after allowing for reciprocity failure. Unless you want to include the dynamic feeling of movement within the shot – which can be good in the right amount – an absolutely windless day is needed.

Shooting landscapes in hazy or bright cloudy conditions is usually very difficult. The light is often rich in blue wavelengths, so you will need to use an 81A or 81B filter to have any chance of overcoming this. Even then, many views will be flat and lifeless, and if the sky is much brighter than the land – as it normally is under these conditions – there

Figure 57 The hills and rainforests around Fraser's Hill, a hill station in Malaysia, silhouetted by dusk. Sometimes the search for the right dusk view seems to get nowhere and on other occasions a lucky break just throws one at you. Such was this situation: I had been driving all day from Malaysia's east coast, determined to reach Fraser's Hill before the end of the day. By the time I arrived it was already getting dark, and not knowing where I was going I simply kept driving higher into the hills until I ran out of road. That happened in a small car park that opened into this stupendous view, with the colours of dusk just at that moment reaching their zenith. I grabbed camera and tripod and snapped away as fast as possible. Ten minutes later it was all over.

Figure 58 Early morning sun lights up mist in a valley; Yushan National Park, Taiwan. A very simple image of mountain backlit by a rising sun with all the detail lost. The view was a monochromatic grey, but addition of a blue filter added some colour interest while enhancing the feeling of calm coolness. This is an example of one of the few situations where a blue image really works.

Figure 59 Oystercatchers at high tide on the estuary of the River Exe, in Devon, UK, taken from a pemanent hide on the shore. The rising tide forces hundreds of birds closer to the hide, until finally the only dry land is a small island just in front of it. The island is just too far away for individual shots of birds, except with the most powerful of lenses, but is close enough to allow good views of the crowd of restless birds.

will be the problem of getting both land and sky correctly exposed. Besides this most clients will not be interested in views showing depressing grey skies. If you do have to shoot landscapes in these conditions, either concentrate on views in which it is possible to minimize or do away with sky altogether, or attempt a little creative use of graduated filters. If the sky has some interesting cloud formations or is simply very threatening, addition of a graduated neutral density filter will reduce its brightness to something similar to that of the land, creating a dramatic, evenly exposed image. The dark brooding sky in the final picture may not impress clients in the tourist industry, but it could well be exactly what others are looking for. Another popular and often successful approach is to use a graduated tobacco filter, which gives the sky an unearthly orange hue, something which, although often not liked by photo libraries, appeals to many clients (including those in tourism) in search of moody images. Often, however, it is simply better to take note of the best views and come back when the sun returns.

Shooting from a hide

Anyone attempting to photograph birds or shy forest mammals may well find themselves needing to use a hide in order to get close enough and yet still remain invisible. The standard kind of hide is basically a tent, though usually without a sewn-in groundsheet, with camouflaged viewing slots cut in the sides. They need to be anchored to the ground like a tent and so, once set up, you are immobile: you have to wait for the wildlife to come to you.

Therefore, the first step to success is to set up the hide in the right place. Do not bother putting a hide in some forest clearing and then expecting to have birds flocking around simply because they cannot see you. You need to select a site where the wildlife is almost guaranteed to gather sooner or later, preferably sometime within the limits of your patience. For shore birds, for example, you need to set up close to some well-used stretch of intertidal sand or mud, a place where large numbers of birds are likely to come to feed.

Another likely site for bird photography is close to the nest, a place where you are guaranteed to have birds regularly flying back and forth. The use of a hide can even be useful in the suburban garden, allowing you to take close-up photographs at a bird table, although the neighbours may think you a little odd. For mammals, such sites as a well-used watering hole, especially during the dry season, a popular animal trail, or close to den entrances may all prove successful.

Once again, the key to success is preparation. In your home area you may well be familiar with those muddy shorelines that attract wading birds, or with the watering holes that draw in thirsty mammals, but what about when you are sent out to a region you do not know? It helps enormously to be in contact with local people before you go, people who can impart to you more valuable information in minutes than you could gather in weeks of your own research. They can certainly be invaluable in guiding you to the right sites, but once there it is down to you to work out how to make the best use of the sites for your needs.

Continuing the example of the muddy shoreline bird photography, you will need to set up in a place that not only attracts large numbers of birds at low tide, but which also enables you to photograph the birds on a rising tide (so they are constantly driven towards you) with the early morning sun directly or at an angle behind the hide. These requirements may render many otherwise excellent birding sites unusable for photography. Early morning is definitely the best time to do this photography, so study the tide tables and make sure you visit your chosen sites only at a time when there is a rising tide at sunrise.

Shoreline birds are usually very sensitive to human presence, so you will need to be in the hide before dawn. For this reason it may be better to set up the hide the previous evening before dusk, abandon it for the night and then return before first light the next morning. Even with the use of a super telephoto lens, to be sure of getting close enough to the birds you will probably need to set up the hide quite some way below the high tide mark. Since you will be photographing on a rising tide be sure to choose a morning on which the hide will not be flooded until an hour or two after sunrise, and a location from which you can safely retreat with all your precious equipment to higher ground. You may be unable to retrieve the hide at this point, so when setting the hide up make sure it is firmly held down and is able to resist the tide, allowing it to be retrieved when the tide falls. A final word of warning: do not try this kind of photography on a beach or mudflat where the tide comes in like an express train. You need a slowly rising tide, both for your own safety and to ensure that the birds are slowly and gently pushed closer to the hide, giving you plenty of time to get ever-closer photographs of them.

SOME SPECIAL SKILLS

With other uses of a hide you will need to make similar considerations, especially concerning the sun's angle at the time of day (usually early morning) when you are likely to want to shoot. With mammals you will also need to consider such factors as wind direction (make sure your hide is downwind of where you expect the animals to be) and whether or not the animals are likely to be dangerous should they either detect you or take exception to the hide's presence.

Other considerations include local or national laws concerning disturbance to wildlife, and the possible need to obtain a permit for what you intend to do (this is especially so when photographing birds at or near their nest).

Whatever the situation and subject, be sure you get into your hide well ahead of the expected arrival time of your subject, or at least at a time of day or night when they are least likely to detect your arrival. Once inside stay quiet and reasonably motionless. Make yourself as comfortable as possible, and if you expect a long wait for any action, have some snacks and reading material to help pass the time.

Shooting from a hide does have a number of drawbacks. One of these is the inevitably limited field of vision. Time and again I have found the perfect subject off to one side from the hide and visible only at a very acute angle from the window. Pushing the camera around to attempt to take in that angle, or moving the camera to another window almost invariably causes sufficient disturbance to frighten the subject

Figure 60 *Zebras in their natural environment. Of course they cannot be approached as closely as a zoo animal, but this kind of shot shows the family group and the habitat in which they live.*

away, usually just as I have finally managed to make all the necessary adjustments.

Another problem can be the use of flash, if you are in a situation where it is needed. In order to remain invisible, the viewing window is usually either very small or is covered with camouflage netting, the lens being pushed through a small hole in this. A flash gun mounted close to the camera cannot be fired through the netting, so it must be mounted on the outside of the hide. This in itself is not a major problem, but you may find it difficult to ensure that the immovable flash is able to cover a sufficiently wide angle to take in every direction the lens is likely to be fired in. This can be overcome by rigging up several flash guns, all pointing in slightly different directions.

A hide's biggest limitation is its immobility. An alternative to the traditional hide that helps to overcome this is to simply bury yourself under a massively oversized cape or raincoat, suitably camouflaged and modified with holes in the right places for lens, eyes and, perhaps, flash gun. This will clearly enable mobility, but it does not take much to imagine the problems that could result from stumbling almost blindly along through rough undergrowth, draped in this heavy, hot cape as you struggle with a camera attached to a big telephoto lens, set up on a tripod, as you attempt to creep up on your quarry. Mobile yes, but only to a limited degree, and only with lots of practice.

Stalking animals

Small wonder, then, that a good many photographers dispense with any form of hide as often as they can. But how on earth do you approach often shy animals and, especially, small birds? It is no coincidence that a vast proportion of the world's wildlife photography is of African grassland mammals. In addition to their great predominance in zoos, which has rendered them popular among the general public, they are among the easiest animals to approach in the wild. This is especially so in the most heavily visited of Africa's national parks, where many of the animals have become almost oblivious to the truckloads of camera-toting visitors that pass them by each day.

If only this could be so for most other forms of animal wildlife. So many times have I pleaded with jumpy birds that I am a friend and that all I wish to do is get their photograph, all to no avail. There are of course numerous tricks that can help you approach closer, although none of them guarantees success. The first step is to dress in sombre, though not necessarily camouflaged, clothing, and to move slowly, carefully and quietly. If stalking mammals, always remain downwind. If repeatedly walking the same area, wearing the same clothes each time and sticking to more or less the same route can help the local wildlife to recognize you as a familiar feature of the landscape. Regularly laying out food at specific sites can also help to draw in animals over a period of time, but you may not get the species you intended.

Inevitably, all these steps towards encouraging wildlife to accept your presence take a long time, and may be all well and good in your home area, or on a project which is open ended and well funded, but on most projects and especially in unfamiliar areas you will have to produce results more quickly than this will allow. As ever, one of the

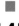

Figure 61 (left) A mute swan on the River Cam, in Cambridge, UK. Wildlife does not necessarily have to be photographed with a wild setting. This kind of shot reveals the extent to which some forms of wildlife have been able to integrate with the human environment, and so is itself an important statement of a positive human/wildlife interaction.

Figure 62 (above) A white-naped crane, with a chick almost hidden in the grass, in the grasslands of Zhalong Nature Reserve in the far northeast of China. Birds such as this one, that have been captively bred, released into the wild and who then begin to breed in the wild not only give renewed hope for an endangered species, but also become great photographic subjects due to their lack of fear of people.

SOME SPECIAL SKILLS

■

Figure 63 A great mormon swallowtail butterfly, a tropical species of southern China. Photographed with handheld camera, macro lens and flash, this perfect specimen proved quite easy to approach. It is likely that it had just metamorphosed and was in the final stages of waiting for its wings to dry out before flying away.

most important steps is to recruit local help. Park rangers, guides, foresters, farmers and – yes, dare I say it – even hunters (or perhaps I should say especially hunters) can all give invaluable help in tracking local wildlife.

You can also use a number of short cuts, resorting to photographing wildlife that has been human habituated. Wildlife living in suburban or rural gardens and parks is one very good option and, although mammals and birds that have taken to raiding picnic sites may be seen as a nuisance by some, to struggling wildlife photographers they can be a great boon.

With forest birds, simply sitting quietly and motionless in a shady area next to a popular feeding spot can quite quickly be very rewarding, at least in terms of being able to see the birds skipping around among the branches. Another way to encourage birds to come close is to broadcast tape recordings of birdsong, but not just any old chirping. Generally, a recording of species A's song will attract only birds of that species, usually a male come to check out who is muscling in on his territory. However, being able to get good clear shots in forest conditions, even with a powerful lens and a flash, and ensuring that any movements with the camera do not immediately frighten everything away, can still be very problematic.

Photography of insects, amphibians and reptiles is often simply a matter of learning how to creep up to them very gently, something

which – especially with butterflies and lizards – at first seems almost impossible, but which with practice appears for no obvious reason to get easier. Keep your equipment simple for this: use a camera handheld, equipped for macro photography, mounted with a flash gun that is able to illuminate subjects within the macro-shooting distance, and without casting the lens's shadow across the subject. Indirect flash using a reflector is the best way to use such a gun, but in poor lighting conditions, such as on the forest floor, you may be forced to use direct flash simply to get enough light. Use of a flash not only supplies instant, artificial sunlight, revealing details and colours on your subject's skin that might otherwise be invisible in shady forest light, but it also enables you to use a much slower shutter speed than would be possible for handheld photography without it. For this reason, I usually use the flash for this kind of work even when my subject is in sunlight. Even with this reduced shutter speed on many occasions it will be necessary to shoot with a wide aperture, resulting in a narrow depth of field, something that can be a real problem with macro photography. Ideally, you would use a tripod and then concentrate on maximizing depth of field at the expense of your shutter speed. However, this approach is usually too cumbersome for dealing with sensitive animals such as butterflies, and the handheld approach is the only one in which you can react quickly enough to your subject's frequent movements.

Returning to the photography of mammals, when things get really desperate there is the remote triggering option, one of the most specialized forms of wildlife photography. Basically a camera and flash are set up somewhere on a well-used animal trail, and are linked to some kind of trigger that will fire the camera every time it is activated by a passing animal. The trigger is usually either a pressure-sensitive mat placed on the path but hidden from view by leaves or a thin layer of soil, or an infra-red beam shone across the path. The shots that result from this technique can be superb and may give images of rarely seen or never before photographed wildlife. However, problems abound and if you decide to try this technique be sure to use equipment you do not mind losing.

The first problem is that of ensuring a continuous stream of electricity for however long the photographer chooses to, or has to, leave the camera on site. Camera, flash and infra-red beam will all have to remain switched on, perhaps for as long two weeks. Inevitably, the usual AA or lithium batteries will be quite insufficient for this task. The traditional solution is to haul car batteries in with the cameras, something quite feasible for a short walk, but impossible for deep penetration of a dense forest. Innovative attempts to overcome this have involved solar panels, which work well if it is possible to set them up in a clearing, but which in dense forest need to be fixed near the tops of the trees. In this situation be sure to take along a coconut farmer or a trained monkey! If setting cameras up near a stream, another possible solution that has been suggested to me, but which has not yet been tried out as far as I know, is to rig up a simple water-mill generator.

You also have to keep the rain out. Camera and flash gun (set up separately to prevent photographs from being ruined by red-eye) must be enclosed in waterproof perspex boxes, with the connections for all

Figure 64 The Yangtze River dolphin, the world's most endangered cetacean, restricted to only a few parts of China's Yangtze River. With only about 100 animals left in the wild, spread over a 1500 km stretch of the river, finding one to photograph in its murky waters is virtually impossible. At the time of this photograph the dolphin shown here was the only one in captivity, so this became a very rare shot that was used to good effect in Asian magazines to publicise the dolphin's plight.

linking cables thoroughly waterproofed. When set up, make sure the camera is angled down to reduce the risk of raindrops sitting right over the lens. Placing silica gel inside the boxes can also help keep the atmosphere inside dry. In most climates this arrangement should work well, though I have heard horror stories of cameras destroyed by fungus after just a couple of weeks set up in tropical rainforests during the rainy season.

Finally, there are the problems of the triggering device, and not just the supply of electricity. First, pressure-sensitive mats, being buried in the ground, can easily have their electrical contacts damaged by damp to such an extent that at one extreme they will not fire even when stepped on by an elephant or, just as bad, fire off continuously with no animal in sight, finishing an entire roll of film in a few minutes. Furthermore, some animals – especially deer – seem to be astonishingly sensitive to anything not quite right about their path, and have been known to repeatedly walk around an apparently invisible mat, regularly passing the camera without a single frame being fired off. Use of the infrared beam overcomes virtually all these problems, except one.

Figure 65 Hartmann's mountain zebra. A full face portrait of even a large mammal such as this is virtually impossible in the wild, and so zoo animals are very important for this kind of photography. Not only are they approachable but they remain relaxed, and the result is a fine portrait that gives good 'publicity' for the captive animal's wild cousins.

**PROFESSIONAL
NATURE
PHOTOGRAPHY**

151

Heavy rain, or drops falling from overhead leaves, can break the beam, firing off the camera.

If you manage to overcome all these pitfalls, there is still one more that will very likely get you: when setting up the camera you forgot to focus the lens on the point where the animal's head will most likely be at the moment the camera is triggered, ensuring that you have a wonderful set of pictures of rare, never before photographed mammals, but all out of focus!

Photographing captive animals

In view of all the problems often associated with the photography of wild birds and mammals, it is no small wonder that professional photographers often resort to obtaining their images by using captive animals. Accusations that this is cheating usually come from people who do not have to collect a certain minimum number of images of a range of species within a tight budget and an even tighter deadline. While it would be wonderful to be able to always photograph wildlife in the wild, actually achieving this goal is a luxury that is not affordable much of the time.

Whether they are people's pets or parts of zoo collections, captive animals lend themselves beautifully to close-up portraits, for example. With a little patience and the right lighting it is quite possible to finish up with some highly appealing images that appear to penetrate right into that animal's personality, or at least some anthropomorphic interpretation of it. Images such as these are of immense appeal for the way they seem to bridge the human–animal divide. This kind of situation is also useful in obtaining images that can be used in identification keys, especially of birds. In this case, obtaining a shot that suggests personality is less important; instead, you will need good clear pictures in which the crucial identifying features are unambiguously visible.

Photography of captive animals involves a number of simple techniques. First, you will very likely be able to approach close enough for flash to be effective. Use of fill-in lighting is very useful if your subject is not in sunlight, and it may also put a lively twinkle into the animal's eyes. However, be careful not to overexpose any areas of white fur or feathers or to create any harsh shadows behind it. One way to help reduce both these problems is to use indirect flash, bouncing the light off a reflector. This will also help to reduce the danger of red-eye with an animal that decides to stare your camera down.

In many zoo situations you may find yourself looking at your subject through wire fencing. This may not be the disaster for photography that it seems, for provided the mesh is not too small it is often possible to obtain good images by pressing the lens right up to the wire. In doing this the wire becomes so far out of focus as to be invisible. It is advisable, however, to only do this with wire that is painted matt black and which is not itself in sunlight, otherwise all kinds of extraneous light reflections will find their way into the lens.

On occasions you may find yourself allowed into animal enclosures, all the better to approach close to your subjects and without such constraints as wire fences. Doing this may reveal that even captive animals have a strong sense of territory; they may be perfectly happy to

have humans quite close by, provided they are separated by a fence. However, as soon as you enter their patch they may well become quite nervous. This can often be overcome by sitting still and waiting for a while until they accept your presence, or by moving around slowly and quietly, remaining in the shadows as much as possible. As usual, wear sombre clothing.

Even in photography of captive animals, you may often want to make the environment appear as natural as possible. Slabs of concrete and fences visible in the background are obviously distracting, unless of course they are included deliberately either to make a statement about captivity in general or to highlight, for example, some captive breeding programme or a zoo's facilities. To cut out such artificial features, it will be necessary to choose your viewpoint carefully to ensure a backdrop of vegetation. With pets it may well be possible to place the animal perfectly, and have a reasonable expectation of it staying there at least for a short time. With a zoo animal, however, this may prove impossible, either due to the animal's surroundings or unpredictable behaviour. A solution that is often acceptable is to light your subject with flash but with the background underexposed by two stops. The background will come out black, a lighting situation which though seemingly unnatural can in fact occur in the wild.

There are two of major pitfalls in the photography of captive animals. First, such animals may appear and behave rather differently from their wild cousins. While behaviour is only occasionally a problem in stills photography, the former is of major concern. Birds may not look after their feathers as well as they would in the wild, for example, while diseases and injuries almost unheard of in the wild may become common in captivity. If your work requires you to frequently photograph a wide range of species from a great diversity of origins, it is difficult to be an expert in everything you see, so you may need to rely on specialists to point out problems in unfamiliar species. Who would have guessed, for example, that captive Thai Water Dragons have a habit of rubbing away the skin on their noses? So, whenever photographing captive animals, develop a keen eye for possible abnormalities, and if you suspect any problems check with a specialist before wasting film on any atypical animals.

The second major pitfall is that of inappropriate vegetation. It is all very well struggling hard to ensure that your captive subject is photographed surrounded by vegetation without a hint of concrete or wire anywhere, but what if the vegetation is wrong for that animal's wild environment? A bird of the marshes photographed on dry, dusty grass, or a tropical mammal set against a thicket of oak hedging, for example, is clearly out of place. It may well be that it really does not matter for the purposes of the project in hand, but for a project that is aiming to reproduce any photographed animal's probable natural environment it would be a disaster. One way to get around this is to ensure that all the vegetation is well out of focus, something often not difficult to achieve with a telephoto lens set on a wide aperture. The sure way to overcome the problem is to photograph captive animals only when you see them with the right kinds of vegetation, travelling to parks that have made the effort to create the right environments. Of course, if you

SOME SPECIAL SKILLS

■

want to avoid the syndrome of tropical animals set against temperate vegetation, or vice versa, you may have to travel halfway round the world.

Finally, a brief word about photography of wild animals that are temporarily held in captivity, perhaps even caught specifically for you to photograph. For the lower animals, such as insects, amphibians and reptiles this is generally quite acceptable, provided they are not restrained in any harmful way, and provided they are released soon after being photographed, preferably at the site where they were caught. For aquatic species this may be the only way to obtain photographs, animals being scooped out of a pond or river and placed in a portable aquarium for photography. This can be done on site, with the aquarium set up on the pond or river bank, the animals returned to their home within minutes of being caught.

Similarly, with those reptiles that can be caught by hand, it is perfectly possible for a helper to hold its tail while you photograph the head end, releasing it as soon as photography has been completed. Do not bother trying this with lizards – you will just end up with a handful of tail – and anyway with care they can often be photographed as wild animals without restraint. With snakes, only hand-catch those that you know to be non-venomous.

When it comes to birds and mammals, however, you may run into serious objections to trapping simply for photography. Indeed, it may

Figure 66 Photography of trees stands at the uncertain border between plant and landscape photography. This image shows the open, savannah-type landscape of Calauit Island Wildlife Sanctuary in the Philippines, with the trunks of a tree lit by the setting sun as a strong element in the image. The animals visible are Calamian deer, a species endemic to this part of the Philippines.

well be illegal, unless you first make sure to obtain whatever permits are necessary. It may be possible, however, to join up with a team of scientists who have been allowed to catch animals for their research, incorporating the photography as an additional component of their project. It has to be said that, except simply for the sake of record-keeping, photography of trapped wild birds or mammals can be a waste of time as such animals are often so stressed that this shows up clearly in any resulting photographs. This can be overcome, however, by releasing them into a small purpose-built enclosure, leaving them for a time to calm down, and then photographing from a hidden viewpoint. Think hard about the rights, wrongs and practicality of this approach before investing in the time and expense needed to make it work.

Photographing plants

One of the great advantages of plant photography over that of animals is that your subjects, whether mighty trees or tiny mosses, do not run away. You can take your time selecting viewpoint, composition and focusing, and if you cannot get the light right one day, you can always come back the next and your subjects will still be just where you left them. This does not mean that plant photography is absolutely straightforward, it is just that with any one subject you are likely to have many more opportunities to get it right.

At the top end of the scale, plant photography merges hazily with landscape work in the portraiture of trees. It is possible to produce truly glorious images of stately, mature trees, individually or in groups set against a backdrop of their environment, whether it be a wild mountain scene or a manicured parkland. Techniques are essentially as described for landscape photography.

Once within the confines of a forest and unless a suitable clearing can be found, getting clear images of any one tree – or even a small group – can be virtually impossible, the only option usually being to shoot upwards more or less right along the line of a tree's trunk. The strong diagonals that result often produce great dynamic pictures, provided the light is right. A bright, hazy or lightly overcast sky is disastrous because with the camera pointing upwards it will be very difficult to correctly expose the tree against it, although a graduated neutral density filter may help here. Misty conditions or a heavily overcast sky can be useful, reducing the amount of backlight above the trees, and often resulting in them being fairly evenly lit along most of their length. Clear sunshine will produce excellent results provided it is falling on the tree at the right angle, illuminating at least most of it more or less evenly – select the tree or trees to be photographed carefully.

Photography of herbaceous vegetation can be quite challenging due to the propensity for such plants to move in even the slightest breeze, and the difficulty of obtaining a strong image in which the intended subject is clearly separated from the general tangle of vegetation – especially in the wild. In situations where a photogenic plant can be found that stands well clear of its neighbours, a close-up wide angle shot may produce a dramatic image of the entire plant. But in situations where this is not possible it may be solved by concentrating on only the visually most striking part, usually its flower or fruiting body.

Figure 67 A *Karpia* species dipterocarp tree standing in a small forest clearing provides a rare opportunity to photograph almost its entire length in good sunlight. Seen in Subic-Bataan Natural Park, Philippines.

This will often entail the use of macro techniques, which immediately introduces the problem of depth of field, something that is important even with the close-up wide angle view. Though limited depth of field will be useful in throwing the background right out of focus, you must ensure it is great enough to bring all the critical parts of the intended subject into focus, whether it is shot with a wide angle or a macro lens. The slow shutter speed needed to do this – especially if you have added a polarizing filter to cut out reflections and strengthen the colours – will not only make a tripod absolutely obligatory (you should be using one anyway), but will also mean you need windless conditions.

Anyone who has ever photographed a plant will be familiar with the syndrome of the subject that is completely motionless until the instant the camera is set up and ready, at which point it suddenly starts waving around in a breeze that has appeared from nowhere. If this happens you will simply have to wait until a lull allows the plant to rest and you to snatch a few shots. Erecting a windbreak on the plant's windward side will greatly help, though this of course means yet another item to carry around. Your own body can make a useful windbreak if necessary, but take care not to block the light from your subject. If the shutter speed is half a second or less remember to allow for reciprocity failure.

If the ambient lighting is rather dull you may want to use flash, not in order to shorten the shutter speed, but to import a little artificial sunlight. With balanced flash and a slow shutter speed not only will the

Figure 68 A lotus flower photographed in the botanical garden in Xiamen, China. Nature photography often entails collecting pictures of garden flowers, and in the tropics at least, the lotus is one of the most spectacular.

PROFESSIONAL NATURE PHOTOGRAPHY

157

Figure 69 A studio shot of the flowers of a Taiwanese species of berberis. I stumbled upon a huge flower-laden berberis bush when walking near the coast one day. The wind proved far too strong for any kind of shot to be possible, so I cut a small piece off and took it back to my hotel room where I was able to photograph it in comfort, using flash.

background be correctly exposed by the ambient light and depth of field maintained, but the main subject will be brought to life, the colours of berries or flowers enhanced. In situations where there really is too much wind for a slow shutter speed to be of use, and you will most likely have no opportunity to reshoot your subject on another day, flash photography with a fast shutter speed may produce a usable and sometimes even dramatic image, one in which the background will be completely black. Always use the flash indirectly, bouncing it off a reflector in order to minimize shadows.

Finally, a word about white flowers. They are often one of the hardest subjects to tackle, the exposure needed to show up any detail in them often rendering every other part of the photograph badly under-exposed. Correctly exposing the photograph as a whole will often result in the white flower being completely washed out and devoid of detail. The best solution to this is to never photograph them in sunlight – either use a cloudy day or erect some kind of diffuser between flower and sun – and avoid the use of flash.

Underwater photography

A consideration of special skills would not be complete without a look at underwater photography. The surge in interest over the past few years in coral reefs in particular and marine life in general has opened up a whole new area of niche photography for those able to master the

Figure 70 A diver swims past a gorgonian sea fan off Puerto Galera, Philippines. Gorgonian sea fans are a coral that vary in size from a few centimetres to several metres across and come in a whole range of colours. Although the diver is clearly some distance behind the sea fan, he does serve to give some feeling of scale to an image that otherwise would be difficult to judge.

Figure 71 A minute crab attached to bubble coral, on a reef close to Apo Island, Philippines. Finding minute subjects, only a couple of centimetres across, such as this, requires intense observation, looking past the overall beauty of the coral reef to its finest details, often not an easy task when there is so much to look at.

necessary skills.

The first requirement is, of course, to be able to dive. Although some underwater photography is possible while snorkelling, the limited depth and the very limited amount of time you can spend under the water greatly restrict working in this way. Diving courses managed under the auspices of such international bodies as the Professional Association of Diving Instructors (PADI) are widely available, will quickly get you under the water and learning many of the basic skills, and will give you a qualification that is recognized worldwide.

The photography is the most difficult part, and will take much practice to master fully. In terms of equipment there are two options: you can use either a standard terrestrial camera enclosed in a special housing, or a purpose-built underwater camera, usually the Nikonos. Both are expensive and end up costing just about the same. In terms of usability, the former is very flexible, allowing the same autofocus wide angle and macro functions that you would use on land. However, the controls on the housing may take some time to master, and the whole thing is both large and cumbersome to handle, even under water. The Nikonos camera, on the other hand, is small, compact and relatively light, but as a viewfinder camera with limited focusing functions, anyone used to an autofocus SLR may take a while to get to grips with its use.

Flash is obligatory underwater, not just owing to the reduced overall lighting, but also to the prevalence of blue wavelengths, other colours being filtered out close to the surface. The flash is mounted well to one side of the camera, never right next to it, thus reducing the risk of light backscattered by particles suspended in the water getting into the lens.

One of the main requirements in obtaining good underwater photographs is to minimize the camera–subject distance. Doing this reduces the amount of intervening water and hence suspended particles. For this reason most underwater photography consists of macro, close-focus and close-up wide angle images, the last of these using super wide angle lenses of about 15 mm focal length. Telephoto and even standard lenses are never used.

It is not surprising, then, that the resulting photographs take in very limited views that at best include, for example, only a few coral structures. Even in crystal clear waters (which are very rare) long distance views are not possible. Most images, even those taken with a wide angle lens, are basically portraits of just one or two corals, anemones, sponges or fish, or even just details of each these.

The flash's angle is critical and one must be flexible in moving it around to ensure appropriate lighting for the subject's orientation. For this reason it is better to handhold the flash at all times. The use of two flash guns, one on either side of the camera can ease lighting problems, but even here it is better to handhold one of them to retain maximum flexibility.

Overall, underwater photography can produce stunning results after some extensive study and practice. Anyone intending to invest time and money in this skill needs to take it seriously in order to make it work well.

Summary

This chapter has looked at some of the special skills that a nature photographer will need to master. It is crucial to learn to see your subjects in the same way that your film will 'see' them, understanding, predicting and either compensating for or enhancing the way it is likely to record colour and lighting.

In landscape photography you should go beyond producing images that simply record a location, instead evoking some atmosphere or mood in which the role of the actual location may be reduced to a secondary function. Low sunlight, mist and even gloomy rain-soaked light have their respective uses in landscape photography.

Shooting from a hide can be useful in photography of very shy mammals or birds, but it requires a great deal of planning to make sure the hide is in the right place. Once set up, you need to be patient and wait for the animals to come to you. Your mobility is greatly restricted.

In stalking animals, mobility is restored, but you will now most likely be visible. With truly wild mammals and birds in a particular location it may be possible to overcome this over time by visiting their habitat regularly in order to get them used to your presence. Faster results are possible with human habituated animals, around picnic areas or in suburban gardens for example. Insects, reptiles and amphib-

ians can be photographed by approaching them with care and the use of handheld flash photography. For photography of very shy mammals, remote triggering may be an option, but this technique is fraught with problems and usually takes practice to perfect.

Captive animals are often used, especially for portrait photography. It is possible to shoot through wire fences. If allowed into enclosures, take care not to upset animals unused to a human presence within their space. Temporarily capturing wild insects, amphibians and reptiles often produces successful results, but doing this with birds and mammals can be difficult to justify and may be illegal. Teaming up with a scientific research group may help to overcome these problems.

With plant photography at least your subject will not run away. However, you will need to concentrate on obtaining sufficient depth of field while at the same time getting shots in which the plant is not blurred by any movement. Use of flash will help bring a dimly lit subject to life, and in windy conditions may enable the production of usable photographs.

Underwater photography has become an important speciality skill, but it requires a whole new set of equipment and techniques that may take some time to master. If investing in this area take it seriously; do not dabble.

10 PROFESSIONAL ISSUES

In this final chapter it is worth considering some of the issues that surround the way one goes about being a photographer. Not only will you most likely have some overall goals that you wish to reach with your work, but you will also have clients to satisfy on a job-to-job basis. Moreover, since much of your work will entail photographing living beings, regardless of whether they are plants, insects or highly intelligent mammals you will have to contend with the issue of how to treat them with respect and within the law while you carry out your work. This is very much part of the question of what is acceptable in striving to get the 'right' image, both in terms of treatment of the living world and post-camera manipulation of images. Then there are such questions as the way in which you present your images to the world, the manner in which you relate to your competitors – your fellow photographers – and what kind of role you feel nature photography in general, and yours in particular, does or should play in the world. These issues will be looked at in the following sections.

The aims

The aims of any photographer's work can perhaps be best divided into two broad categories. First is the overall aim of which direction he or she wants their photography to go, whether it is simply to provide the best service to clients, to put across some artistic expression of their feeling for the environment, or for it to serve as an effective campaign tool in environmental issues. Second, there is the project-oriented aim of ensuring that each piece of work, whether produced speculatively for a magazine or as a commissioned piece for a specific client, is produced to a consistently high standard.

Overall aims

As previously mentioned, your reasons for becoming a professional nature photographer – and presumably, therefore, your overall aims at least at the outset – could be as varied as simply a desire to provide a good client service, producing whatever a client asks for in the nature photography field, to a burning desire to record on film anything alive, to the campaigning zealot out to change the world and its profligate environmentally destructive ways, with a whole host of positions somewhere among these three. Most likely, there will be a

**PROFESSIONAL
NATURE
PHOTOGRAPHY**

163

Figure 72 Shooting straight up the trunk of a tree can give a dramatic impression of its size, but success depends on lighting being at least reasonably even along much of its length. The picture shows a dipterocarp tree (*Shorea curtisii*), one of the giants of Southeast Asian tropical rainforest, in Bukit Timah Nature Reserve, Singapore.

variety of reasons for entering the field, and so a mixture of goals to fulfil.

It is perfectly possible for your overall aims to be clearly formed when you start out on the road to becoming a professional photographer, but that as you become involved in the daily competitive struggle to survive so they become more distant, uncertain and increasingly less important. If this bothers you it will be necessary to step back from the work occasionally, assess how what you are doing is helping or hindering progress towards fulfilling your aims, and make adjustments either to your goals or to the type of work you take on. Modifying your goals should not be seen as breaking or watering down any principles. Nothing is written in stone and everything evolves, including the world around you and your perception of it, so you must at all times be prepared to alter the way you intend to tackle it.

If, however, you find that your overall goals are still appropriate but that the kind of work you are doing is taking you in the wrong direction, then you should start working out how to change direction. Obviously commissioned work in hand cannot just be dropped, but you may feel the need to set new criteria by which new work, both commissioned and self-initiated, are allowed into your future work schedule. Much will depend on the relative priorities of the need to fulfil your goals and to make a living. You may find it helps to divide your work into two, at least psychologically: one kind of work that is perhaps quite commercially oriented, which makes little direct contribution to fulfilling any personal photographic or environmental goals, but which does pay all or most of your bills, and the other kind of work which perhaps at best breaks even but which helps satisfy your drive to produce work that is either artistically or environmentally expressive.

Project aims

At the individual project level, regardless of your overall aims, every photographer must aim to produce a consistently high standard of work, in terms of both quality and style. The latter will often take care of itself, as over the years most photographers will develop their own distinctive style, often almost unaware of it themselves although usually clearly visible to others. While many elements of style will always remain the domain of conscious decisions, others will be the result of the way you choose to work, the kind of equipment you like to use and instinctive reactions to particular situations, elements which will probably be conscious – and perhaps laborious – decisions in your early days, but which slowly become intuitive and instantaneous with increasing experience and knowledge of what does and does not work for you.

In terms of quality of work, it is essential for the photographer to consistently produce his or her best photography. Almost every project will entail the production of a batch of photographs – perhaps several hundred if you are working on a book – and so the occasional flash of genius, a few utterly brilliant photographs mixed in with a sea of mediocrity, is not of much use. The occasional brilliant stroke most definitely needs to come second place to concentrating on ensuring that every image to be submitted at the end of a project is of a similar high stan-

Figure 73 A low morning sun backlights both the spring leaves of a maple sapling and the trunks of mighty Japanese cryptomeria trees, photographed in the forests of Chichibu-Tama National Park, on the edge of Tokyo, Japan. Often when in the forest it is difficult to get any kind of meaningful view due to the density of the vegetation, a problem often heightened by a low sun that creates areas of strong light set against blocks of dense shadow. The solution is to pick on some small highlight, a little piece of the forest that suggests the strength and grandeur of the whole.

dard – and similar style – to every other. This does not mean that you should not strive to produce your very best in every image, simply that you should aim to consistently reproduce a high standard in all your work, and avoid the temptation to go overboard on a few images, putting at risk – due to a lack of time, for example – the quality achievable with the bulk of a project.

The client

Whatever your reasons for becoming a professional photographer, and whatever types of work you do, whether commissioned or self-initiated, you will have clients to satisfy. Keeping them happy is not simply a question of turning in work of a high quality, although this is an essential part. Even if you feel that clients are little more than a necessary evil in the struggle to pay your bills, preventing you from really getting on with the kind of photographic expression you crave, you are nevertheless providing a service and should treat these bill-payers with the respect they deserve. As described earlier, from the start be honest about what you can and cannot do (but at the same time not excessively modest), respond to queries and requests quickly and politely, adhere to agreements, and deliver work on time and well presented. Basically, treat your clients as you would have them treat you.

Ethics and the living world

It should be remembered that much of a nature photographer's work involves the photography of living beings, sometimes rare and endan-

**PROFESSIONAL
NATURE
PHOTOGRAPHY**

■

166

gered species. Whether they be plant or animal, one should respect their existence, not only for the sake of the specific individual being photographed but also for the wellbeing and survival of its species and the natural environment as a whole. Do not inflict pain on any animals, minimize the damage you do to plant life – including those plants that surround your intended subject and which might be badly trampled during your photographic efforts – and obey local conservation laws, whether that means, for example, avoiding disturbance to badger setts, photography of birds at the nest, or the digging up or picking of wild flowers.

Yet there may be occasions when the pressure to produce results, to get the right photographs and to finish a project may tempt you to push such ethical considerations to one side. The clinching shot would be perfect if only you could make that animal stay still, or if you could just get in a bit closer to the nest, and you could do away with wind and the wrong light if only you could move that plant indoors, etc., are all thoughts that may well run through your head when struggling to make a project as near perfect as possible.

Having the right equipment and perfecting your techniques are important aspects of ensuring that the best photographs can be obtained with the minimum of disturbance, but if you find yourself in situations where there is a danger of either an ethical or legal barrier being breached, stop and go no further. If possible, consult with spe-

Figure 74 Dusk over Cadlao Island in Bacuit Bay, El Nido, Philippines. A restful dusk shot, the rocky island and its reflection provide the required silhouette.

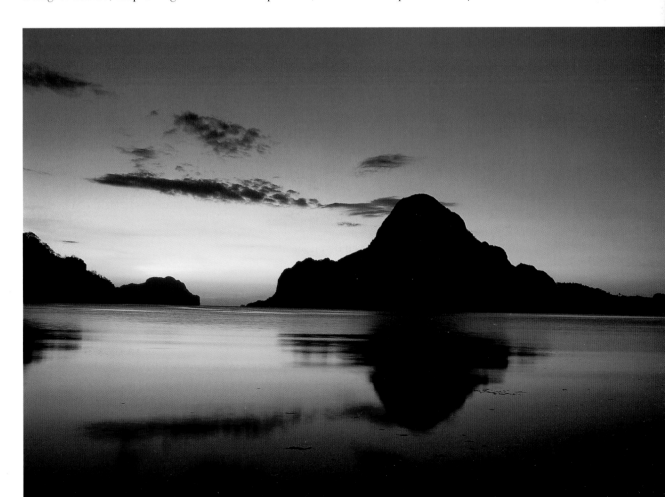

cialists who may have greater knowledge of your subject species than you, and where appropriate obtain any necessary permits before pushing ahead with potentially spectacular but intrusive shots. If there is clearly no way forward without harming either the environment or a species, then call it a day and leave. It is very rare for any one or two images to be crucial to a project, and the regard in which your work is held would suffer if it came out that you trampled on the lives and environment of living beings – especially endangered species – in order to get a few great shots. Feel good about yourself for sacrificing those shots for the good of conservation.

Photography of captive animals

There is something of a puritanical feeling in some areas of conservation that believe photography of captive animals is an appalling heresy. But, as described in Chapter 9, with most forms of wildlife – other than, perhaps, mammals of the African savannah – photography in truly wild situations is extremely difficult and time-consuming. While a proportion of wildlife pictures for any one project may well be obtained in the wild, with tight budgets and even tighter deadlines it is very often essential to obtain some in captivity. After all, with captive animals you may well be able to approach far closer than would ever be possible in the wild, regardless of the brilliance of your techniques, the perfection of your equipment or the correctness of the permits you have obtained. As a result you may be able to photograph aspects of an animal's anatomy or behaviour never recorded before.

The use of captive animals in photography, then, has an important role to play in understanding their wild cousins, and it should in no way belittle either the value of the resulting photography or the importance of the species concerned in the wild. However, there are a number of issues that arise from this kind of work.

The first of these is the conditions under which any animals that you may wish to photograph are kept. Conditions at zoos and wildlife parks vary enormously from country to country and region to region, and in choosing where to do your photography you should use only those places that truly care for their animals. Not only are the animals likely to be in better condition and more naturalistic surroundings, but you should not want to appear to support the work of, or have your name associated with, disreputable places.

Secondly, there is the way animals are treated while you are actually photographing them. While the only control you may have over the way animals are kept generally is to work only with those places that really care, when it comes to taking the photographs the wellbeing of the subject animals is down to you. While some captive animals may actually be quite fascinated by your presence and your antics with the camera, others will be terrified, at least to start with. You must not do anything that will either cause injury to an animal (such as any attempt to restrain it, or an injury inflicted as it attempts to get as far away from you as possible, even within its confined enclosure), or that will further heighten its fear. Refuse well-meaning but misguided offers by rangers to help drive animals into the right positions (really, this does happen, but seldom works due to the animals' terror factor). Try to resist the

temptation to prod sleeping animals into wakefulness. While captive animals do seem to spend huge amounts of time asleep – after all, what else is there for them to do? – many are naturally nocturnal, or partially so, and should by rights be asleep at the times of day you are most likely to show up. To overcome this, change your habits, not those of the animals; visit early in the morning, late in the afternoon or at feeding times.

Thirdly, there is the danger of giving misleading impressions about the state of wildlife in the wild. Photography of captive animals can be a very valid way of either bringing to public attention the diversity of wildlife that exists or of illustrating the kind of wildlife that lives in a given region (such as in a book about the wildlife of a particular country), but there is a danger that such photography could mislead viewers into believing that these animals are extremely easy to find in their wild habitats, and perhaps exist in healthy numbers. This possible misrepresentation of the true state of the environment is a definite problem with books and magazines whose overriding aim is not only to sell copies but also to promote a particular place as a tourist destination. Photographers need to be vigilant about this.

Even within the context of the many magazines that want to publish only good news, with self-initiated projects it should be possible to ensure that the true situation is well represented. With commissioned work, however, it can be very difficult to influence how your material is used in the final product. Asking how the material will be used before agreeing to do the job may help but is not fully reliable. After all, no client is going to admit that the real situation is going to be misrepresented; you may have to read between the lines of what they say. Once a project is finished, you may need to keep a close eye on the way your photographs are being used in order to try to ensure that the result is something you are happy to be associated with.

Finally, we come to photography of wild animals temporarily held captive, perhaps specifically for your photography. As outlined in Chapter 9, this is a very difficult issue, and especially for higher animals it will not be easy to justify capture purely for the sake of photography. If you do this work, perhaps in association with a scientific research team, all the rules described above for captive animals apply, only even more so. Successful photography, in the sense of being able to minimize the animals' fear, may well rely on you remaining hidden. It is essential to release all animals unharmed as soon as the photography is finished.

The digital manipulation war

Photography is going through a revolution in which the chemical darkroom is being replaced by the digital one. Film still rules in most applications over and above digital cameras, but with the ability to manipulate the resulting images on computers post-film processing has never been easier. Such manipulation is increasingly widespread in most fields of photography, but it is still largely frowned upon in nature photography. The reason is not difficult to see: start fiddling with images of the natural world and you could very easily end up with pictures of something that simply does not occur. Having trouble getting a shot of a Giant Panda in the wild, for example? Simple. Take a picture of a

captive panda and one of a Chinese forested mountain landscape, merge the two together in all the right ways, and hey presto there is your wild panda shot. But is that mountainous forest actually the right environment? Not many people are going to know the answer to that question, so does it really matter? Well, yes it does, because it all comes down to the danger described above of misrepresenting the truth about the natural world, in this example both in terms of the ease with which one might be able to find pandas in their wild environment, and as to what exactly their wild environment is.

Quite clearly, then, it would be very easy to accidentally or deliberately generate images that falsify what is happening in the natural world, and unless very high standards of ethics are maintained in this area there will come a point where no one will believe the photograph as proof of a given situation, animal behaviour or environment.

Nevertheless, digital manipulation should have a wide range of highly beneficial uses, for example in improving images that have fallen foul of any of a range of technical problems that bedevil nature photography – exposure in poor light conditions, or insufficient depth of field. In underwater photography, backscatter of the flash light from particles suspended in the water can easily be cleaned up by digital manipulation, greatly improving many images at no detriment to their biological accuracy. These are all improvements that many photographers have struggled to achieve for years in the chemical darkroom, and which have only become controversial due to the very ease with which they can now be achieved on computer.

No doubt purists will continue to argue against digital manipulation, and with many good reasons. However, for those photographers – including nature photographers – working in a commercial environment, a digital imaging capability has become an essential tool in the image-making process, and it is not going to go away. We just have to make sure that it is used wisely and truthfully.

Facing the competition

There are a large number of photographers out there trying to do almost exactly the same as you, and to succeed you will have to compete energetically with them. Nature photography is very much a solo business and you may not meet many of your competitors very often, but if you join any professional bodies or attend any seminars you will undoubtedly do so from time to time. How do you react to their presence? At one extreme you may see them as the arch-enemy, hungry predators itching to steal your business and any trade secrets that you may accidentally let slip. When they are around perhaps you should stay quiet and say not a single word. At the other extreme you might be so glad to have presumably like-minded people around that you throw yourself on them, virtually pleading for their camaraderie and an unlimited two-way flow of anecdotes and advice.

Over the years I have only occasionally experienced examples of these two extremes, most photographers falling somewhere in-between, although exactly where often depending upon time and place. Most nature photographers, being generally lone workers, are only too pleased to meet others working in the same field, to exchange ideas and

experiences, and generally give support. It is surprising how much of a boost you can receive from hearing that other photographers are having similar experiences, such as difficulties with equipment or success with particular agencies or magazines. Most photographers will hold back on their most important trade secrets and may well be unwilling to divulge who their best clients are, but are very willing to exchange ideas generally.

The fortress mentality of refusing to let anything slip to the competition is not a very helpful attitude, because the friendly exchanges that ought to be possible with your colleagues can lead to an extensive network of contacts. These people may not only be willing to help with advice in future projects but may also be able to direct work your way if, for example, they are approached to work on a project that is either not really their type of work or for which they are already too busy. Of course, you must always be ready to reciprocate too.

The network may already exist in a formal form as a professional association, and so these bodies are worth joining for this reason alone, provided that you are then able to make yourself known within that organization. Alternatively, you may with time be able to build up a loose, informal network of photographer contacts, not necessarily limited to those within the nature photography field, starting with those in your locality and then expanding further afield.

A widely spread and highly diffuse band of competitors are the amateur photographers, those for whom photography is simply a hobby. A surprisingly large proportion of published photography comes from this source, allowing amateurs to have a significant impact on both the supply of photographic material and the fees paid for images.

While the number of amateurs that concentrate on nature photography and are truly competent is relatively small, they still present significant competition for the professional. The keenest amateurs inevitably use the same equipment as the professionals, at least in 35 mm work, and can be just as good technically. Furthermore, since this is largely a hobby for them they do not need to cost their time, and many are happy if the fees they receive merely cover their costs. After all, their real income comes from a full-time job. Much of the photography they submit for publication is relatively general material, but some amateur photographers specialize in focusing on one particular species at a time, for a whole year photographing the behaviour of, say the Greater Spotted Woodpecker, and at the end of that year coming up with a superb portfolio of that one species. They really should be applauded, for this is important nature work, enabled only because the time needed to get the shots and the likely financial reward resulting from the work may be almost immaterial to them. For a professional tied to a variety of deadlines and tight budgets, such work would be possible only if it came with a very well-paid commission and a distant deadline.

For the professional, many amateurs may remain anonymous since they are unlikely to belong to any of the professional bodies and will not be attending professional seminars or other events. So it is unlikely that you will be able to establish much rapport or even contact with them. In competing with them you need to work on the types of

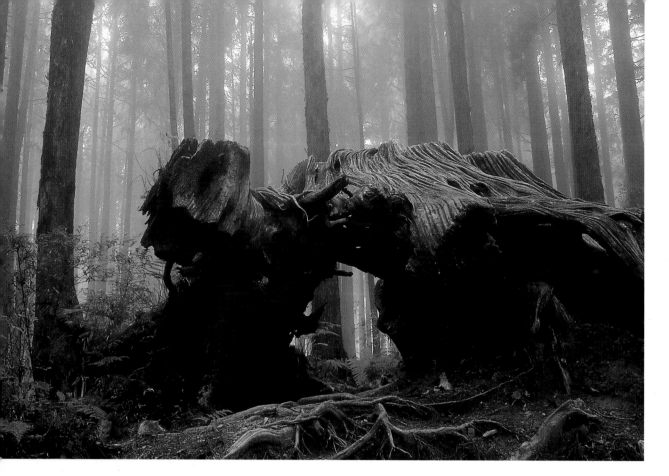

Figure 75 This massive stump is all that remains of an ancient forest of Taiwan spruce that used to stand at this site high in the Taiwanese mountains. With the stump surrounded by a young forest half lost in fog, this image tells a story of destruction of the ancient and renewal with a young, albeit man-planted, forest.

projects that amateurs will not be involved in, something that makes commissions valuable over speculative work, and to ensure that in areas where you do overlap, your work as a professional is strikingly better. Two ways of achieving this are to shoot as much work as possible on medium format and to concentrate on photographing only when the light is absolutely at its best. If you follow these rules you should only lose out with clients for whom price is the overriding consideration, with quality a very secondary factor.

Taking sides in environmental issues

As I mentioned earlier in the book, I find it almost inevitable that anyone who takes an interest in the natural environment and its wildlife will eventually become an ardent supporter of conservation. As a professional nature photographer this has a number of implications that must be considered seriously. For commissioned work, this essentially covers the question of how far you are willing to go to produce whatever results a client may request, and with self-initiated, speculative work how much of a biased slant you intend to use.

For work that concentrates simply on recording species or natural environments and habitats, or producing striking artistic images of these, there is likely to be no danger of any controversy. If your work is heading for material that will have application to or direct use in tourism, then as outlined earlier you may be starting to head into an area where there is a danger of reality being distorted, usually to

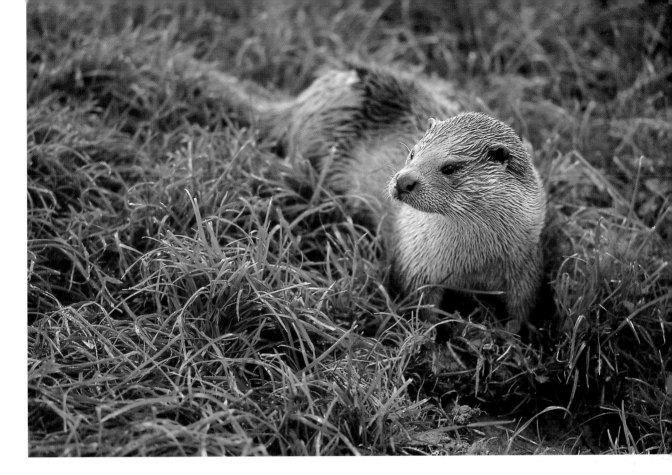

produce a rosier impression of the state of the environment than is actually the case.

If your work involves coverage of environmental issues, such as loss of or damage to habitats due to industrial activities, then you should think carefully about what your involvement is. If you see yourself as providing purely a service to whoever commissions you then you may be happy to produce photographs that give whatever angle your client requires, whether it be pro- or anti-conservation. If you are crusading for the protection of the environment then inevitably you will vet any potential clients that approach you and take commissions only from those that want to support your pro-conservation stance. Any of these stances is fine provided you make any position you have clear to potential clients before they commission you. Do not agree, for example, to produce photographs for a quarry company showing that their expansion is not harming the environment, only to then go out and deliberately get shots that suggest it is. Although any particular stance that means you have to restrict your clients may be limiting to your overall business, any photographer who gains a reputation for deliberately lying to potential clients in order to get commissions and then produces the opposite of what was agreed, is going to lose favour with a wide range of potential customers.

If you are intending to cover an environmental issue as a speculative project, perhaps with the intention of later selling it to a magazine, of course you are free to choose your photography to promote any stance you want. However, that stance will inevitably determine what

Figure 76 A European otter. Although the uniformity of the grass around it reveals that this is not a wild animal, nevertheless this shot puts over the personality of the otter as an alert, inquisitive creature, something that would be very difficult to achieve with the wild animal and its often nocturnal habits.

**PROFESSIONAL
NATURE
PHOTOGRAPHY**
■

173

types of magazines you will eventually be able to sell to, and if the finished project is so excessively biased one way or another, with important subjects that are inconvenient to your viewpoint deliberately missed out, then you could end up with a reputation for unreliable, perhaps even bigoted reportage. It may be better to try to cover the issue as fairly as possible, restricting the influence of your own views, and leave the images to speak for themselves. The one vital area where greater bias one way or the other may be introduced later is at the editorial stage, where your images may be selected to reflect the editor's own views. If this worries you, try to keep a firm hand on the editorial process.

Natural history photography in society

There is no doubt that the popularity of nature photography has grown enormously in recent years. Why is this? Certainly a steadily growing concern for the state of our environment has played a large role, but also important has been the fast improving quality and drama of many television wildlife documentaries. These have brought astonishing images of the natural world right into everyone's living rooms. As each species has come under the camera's scrutiny, so many have then gone on to have a great popularity with the public, from baby seals to meerkats. The appeal is more often than not based less on a concern for each species' wellbeing in the wild than from an anthropomorphic reaction. The huge popularity of Walt Disney's characters is testament to this.

Thus, one of nature photography's major roles is simply in entertainment. For the photographer this can mean cute images of cuddly animals, an amusing and apparently near-human personality showing through in the facial expression or posture. Such images sell, and many a postcard company does well out of producing and promoting them. They also have an important role in some aspects of advertising, where one or more species simply becomes an icon to promote the sale of a product.

For those who find this insulting to the glory of the natural world, rescue is at hand in that many of the entertainment aspects link up well with a much more serious expression of nature, and indeed conservation messages, in the form of stunning images of wildlife and wild places. Some of the best television documentaries and magazine stories have been both cause and result of growing interest in the environment, and while many of the images in this arena are presented as entertainment, they clearly carry a strong message to the viewing public that the world is still rich in astonishing creatures and environments.

This type of entertainment is very educational too, and when linked with work that highlights conservation issues both negative, such as the rapidly declining wild tiger population, and positive, such as the possible reintroduction of beavers to Britain, has the power to arouse public opinion to generate some real action. This work may either set out to simply report or document a given situation, with no intention of provoking a reaction from any particular quarter, or it may be overtly campaigning in its stance. It is true that the best pictures are worth a thousand words, and few environmental campaigns have been successful without the use of stunning photography. The appeal that pho-

tographs used in these campaigns carry is usually emotional rather than purely factual, because they are often used singly rather than as a complete documentary essay and so have to carry the campaign's entire message. For example, a picture of a white-furred baby seal staring appealingly up into the camera as it is about to be cudgelled to death is quite definitely one that pulls at the heart strings with no space for any intellectual consideration of the rights and wrongs of the issue.

There are no clear lines separating the areas of entertainment, advertising, education, documenting and campaigning, and you will find your work spanning all of them. Indeed, you may find the same image being used in several fields, perhaps at the same time. Even those photographers intent on using their work to make a difference in the world, to help save at least some part of the natural environment, should be glad to have their images used in what they may consider to be some of the less serious aspects of nature photography. Every photographer has to pay their bills and make a living, and the entertainment and advertising fields are often the best payers. Moreover, every little bit of exposure has to be good news both for the photographer's future career and the general prominence and popularity of the natural environment.

Summary

When you start out as a professional photographer you will probably have some overall aims for where you would like your photography to go. As you get busier, however, you may find that either these goals

Figure 77 Late autumn sunlight pours down upon a family enjoying the autumn colours of 500-year-old oaks at Bradgate Park, near Leicester, in the UK. While summer offers the greatest opportunity to shoot in sunlight, the quality of autumn and winter sunlight when you can get it, is truly magical, giving a completely different perspective even on a park landscape.

**PROFESSIONAL
NATURE
PHOTOGRAPHY**

175

need to be reassessed, or new criteria for the kinds of work you take on established. At the individual project level, you should always aim to produce your best work, remembering that most projects require the production of a set of pictures, all of which need to be of a similar high standard and style. When working with a client be sure that you treat them with the respect they deserve, giving them your best work and delivering on time.

Similarly, treat your animal and plant subjects with respect, inflicting no pain, doing your utmost to limit any fear they may feel, and avoiding or at least minimizing damage to vegetation. Know and obey the law regarding wildlife, and obtain any permits that might be needed. If it is impossible to obtain photographs without causing serious disturbance or even injury to your subject or its environment, back off.

Photography of captive animals may overcome some of the ethical and practical problems associated with their wild cousins, largely because they are much more approachable. This kind of work may enable pictures to be obtained that would be impossible in the wild. However, zoo animals may still be relatively timid, and you should take care not to cause them any injury or unnecessary disturbance. Be sure that the relative ease with which captive animals can be photographed does not lead to any misrepresentation in the finished project regarding the state of their wild cousins.

Digital manipulation of images has become an important part of all forms of photography. In the nature photography field there is great concern that such manipulation could result in factually incorrect images. Nevertheless, it should be useful in such areas as improving underexposed images or the removal of blemishes.

Competition among photographers is intense, but this does not mean that you should adopt a fortress mentality to your colleagues. There should be camaraderie among like-minded people, and much help may be available from other photographers, who after all are in a similar situation to yourself.

When considering environmental issues take care when deciding whether or not your photography should promote one or another side of any arguments, especially if the work is commissioned. Be honest with clients if you have a particular stance on any issue which you are not prepared to compromise. When covering issues for a magazine you may be better off covering it fairly, regardless of your own views, and leave the photographs to speak for themselves.

Nature photography has a variety of roles in society at large, from entertainment, through advertising, to education, documenting and campaigning. Your work will probably range across all these fields, and even if your main aims are to work on the campaigns you should be glad of the income and exposure obtainable in the entertainment and advertising fields.

APPENDIX

Professional organizations

Association of Photographers
81 Leonard Street, London, EC2A 4AQ, UK
Tel: +44 (0)171 739 6669
Fax: +44 (0)171 739 8707
E-mail: aop@dircon.co.uk
Website: http://www.aophoto.co.uk

Australian Institute of Professional Photography
PO Box 11, Fortitude Valley, Queensland 4006, Australia
Tel: +61 (0)7 5544 6600
Fax: +61 (0)7 5544 6601

British Institute of Professional Photography
Amwell End, Ware, Hertfordshire, SG12 9HN, UK
Tel: +44 (0)1920 464011
Fax: +44 (0)1920 487056
E-mail: bipp@compuserve.com
Website: http://www.bipp.com

Bureau of Freelance Photographers
Focus House, 497 Green Lanes, London, N13 4BP, UK
Tel: +44 (0)181 882 3315/6
Fax: +44 (0)181 886 5174

North American Nature Photography Association
10200 West 44th Ave, #304, Wheat Ridge, Colorado 80033-2840, USA
Tel: +1 303 422 8527
Fax: +1 303 422 8894
E-mail: nanpa@resourcenter.com
Website: http://www.nanpa.org

Professional Photographers of America
229 Peachtree St NE, Suite 2200, International Tower,
Atlanta, GA30303, USA
Tel: +1 404 522 8600
Fax: +1 404 614 6404
E-mail: info@ppa-world.org
Website: http://www.ppa-world.org

Professional Photographers of Canada
PO Box 337, Gatineau, PQ, J8P 6J3, Canada
Tel: +1 819 643 5177
Fax: +1 819 643 7177
E-mail: ppoc@qc.aira.com
Website: http://ppoc.ca

Professional Photographers of Southern Africa
Ground Floor, West Block, Dunkeld Crescent, Albury Road,
Dunkeld, PO Box 47044, Parklands 2121, South Africa
Tel: +27 (0)11 880 9110
Fax: +27 (0)11 880 1648
Website: http://www.profoto.co.za

Useful directories and other publications

1999 Photographer's Market: 2,000 Places to Sell Your Photographs. Published annually by F & W Publications, 1507 Dana Ave, Cincinnati, Ohio 45207, USA.

Advertisers Annual. Published annually by Hollis Directories Ltd, Harlequin House, 7 High Street, Teddington, Middlesex, TW11 8EL, UK.

The Creative Handbook. Published annually by Cahners Publishing Co. Ltd, 34–35 Newman Street, London, W1P 3PD, UK.

The Freelance Photographer's Market Handbook. Published annually by the Bureau of Freelance Photographers, Focus House, 497 Green Lanes, London, N13 4BP, UK.

The Green Book. Published annually by AG Editions Inc, 44 Union Square West #523, New York, NY 10003, USA.

Self-Publishing for the Freelance. Nik Chmiel (1995). Published by BFP Books, Focus House, 497 Green Lanes, London, N13 4BP.

UK Press & Public Relations Annual. Published annually by Hollis Directories Ltd, Harlequin House, 7 High Street, Teddington, Middlesex, TW11 8EL, UK.

Willings Press Guide. Two volumes (UK and Overseas) published annually by Hollis Directories Ltd, Harlequin House, 7 High Street, Teddington, Middlesex, TW11 8EL, UK.

Writers' & Artists' Yearbook. Published annually by A&C Black (Publishers) Ltd, 35 Bedford Row, London WC1R 4JH, UK.

INDEX

182